MORRIS LOUIS

MORRIS LOUIS

THE MUSEUM
OF MODERN ART
NEW YORK

JOHN ELDERFIELD

Published on the occasion of
an exhibition at
The Museum of Modern Art, New York
October 6, 1986–January 4, 1987

The Fort Worth Art Museum
Fort Worth, Texas
February 15–April 12, 1987

Hirshhorn Museum and Sculpture Garden
Smithsonian Institution
Washington, D.C.
May 20–July 26, 1987

The exhibition, *Morris Louis*, has been made possible
by the generous support
of GFI/Knoll International Foundation.

The publication has been supported
by a generous grant
from Marcella Louis Brenner.

Edited by Harriet Schoenholz Bee
Designed by Carl Laanes
Production by Tim McDonough and Daniel Frank
Type set by Trufont Typographers, Inc., Hicksville, New York
Color separations by L.S. Graphics, Inc., New York
Printed and bound by Arnoldo Mondadori, Verona

Distributed outside the United States and Canada
by Thames and Hudson Ltd., London

The Museum of Modern Art
11 West 53 Street
New York, New York 10019

Printed in Italy

CONTENTS

LENDERS TO THE EXHIBITION

Mr. and Mrs. Harry W. Anderson
Marcella Louis Brenner
The Eli and Edythe L. Broad Collection
Mr. and Mrs. Marshall Cogan
Lois and Georges de Menil
William S. Ehrlich
Helen Frankenthaler
Mr. and Mrs. Graham Gund
Stephen Hahn
Dr. and Mrs. Charles Hendrickson
Mr. and Mrs. James J. Lebron
Sally Lilienthal
Mr. and Mrs. David Mirvish
Mrs. John D. Murchison
Mr. and Mrs. I. M. Pei
Mr. and Mrs. Arthur Rock
Robert A. Rowan
Mr. and Mrs. Eugene M. Schwartz
Sylvia and Joe Slifka
Mr. and Mrs. Thomas Weisel
Mr. and Mrs. Bagley Wright
Donald and Barbara Zucker
Six collectors who wish to remain anonymous

Ulster Museum, Belfast
Staatliche Museen Preussischer Kulturbesitz, Nationalgalerie, Berlin
The Fogg Art Museum, Harvard University, Cambridge, Mass.
Des Moines Art Center, Des Moines
The Museum of Fine Arts, Houston
Sheldon Memorial Art Gallery, University of Nebraska, Lincoln
The Solomon R. Guggenheim Museum, New York
The Museum of Modern Art, New York
The Lannan Foundation
Philadelphia Museum of Art, Philadelphia
Hirshhorn Museum and Sculpture Garden, Smithsonian Institution, Washington, D.C.
National Gallery of Art, Washington, D.C.

PREFACE

THIS PUBLICATION accompanies an exhibition of Morris Louis's paintings at The Museum of Modern Art, New York, subsequently shown at The Fort Worth Art Museum, Fort Worth, Texas, and the Hirshhorn Museum and Sculpture Garden, Smithsonian Institution, Washington, D.C. Its forty-six color plates illustrate the contents of the exhibition, which is the first in New York (and in Fort Worth and Washington) to represent in depth all the important series in Louis's *oeuvre:* the Veils of 1954 and 1958–59, the Unfurleds of 1960–61, and the Stripes of 1961–62. In addition, certain major transitional pictures of 1959–60 are represented. Pictures have been chosen above all on the basis of quality and with the limits of the Museum's gallery space in mind. In this publication, however, virtually every type of painting by Louis is discussed. Its aim has been to provide a historical overview of Louis's development and to elucidate the evaluations that have informed the selection of the exhibition.

As director of the exhibition and author of this publication, I wish to thank Marcella Louis Brenner, the artist's widow, for her support and encouragement of my work on Louis over many years, and for her generous grant toward the production of this publication. I also owe a great debt of gratitude to Clement Greenberg, the first supporter of Louis's art. Additionally, André Emmerich and I. S. Weissbrodt have been extremely helpful, and I very much appreciate the assistance of Diane Upright. The exhibition has been made possible by a generous grant from GFI/Knoll International Foundation, and I wish particularly to thank Marshall Cogan for his keen interest in its progress.

On behalf of the Trustees of The Museum of Modern Art, I gratefully thank the lenders to the exhibition, listed on the opposite page. I gladly acknowledge the important help, either for my research on Louis or for the realization of this exhibition, of Robert Abrams, Lee Armstrong, Michael G. Auping, Lynn Becker, John Berggruen, Leonard Bocour, Alan Bowness, Edgar Peters Bowron, Abner Brenner, J. Carter Brown, Bonnie Clearwater, Diana Coleman, Charles Cowles, Roger Davidson, Mrs. R. Dippel, Michael Fried, David Geffen, Lady d'Avigdor Goldsmid, Bruce Guenther, Anne d'Harnoncourt, Joseph Helman, Heather Hendrickson, Ted Hickey, Knud W. Jensen, Carolyn Jones, John Kasmin, Dr. Pieter Krieger, Catherine Lampert, James J. Lebron, Janie C. Lee, Norbert Lynton, Peter C. Marzio, Charles Millard, Kenworth Moffett, Jane Mulkey, Sybil Myersburg, Steven Nash, George W. Neubert, Kenneth Noland, Barbara Osborn, Christina Petra, Edmund Pillsbury, Mark Rosenthal, Lawrence Rubin, William Rubin, David Ryan, Mr. and Mrs. Fayez Sarofim, Mr. and Mrs. Toby Schreiber, Douglas G. Schultz, Katie Solomonson, Melville Straus, Liane Thatcher, Anne Truitt, Maurice Tuchman, Leslie Waddington, Diane Waldman, David Warren, and Marcia Weisman. I also owe a debt of gratitude to four friends with whom I have discussed Louis's work: Carl Belz, Monique Beudert, Jack Flam, and William Edward O'Reilly.

At The Museum of Modern Art, my main debt is to Robert McDaniel, who assisted me on all aspects of the exhibition and publication, making important contributions to both. I wish also to thank Al Albano and Antoinette King for advice on conservation, and Harriet Schoenholz Bee, Kathleen Curry, Daniel Frank, Betsy Jablow, Mary Jickling, Janet Jones, Carl Laanes, John Limpert, Jr., Christopher Mount, Jerry Neuner, Richard L. Palmer, Eloise Ricciardelli, and Gretchen Wold.

Additionally, thanks go to E. A. Carmean, Jr., and James Demetrion, directors of The Fort Worth Art Museum and the Hirshhorn Museum and Sculpture Garden, respectively. The Museum of Modern Art is grateful for their cordial cooperation. —J. E.

1

Louis's early career; friendship with Noland and
introduction to Abstract Expressionism;
influence of Greenberg; 1954 Veils; repudiated
pictures of 1955–57 and the New York School

MORRIS LOUIS's historical position, and consequently his identity as a modern painter, is one of the more difficult to establish in recent art. Exactly what makes his resplendently beautiful canvases more than pleasing decorations is certainly as compelling a question (perhaps more so, since it carries us immediately to an evaluation of Louis's importance). But that question is partly answered by an understanding of his historical position, as are other necessary questions concerning his artistic development, which at times was erratic and at others so single-minded, obsessive, and astonishingly productive as to have virtually no precedent in modern art.

He was born Morris Louis Bernstein, the third of four sons in a lower-middle-class Jewish family, in Baltimore, Maryland, in 1912. He was the exact contemporary of Jackson Pollock and three years older than Robert Motherwell, of the same age group as the younger members of the so-called First Generation of Abstract Expressionists. His early life was uneventful, but at the age of fifteen he opposed family pressure to follow his brothers' careers in medicine and pharmacy and won a four-year scholarship to the Maryland Institute of Fine and Applied Arts. Graduating in 1932, he supported himself by a variety of odd jobs while pursuing his painting and becoming active in local art affairs; in 1935 he was elected president of the recently formed Baltimore Artists' Union. None of his paintings from this period remain.

Like many of the Abstract Expressionists, he was employed during the Depression by the Federal Art Project of the Works Progress Administration (WPA); first in Baltimore in 1934, where he worked on a mural titled *The History of the Written Word* for which he researched early forms of writing;[1] then in New York (he moved there in 1936), where he changed his name to Morris Louis.

While in New York he participated in David Alfaro Siqueiros's experimental workshop, where automatic painting procedures and commercial materials and equipment, including spray guns, airbrushes, and synthetic paint, were examined, at times in collaborative projects with other artists. Pollock was also a member of this workshop, but the two seem not to have met then. He did get to know Arshile Gorky and Jack Tworkov. But Louis was apparently an extremely withdrawn figure who preferred his privacy and, except for the woman with whom he then lived, a fellow WPA artist, he made no lasting friendships in New York. Painting was already virtually a full-time obsession. He regularly visited The Museum of Modern Art and was very interested in the work of Max Beckmann, whose influence is clearly seen in one of the handful of his paintings that survive from these years, a harsh, somewhat troubled image of two workmen. Many of his paintings were somber scenes of poverty and of working people, appropriate to the conditions of his life then. However, his paintings were untouched by contemporary artistic influences. In the early 1940s (the exact date is uncertain) he returned to Baltimore to live with his parents, where he remained until he married Marcella Siegel in 1947.

After his marriage Louis moved into his wife's apartment in the suburbs of Washington, D.C. For the next five years he worked in isolation. During this time he gradually absorbed, mostly from reproductions rather than first-hand contact, a range of abstract styles from Joan Miró to Pollock, whose only common denominator was an emphasis on drawing. Louis also drew obsessively, most successfully in a Surrealist-influenced style indebted to Gorky. None of the paintings or drawings from 1947–51 is particularly original, although some, especially those from 1950–51, evidence an intelligence highly receptive to what was most demanding about an abstract art based in drawing—especially the way in which a drawn armature can simul-

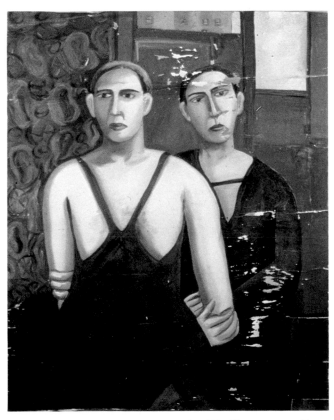

Morris Louis. *Untitled (Two Workmen)*. 1939. Oil on canvas, 44 × 34″. Museum of Fine Arts, Boston

taneously establish an allover, relatively evenly accented surface and allow more detailed, specifically incidental readings of the elements that comprise it. While it would be too much a hindsight interpretation to see in paintings like the Pollock-influenced Charred Journal series of 1951 an overriding emphasis on the organization by drawing of an allover monochrome field, it is not unreasonable to see these works as the springboards of Louis's mature art.

The Charred Journal paintings, in particular, and the Motherwell-influenced Tranquilities collages that followed in 1952–53, reveal a highly astute, knowledgeable artist preoccupied with the problem of fixing emphatically charged imagery onto a demonstrably flat, wafer-thin surface. In these paintings and collages his solution was to exaggerate contrasts of light and dark. Whether by setting pale, wirelike filaments against a dark, striated surface or by imposing regularly spaced dark verticals against a light surface, he worked with an ultimately Cubist system of tonal oppositions. The give and take between figure and ground simultaneously forces the imagery to the eye and locates it within a shallow planar continuum whose limits are established by the character of the imagery itself, either because the drawing turns in upon itself around the edges of the picture, as Pollock's does, or because it aligns itself to the edges of the picture, as Motherwell's does. At least, that seems to have been the intention. In either case, however, the sense of tangible images laid out on top of the ground makes the coherence of these works somewhat problematical, certainly somewhat plotted and conventional.

One thing further should be noted about these flawed but nevertheless accomplished pictures: their serial character. Even with Louis's earlier figurative works, "when he'd get interested in something he'd practically wear it out. He had this ability to select something and stick to it. For example, when he was trying to make one figure sit in a space, he'd do twenty or thirty versions with hardly any difference between them."[2] While only about fifty of his pre-1954 paintings have survived, it is clear that he was already an extremely prolific artist. The numerous surviving drawings of 1950–53 are also evidence of this, particularly a large series based on a flattened oval shape (some derived from a fish) with scattered scribbles and lines, and occasionally ruled grids, inside.[3] Kenneth Noland, whom Louis met in 1952, has said that while he considers himself prolific, he remembers that at one time Louis seemed to be painting twenty pictures to his one.[4] Clement Greenberg, to whom Noland introduced Louis in 1953, has referred to Louis having been like an express train, unstoppable once started on a particular track.

In 1952 Louis moved from the suburbs into Washington itself and obtained a job teaching evening classes at the Washington Workshop Center of the Arts, a "gathering place for advanced art people," as Leon Berkowitz, its director, described it.[5] Noland began teaching there the same year, and the two quickly became good friends despite their differences in age (Noland was twenty-eight, Louis forty) and temperament (Noland was gregarious, Louis withdrawn). Louis later said of their meeting, "Suddenly I wasn't alone."[6]

By 1952 Louis was a respected provincial artist who won prizes at local exhibitions, served on the Artists' Committee of The Baltimore Museum of Art, and attracted private pupils. He was an extremely experienced artist, having worked at his painting for some twenty years since graduating from the Maryland Institute. In terms of recent art, however, Noland was the more informed.[7] Not only had his education been in avant-garde art (at Black Mountain College in North Carolina in 1946–48, where he studied with Ilya Bolotowsky, and in Paris in 1948–49, where he studied with Ossip Zadkine) but he had already made contact with avant-garde circles in New

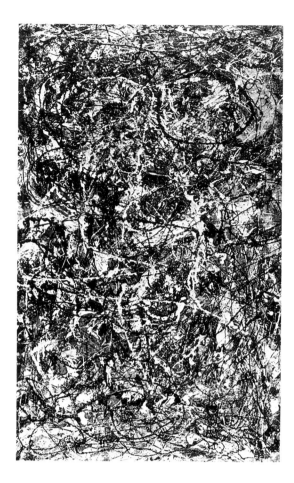

opposite above: Jackson Pollock. *Full Fathom Five*. 1947. Oil on canvas with nails, tacks, buttons, key, coins, cigarettes, matches, etc., 50⅞ × 30⅛″. The Museum of Modern Art, New York. Gift of Peggy Guggenheim

opposite below: Morris Louis. *Charred Journal: Firewritten I*. 1951. Acrylic resin on canvas, 39¼ × 30″. National Museum of American Art, Washington, D.C.

above: Robert Motherwell. *Granada: Elegy to the Spanish Republic II*. 1949. Oil on paper mounted on composition board, 48 × 56⅛″. National Trust for Historic Preservation. Nelson A. Rockefeller Collection

below: Morris Louis: *The Tranquilities III*. 1952–53. Collage (tissue paper and acrylic on upsom board), 37½ × 58½″. The Fort Worth Art Museum, Fort Worth. Gift of Marcella Louis Brenner

York. In the summer of 1950, at Black Mountain College, Noland met Clement Greenberg and Helen Frankenthaler, and later that year, in New York, David Smith. He soon became the main conduit to Washington for ideas and information about the New York art scene. As Anne Truitt recalled, "Ken began to go back and forth . . . and see people like Clem Greenberg and David Smith . . . and all sorts of people . . . [especially] Jackson Pollock. He talked to everybody in New York, and then he would come back to Washington and bring this information . . . about what Jackson Pollock was doing, about Kline, and about Clyfford Still, about Rothko, about Newman . . . turning Washington from a provincial little backwater artistically—which it certainly was— into a sort of brew out of which artists could come who were working, if not possibly at the very highest standards . . . [at least] within the context of modern art."[8]

In the education of the Washington art scene, Greenberg was of unquestioned importance. He eventually visited Washington every six months or so, and advised several artists about their work, Louis included.[9] Renowned for his critical writings as well as for his championship of Pollock's work, he brought to Washington not only the authority of the New York art world but an authoritative interpretation of recent New York art. In 1950–52 he was articulating—as no other critic was—the particular and specific pictorial problems that Abstract Expressionism (or, as he called it, Painterly Abstraction) was currently facing, and especially its need to save the objects of its painterliness, color and spatial openness, from the potentially clogging surfaces of painterliness itself.

Whereas most writing on Abstract Expressionism stressed the supposedly antitraditional, Existentialist, and crisis-ridden aspects of the style (most remarkably, Harold Rosenberg's controversial essay, "The American Action Painters," which appeared in *Art News* in December 1952), and consequently tended to admire its more heated, "gestural" form, Greenberg's interpretation was cool, closely analytical of the formal mechanics of the paintings, and emphatically historical. In particular, it stressed the Cubist heritage in Abstract Expressionism. As he later wrote, "The grafting of painterliness on a Cubist infrastructure was, and will remain, the great and original achievement of the first generation of Painterly Abstraction."[10] By the early 1950s, however, he came to feel that the increasingly showy painterliness developing in the circle around Willem de Kooning either disguised or embodied very conventional Cubist structures. He also felt that the Cubist component of the style hindered the full realization of certain "post-Cubist" aspects that were producing not only more radical but also more deeply felt paintings, most notably by Pollock, whom he described in 1952 as "in a class by himself."[11] These post-Cubist aspects were manifested in decentralized, allover compositional fields created from "relaxed" forms of drawing and design to produce a distinctively nontactile, optical space from which sculptural illusions were expelled. "Instead of the illusion of things, we are now offered the illusion of modalities: namely, that matter is incorporeal, weightless and exists only optically like a mirage."[12]

This was not orthodox opinion in the early 1950s. Indeed, as Abstract Expressionism became acknowledged as a truly important phase of contemporary art, it was the circle around de Kooning that achieved prominence in the art community.[13] This was partly an art-world reaction to Pollock's increasing public fame; partly a response to de Kooning's greater accessibility at the heart of things "downtown" on Tenth Street; and partly a result of the greater accessibility, to critics as well as painters, of de Kooning's art. While Pollock was presented as a

radical, crisis-ridden expressionist as often as de Kooning was, Greenberg's vocal support of Pollock in very different terms meant that (in the art community at least) it was de Kooning rather than Pollock who increasingly became the focus of attention and acclaim as the Existentialist hero of Abstract Expressionism. Moreover, Pollock's work seemed aesthetically a dead end; for younger artists his allover style offered far fewer options, short of mere repetition, than de Kooning's. The same was generally true of Mark Rothko, Barnett Newman, and Clyfford Still. Like Pollock, they had some followers, but far fewer than de Kooning attracted; and like Pollock, they tended to keep apart from the "downtown" scene—more so, in fact. Rothko's one-man exhibition in 1950 was not repeated until 1955, Newman's in 1950 and 1951 not until 1959, and Still's in 1950 and 1951 not until 1961.

Meanwhile, the work of younger artists around de Kooning such as Michael Goldberg, Alfred Leslie, Joan Mitchell, and Milton Resnick began to be shown, in some cases with Greenberg's initial support. But Greenberg's questioning of de Kooning's superiority soon meant that his standing with that circle "deteriorated to that of animosity and belligerency towards him."[14] All this, however, as Irving Sandler has pointed out, was more than a division between the supporters of Pollock and those of de Kooning. It was, rather, a division between the cohesive de Kooning group and those who did not want to be in it or were not welcome in it.[15]

Louis's introduction to contemporary New York art through Greenberg's interpretation of it is a crucial factor in his artistic development. Greenberg's dissatisfaction with Cubist-based Abstract Expressionism meant that he soon became more interested in the work of Still, Newman, and Rothko. But initially, this dissatisfaction directed him to Henri Matisse, and then to Impressionism. Both offered ways around Cubism for contemporary artists, not the least of which was the possibility of imbuing with affective color the atomized lights and darks of Pollock's post-Cubist style. Matisse, in addition, offered a telling moral lesson for contemporary artists. It is difficult to believe that Louis would not have thought about his own situation when reading this passage from Greenberg's review of the large Matisse retrospective at The Museum of Modern Art in the winter of 1951/52: "Like any other artist, Matisse worked at first in borrowed styles; but if he appears to have proceeded rather slowly toward the discovery of his own unique self, it was less out of lack of self-confidence than because of very sophisticated scruples about *his* truth."[16]

ON THE WEEKEND of April 3–5, 1953, Louis made his first visit to New York with Noland. On the Friday morning, they met Greenberg at the Cedar bar and went together to Harry Jackson's studio. The rest of that day and part of the next were spent visiting galleries; they saw paintings by Franz Kline and Pollock, among others; it was probably Louis's first exposure to Pollock's paintings in the original. On Saturday evening, along with Greenberg, Kline, and some others, they visited Frankenthaler's studio, where they stayed for about five hours.

Louis's and Noland's enthusiastic reaction to seeing Frankenthaler's *Mountains and Sea* in her studio—and their immediate, abrupt change in working methods and, indeed, in their very conception of painting—is now so firmly embedded in the written histories of contemporary American art that this "revelation" cannot completely be pried clear from its literary existence and actually imagined as taking place on Twenty-third Street between Seventh and Eighth avenues. More than this: such is the power of the often-repeated to engender not belief but the very opposite that the temptation naturally arises to assume that we are in the realm of myth,

Helen Frankenthaler. *Mountains and Sea*. 1952. Oil on canvas, 7′ 2⅜″ × 9′ 9¼″. Collection the artist (on loan to the National Gallery of Art, Washington, D.C.)

not of historical fact. But it did take place and it was a revelation. It did not provide either artist with ready-made solutions: some ten months elapsed before Louis was able to make paintings that embodied *his* truth from what he learned from Frankenthaler's painting, and it took Noland much longer. But there is no doubt that it made a profound impression on both artists. "For a year after they came back," Howard Mehring remembered, "*Mountains and Sea* was all that Ken and Morris talked about."[17]

This is part of Greenberg's by now classic account of how Louis was affected by this New York visit: "His first sight of the middle-period Pollocks and of a large and extraordinary painting done in 1952 by Helen Frankenthaler, called 'Mountains and Sea,' led Louis to change his direction abruptly. Abandoning Cubism with a completeness for which there was no precedent in either influence, he began to feel, think, and conceive almost exclusively in terms of open color. The revelation he received became an Impressionist revelation, and before he so much as caught a glimpse of anything by Still, Newman, or Rothko, he had aligned his art with theirs. His revulsion against Cubism was a revulsion against the sculptural. Cubism meant shapes, and shapes meant armatures of light and dark. Color meant areas and zones, and the interpenetration of these, which could be achieved better by variations of hue than by variations of value. Recognitions like these liberated Louis's originality along with his hitherto dormant gift for color."[18]

In his gloss on this passage by Greenberg, Michael Fried underscored its implication that Louis's originality and gift for color were simply not in evidence prior to the liberating effects of these recognitions.[19] This is indisputably true. For example, it is known that Louis constantly referred his students to Matisse's work, which he prized above that of any other early modern artist. And yet, there is no lesson of Matisse in his own preceding work; the revelation of *Mountains and Sea* gave Louis access to Matisse. What was involved was certainly an epiphany of a sort. But it is perhaps better described more prosaically, as Noland described it: "It was as if Morris had been waiting all his life for information. Once given the information, he had the ability to make pictures with it."[20]

Louis in 1953, furthermore, was perfectly positioned to use the information. By this I not only mean that he was hungry for first-hand contact with the kind of art he already admired, but that his admirations, especially for Pollock, had already brought him to the point where he knew that Pollock had to be assimilated into his own art and that all he had been able to do thus far was imitate him. Pollock, in effect, stood in his way, as Pablo Picasso had stood in Pollock's way. And just as Pollock was finally able to overcome his slavish dependence on Picasso through Surrealist and other art associable with Picasso's, finding in these sources a way back to unrealized, and therefore realizable, aspects of Picasso's art, so Louis found a way of approaching Pollock's art through Frankenthaler's. "We were interested in Pollock," Noland related, "but could gain no lead from him. He was too personal. But Frankenthaler showed us a way—a way to think about, and use, color." Louis agreed. Frankenthaler, he said, "was a bridge between Pollock and what was possible."[21]

On April 12, 1953, a week after Louis's return to Washington, his first one-man show opened there at the Workshop Art Center Gallery. It included some of the Charred Journal paintings and Tranquilities collages. An artist's first one-man show is usually a cause for celebration, but it is hard to believe that Louis was other than chagrined to see how inconsequential his pictures

appeared compared to those he had seen in New York. What is more, two groups of Abstract Expressionist pictures, including works by Adolph Gottlieb, de Kooning, Motherwell, and Pollock, were simultaneously on view at the Corcoran Gallery of Art and at the Catholic University of America. Louis's friend Leon Berkowitz had written a sympathetic introduction to his exhibition catalogue in which he compared Louis's drawing to that of Paul Klee and Miró. The comparison is apt when applied to the Charred Journal paintings, and points directly to their conservatism. Louis destroyed the 1953 paintings he had done before visiting New York and made a new start.

On the train back to Washington from New York, Louis and Noland had decided that they had to make drastic changes in their approach to painting, and agreed to try what they called, using a jazz analogy, "jam painting"[22]—both working together, even on the same canvas. ("Jazz men listen to each other," Noland later remarked, "criticizing the truth of each other's sound.")[23] Since they had first met, they had recognized in each other "an affinity of taste,"[24] particularly in their admiration of Motherwell and Pollock. Among the lessons of *Mountains and Sea* was freedom in the use of materials and in methods of paint application, both more noticeable in Frankenthaler's work than Pollock's because hers was more eclectic in its pictorial vocabulary. David Smith had advised them of the importance of not being precious with materials but of keeping plenty of supplies at hand and using them liberally.[25] Hitherto, the notion of beginning a picture from nothing had not been a reassuring one for either artist. It is true that Louis had worked freely with materials in Siqueiros's workshop in 1936, but it had not liberated his art as this new experimental episode would. Louis's Charred Journal paintings had been conceived with reference to Nazi book burnings; the Tranquilities collages may well allude to the patterns of picket fences. Now, however, Louis and Noland sought "to break down their previous assumptions" and to "break open painting" by experimenting with the materials of painting itself.[26]

Among the approaches they tried were pouring paint, painting with rags, finger painting, shifting the orientation of the painting as they worked, cutting down paintings, and cropping out paintings from larger areas of canvas. The May 1951 issue of *Art News* had reproduced photographs of Pollock at work on the floor of his studio. Louis and Noland were particularly impressed by both Pollock and Frankenthaler having chosen to work on the floor. It made the canvas "more material—more a real surface and not an (ideal) picture plane."[27] They also tried placing objects randomly on the floor with the canvas draped over them, then pouring paint onto the surface so that it created unexpected configurations as it flowed over and around the protrusions. Later, the flatness of the picture plane was reasserted, as Noland said, "just by stretching."[28]

This last approach is especially interesting given the future direction of Louis's art, for nearly all (if not indeed all) his mature paintings (from the 1954 Veils onward) were made on canvas that was draped on and tacked to a wooden stretcher, which leaned against the studio wall. (Furthermore, it would seem that a few extant Louis paintings of 1955 and 1956 were made using the method that he developed with Noland.)[29] Whereas Pollock needed, he said, "the resistance of a hard surface," Louis, as Michael Fried has observed, "seems to have needed nothing more, but nothing less, than the resistance of the *canvas itself*."[30]

After two or three weeks of "jam painting," Louis and Noland returned to working separately. None of their joint experiments seems to have survived. Nevertheless, their effect can be seen in the new freedom of handling in Louis's nine extant paintings from later in 1953.[31] All use staining (albeit on sized and primed canvas or on board), mostly in swirling or drifting configura-

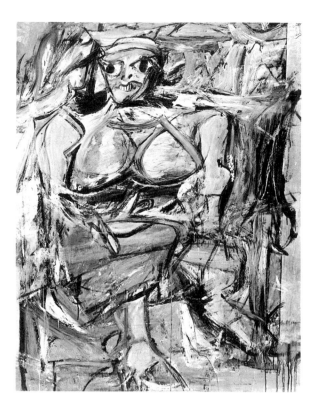

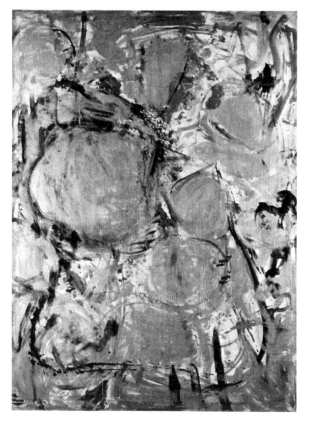

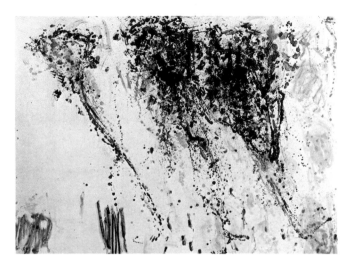

Morris Louis. *Trellis*. 1953. Acrylic resin on canvas, 6′ 4″ × 8′ 8″. Private collection

tions reminiscent of Pollock and Frankenthaler; but not all use it exclusively. Some contain heavy doses of aluminum paint, which clearly derives from Pollock, although the way it is used—to fill in cursively drawn darker lines—produces an effect reminiscent of de Kooning, whose influence can also be seen in Noland's 1953 paintings.[32] Others superimpose the stained areas with heavier, more thrusting (and more Cubist) drawing derived from Kline. The finest picture of the group, *Trellis*, is the one where Frankenthaler's influence is strongest. It is a "drawn" painting, whose soft diagonal drifts of thinned-down color hang from the top edge, generally suggestive of the grape arbor of its title. As with Frankenthaler's work, it evokes landscape, although its pictorial unity is not based on that evocation but, rather, on the artist's manipulation of varied densities of staining, directions of pouring and dripping, and on that sense of air and extension provided by the exposed canvas whose own substantiality (here, because of the white priming) seems as great as that of the areas that are painted.

Even at this moment, however, Louis was still a derivative artist whose combination of the influences of Pollock, Frankenthaler, de Kooning, and Kline, while producing more ambitious, more urgently felt pictures than hitherto, did not yet embody *his* truth. This leads to the conclusion that these 1953 paintings are not, in fact, wholly discontinuous with those made before Louis saw *Mountains and Sea* and that they do not completely repudiate the underlying assumptions of the earlier work. It is undeniable that Louis viewed *Mountains and Sea* as the source of new possibilities, that these required him to alter drastically his methods of painting, and that he himself recognized this as a major shift in direction in his work. It is further undeniable that Louis himself repudiated his earlier work (destroying, as we have seen, his early 1953 production) and its underlying Cubist assumptions. At the same time, it might reasonably be claimed that Louis overstated the extent of the influence of *Mountains and Sea* on his own work; or rather, he may have oversimplified it.

There are, in fact, some anticipations of what followed in the earlier work. To compare typical pictures of 1952 and 1954 by Louis is certainly to recognize an enormous gulf between them, and not only technically and stylistically, but qualitatively as well. However, the pictures of 1953 made after he saw *Mountains and Sea* are no more discontinuous with those of 1952 than the 1952 works are with those that preceded them, and they carry quite smoothly to those of 1954, except in terms of quality. Finally, the transition from 1953 to 1954—the actual transition to the first series of Veils—was achieved not solely by references to Pollock and Frankenthaler. That is the result. But at the actual moment of breakthrough Louis seems also to have been indebted to Kline.

Writing to Greenberg in mid-1954, Louis observed, "I don't care a great deal about the positive accomplishments in [other painters'] work or my own since that leads to an end."[33] With reference to some later paintings of his, he said that they "are lousy enough to interest me now and make me want to explore this further."[34] Additionally, he told his students that their bad paintings held the key to their development and that they should risk failure by pursuing what these, rather than their better works, suggested.[35]

Trellis is the most successful of Louis's 1953 pictures. Certainly the least successful are works such as *Landscape*, which is like a Kline on top of a Frankenthaler. If Louis did indeed work out of his weakest pictures at this time, it seems probable that the earliest of the 1954 Veils were works such as *Untitled A*, in effect a Kline made with the technique of a Frankenthaler,

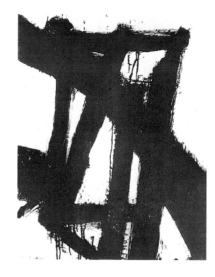

that is to say, composed of broad monochromatic, thrusting planes made by staining.

We do not know the order in which the 1954 Veils were painted. What follows is, therefore, a fictional construction, but it serves the purpose of explaining the stylistic components and options that Louis explored in this series, which comprises sixteen extant works made sometime between early January and early June 1954 (pages 85–95).

The Kline–Frankenthaler conflation of *Untitled A* is closely related to the Kline–de Kooning–Frankenthaler conflation of *Untitled B*, which exaggerates the coloristic lesson of Frankenthaler's art, overlaying planar swathes of intense color across the center of the canvas. The horizontal *Terrain of Joy* belongs in the same group. Robert Rosenblum has astutely characterized it as "an X-rayed De Kooning" where "impulsive, frothing streaks of color that recall brushwork with palpable pigment are paradoxically dematerialized."[36] Louis's dissociation of painterliness from the loaded brush, which he learned from Frankenthaler, is characteristic of all the Veil paintings (both the 1954 and 1958–59 series). In this group of three works within the first series it provides noticeably contradictory clues: the dematerialization of what one expects to be palpable, the blending by absorption into the surface of what looks to be overlaid, and the quieting by that same process of what seems to have been excitedly made. Louis's achieved pictures depend significantly on their provision of conflicting clues especially with regard to the spatial versus the sculptural and the insubstantial versus the physical. In this particular group of Veils, however, the overlaid swathes are inescapably Cubist because they can be read separately as shapes, and inescapably physical because they are self-evidently flung on the canvas, for which reason they seem also somewhat arbitrary or, alternatively, somewhat contrived. They are also composed in such a way as to constitute holistic images suspended just short of the perimeters of the pictures. In this respect, they draw on the work of Pollock.

So does, more obviously, a related work called *Spreading*, whose greater success is attributable to Louis having used areas rather than shapes of color, thereby virtually expelling the Cubist sense of planar overlapping and emphasizing instead the lateral expansion of the painting across the surface. Here, the tonal homogeneity of the allover field particularly recalls Pollock, as does the more intimate relation achieved between the limits of the field and the shape of the support. It is achieved, interestingly, not by Pollock's method of turning the drawing of the field inward as it is about to meet the edges of the picture but by slowing the field to a stop in such a way that its whole drawn shape repeats that of the edges of the picture.

Apart from one other early 1954 painting (a composition of vividly colored horizontal stripes, prophetic of much later Color Field painting, which hardly belongs in the Veil series),[37] the remainder of the 1954 Veils—eleven works—are generally similar in conception and execution. They were made by Louis pouring a sequence of different colored waves or bands of thinned paint down the surface of the canvas to produce a fanlike shape within which the limits of the separate waves are visible, roughly parallel down the center but inclined inward down the sides; and yet they constitute an unbroken, visually continuous surface, whose homogeneity is further enforced, in some cases, by superimposition of the allover wash of darker color that gives the series its name. All but one of what became horizontal pictures were begun with pourings running at right angles to those that eventually dominated. This suggests that Louis's initial intention may have been to produce a Pollock-like interlace of crossing poured "lines," and that he subsequently realized that while his instinct in wanting to overlap the pourings more candidly

Morris Louis. *Untitled A.* 1954. Acrylic resin on canvas, 8′ 10″ × 6′ 1″. Collection Graham Gund, Cambridge, Mass.

opposite above: Franz Kline. *Diagonal.* 1952. Oil on canvas, 43½ × 32½″. Collection Mr. and Mrs. I. David Orr

opposite below: Morris Louis. *Landscape* (*Mid-day*). 1953. Acrylic resin on canvas, 45 × 35″. Collection J. Leon and Pauline Shereshefsky, Chevy Chase, Md.

than in the de Kooning-influenced works was right, his method was not: that all he had to do was overlap the whole set of roughly parallel or splayed pourings, either by setting them down next to each other and then veiling them over, or by overlapping them as he set them down and then veiling them over. Naturally, all of this is supposition. But it is true that the most successful of the 1954 Veil pictures are those that contain both a dominant vertical direction and enough superimposed waves of paint to produce a close-valued field—however they were painted and whatever their final orientation turned out to be.

There is much still to say concerning the technique, facture, drawing, and composition of the 1954 Veils. However, I will postpone this discussion until reaching the point when Louis resumed making Veils in 1958, not only to avoid needless repetition but because I want to imagine what Louis himself saw, in 1958, in his earlier Veil series. Louis himself, in 1954, did not see the possibilities this small group of paintings had opened. He had worked in series since 1951, but it was not until 1958 that he seemed to quite recognize wherein lay the quality and originality of his art. Or, rather, in 1954 he still distrusted even, perhaps especially, his finest achievements, not yet certain they were truly his own. As Greenberg wrote of Matisse, "He had to make sure, before he could move toward independence, that he really felt differently and had different things to say than did those artists whom he admired and by whom he was influenced. He went on doubting himself this way. . . . His hesitations were openly confessed—but they also had a lot to do with the exceptional mastery of his craft that he finally acquired."[38]

WHEN GREENBERG visited Louis in Washington on January 5, 1954, it is unlikely that any of the Veils had yet been started. Certainly, Greenberg was not shown them. He was there to select work for the exhibition *Emerging Talent* at the Samuel M. Kootz Gallery in New York, and chose three paintings by Louis: *Trellis, Silver Discs*, and a lost work, *Foggy Bottom*. Louis, together with Noland, also an exhibitor, brought their paintings to New York on January 7 and spent some of the next day with Greenberg, Frankenthaler, David Smith, and Harry Jackson. The show ran from January 11 to 30, and Louis's paintings were well received. On February 6, Louis and Noland again visited New York, presumably to pick up their paintings, and again saw Greenberg and Frankenthaler.

When exactly in 1954 the first Veil paintings were begun is uncertain. Whether Louis began them before he saw his 1953 paintings in the Kootz Gallery exhibition, whether sight of his paintings there propelled him to new change, and whether the broad range of older and newer Abstract Expressionist art he could have seen in New York galleries in January and February 1954 (including a Kline and a Pollock show) helped him make the move are necessarily matters of speculation. His canvas orders suggest that he made over one hundred paintings a year, which means that the sixteen Veils could have been produced in eight weeks or so. In any event, it seems likely that Louis had already moved on from the Veils to a new run of paintings by June 1 when he wrote to Greenberg about positive accomplishments leading to an end, and certain that he had done so when he wrote again on June 6.

Greenberg had asked Pierre Matisse if he would look at Louis's paintings and consider showing them in his gallery. Louis, therefore, sent to New York a roll of nine paintings, though not without considerable misgivings about which he should include: "It was the usual struggle with my normal doubts re the stuff continually rising & then concluding that they were, after all, ptgs

I'd done & I'd have to let it stand at that this time. I realize I'd gone overboard on the later stuff, none of which you'd seen. By your arrangement with me you'll get to see them & I want that above all. . . .

"There are 9 ptgs in the roll. . . . All are about the same large size but in my mind 2 of them are different than the continuity of simple pattern & slow motion in the majority. These 2 are the rougher ones with lots of black & white areas. Maybe these are lousy enough to interest me now & make me want to explore this further. The others I feel I've done all I feel like doing about that episode. For a moment I looked at 'Trellis' & a couple of others you'd seen before. Just couldn't bring myself to include them & with all the doubts I ever had about anything I've ever chosen alone I submit this group."[39]

The four important points of this statement may be summarized: Louis had doubts about which of his paintings were important and hoped for Greenberg's advice; he realized he had "gone overboard" on the paintings (the Veils) made since Greenberg's last visit; these works were based on "the continuity of simple pattern and slow motion," but that "episode" was now over; the paintings he wanted to develop were some "lousy" works, "rougher ones with lots of black & white areas" that he sent along with the Veils.

When, together with Frankenthaler as well as Pierre Matisse, Greenberg saw the paintings unrolled, he was astonished by the change in Louis's art and found the best of them evidence, for the first time, of Louis as a mature artist. It should be remarked, however, that only two paintings in the group, *Salient* (page 87) and *Atomic Crest* (page 93), were truly first-rate. Louis had sent mostly the less than fully resolved Veils. Even less resolved were the "rougher" paintings, but Louis knew that. Pierre Matisse was not impressed; the paintings were removed to Greenberg's apartment for storage. Louis saw Greenberg in New York later that year (toward the end of December, when he visited the studios of de Kooning and Friedel Dzubas), but Greenberg did not see Louis's paintings again until ten months later, on April 2–3, 1955, when he visited Washington.

What he then saw was disappointing: stained, allover paintings but conventionally Abstract Expressionist. The series of "rougher" works had clearly long been finished, for Greenberg has said that what he saw, "far from being 'rough,' struck me as too bland, in which respect they were quite unlike anything he'd done before & anything he did afterwards (including what he showed at Martha Jackson's in 1957). I remember there being more than thirty of them, & they were all destroyed by the artist."[40] Greenberg urged Louis to visit New York more often, if only to see "what kind of paintings he *did not* want to paint,"[41] reasoning that if Louis saw how similar his paintings were to the many weak Second Generation Abstract Expressionist paintings exhibited in New York, it would force him into change. But not only did Louis have little money to spare to finance such trips, more to the point, he chose not to make them.

Louis's willingness to take advice from Greenberg and one or two other close friends on certain very specific aspects of his art has given rise to the ideas that there were decisions about his art he was willing to leave to others and that his conception of making art allowed for decisions of a collaborative nature. It is true that he was open to, and canvassed, opinions about the cropping and the orientation of some of his Veil and Stripe pictures. It is also true that Greenberg's unenthusiastic response to three groups of paintings was influential in his decision to repudiate them.[42] However, we know that in the vast majority of cases he did not choose to ask for opinions about the cropping and orientation of his Veils and Stripes, not to mention his other

Morris Louis. *Terrain of Joy.* 1954. Acrylic resin on canvas, 6′ 7½″ × 8′ 9⅛″. Collection Graham Gund, Cambridge, Mass.

opposite above: Morris Louis. *Untitled B.* 1954. Acrylic resin on canvas, 8′ 7″ × 7′ 6″. Collection Carter Burden, New York

opposite below: Morris Louis. *Spreading.* 1954. Acrylic resin on canvas, 6′ 7⅛″ × 8′ 1″. Collection Vincent Melzac, Washington, D.C.

paintings, and that he regularly repudiated works he had not shown to anyone that did not satisfy his artistic standards.[43] Louis did solicit Greenberg's advice, and his influence on Louis should not be underestimated; neither should it be misunderstood. After Greenberg's April 1955 visit to Louis's studio, he made only four others in Louis's lifetime, and did not see Louis or his paintings until Louis's November 1957 exhibition at the Martha Jackson Gallery. In any case, Louis's final decisions were his alone; he never delegated the responsibility for these decisions even when he came to the conclusion that the advice he had taken was wrong. This is not to suggest, however, that there would have been anything improper about Louis soliciting or accepting more advice than he did.

Indeed, it is a very reasonable proposition that had Louis been more willing to visit New York in the mid-1950s, and had he remained in closer contact with Greenberg, he might conceivably have saved himself some of the problems that beset his art in this period. However, his unswerving belief in his own powers, even and perhaps especially in moments of difficulty, was inseparable from the intransigent side of his personality. "To be an artist takes not only courage," he once remarked, "but something more—you must be willing to expose yourself to ridicule."[44] Everything had to be worked out in the studio; the only real collaboration possible was with his materials; and it was most important, he told his students, "to risk failure, to produce constantly without concern for what was commonly accepted as ART or as good art."[45] In consequence, he came to dislike looking at other artists' paintings, and after having accepted influence willingly at first seemed later to do so only reluctantly. He assumed that familiarity with earlier art was essential to any ambitious painter's education, yet he also held that "tradition for a painter is an intolerable burden. To hold in one's mind those great works of the past as measures will inevitably cut off the spontaneous flow of creative idea." His first admonition to his students was: "Avoid painting anything that has been done before. Go to museums if you must but destroy any work of your own that is even vaguely reminiscent of the past."

Of what may have been more than three hundred paintings made by Louis between June 1954 and November 1957, only ten are known to have survived and three others are known through photographs; such was the extent of his own revision of his *oeuvre*. Indeed, it is certain that none would now remain had Louis been able to lay his hands on the rest of them, and that he was extremely unhappy about the fact that even so tiny a fraction of these works got into the public domain.[46] The few words I have to say about them should be viewed in this light. These works give us the barest indication of Louis's development—or floundering—in this three-and-a-half-year period; they also give us a very clear indication of the kind of painting, not only his own, he came to abhor.

Louis had abandoned the first Veil series in June of 1954, presumably to make additional "rougher" paintings with areas of black-and-white, then made a series of stained, allover paintings, which Greenberg remembered as being very bland. They were done, Greenberg said, "without the 'veiling' or 'curtaining' [of the Veils] and in more forthright color."[47] Since all these were destroyed, the sole extant 1955 picture must have been made after Greenberg's April 1955 visit. It uses irregular light bars running across loosely poured zones of primary hues. By early 1956 Louis was back doing paintings not too far from the Frankenthaler–Pollock–influenced works of some three years before, only with higher color contrasts and more wet-into-wet pourings. The surfaces of these works comprise allover patterns or more-or-less similarly sized

zones of pooled paint set off by a larger zone or (on one occasion) by the drawn shapes of unpainted areas of canvas. Although highly colored, they read first and foremost through the pattern of tonal contrasts provided by the different hues. Although cropping seems to have been used to fix the dimensions of their surfaces, it has the effect of making them seem cut from larger wholes. The same is true of the few extant 1957 works. By then, however, Louis's use of more saturated hues had led him to superimpose opaque areas on stained ones (as he had done in 1953). He then abandoned the soak-stain technique for a full-blown painterly style of loosely brushed as well as poured areas of opaque paint, with dappled, dripping, and striated patterns of brushstrokes in which the evidence of the artist's hand is manifest.

The impression given above that these pictures were made in a period of self-imposed exile from the New York art scene is essentially true. In addition to his not seeing Greenberg, Louis had personal differences with Noland sometime in 1955, which isolated him from his other principal source of information about New York painting. But his was not a sudden retreat, rather, an unwillingness to develop such introductions and contacts as he had. None of this, however, argues for the usefulness of Louis being classified as a Washington painter. Of course, he lived there, and the distance from New York did have an important effect on his artistic personality and artistic development. Equally, the kind of earlier art he had been exposed to in Washington must have influenced his notions about what constituted an achieved painting. The so-called Washington school of color painters, however, developed on the basis of what Louis, and then Noland, achieved; Louis really had as little contact with other artists in Washington as he did with those in New York. And the art that he did look at was New York art.

Louis must have maintained some contact with what was happening in New York in the mid-1950s, if only through journals and magazines and through occasional visits to the city to buy paint. In any event, the repudiated works of this period that still exist relate quite closely to one of the two mainstreams of contemporaneous New York painting—if only because they share the same sources.

When Louis made his famous visit with Noland to New York in April 1953 and saw Frank-enthaler's *Mountains and Sea*, he could also have seen the controversial exhibition of de Kooning's paintings in which the Women series was unveiled. Accompanied by Thomas B. Hess's article in *Art News* documenting the two-year struggle that led up to *Woman, I*, the exhibition had enormous influence.[48] It legitimized, as it were, representational artists like Nell Blaine, Jane Freilicher, Fairfield Porter, and Elaine de Kooning, drawing them further into the Tenth Street fold; it gave new significance to an artist like Larry Rivers who was beginning to infuse abstractly conceived paintings with realistic details; and it even provoked some painters, among them Grace Hartigan and Jane Wilson, to shift from abstract to representational styles. Hence-forth, not only the extension of de Kooning-influenced gesture painting but its consolidation in figuration became a main-stream preoccupation in mid-1950s New York art.

The important point here is not merely the shift from abstraction to recognizable imagery, although that is worth remembering in the light of Louis's continued commitment to abstract art but, rather, the use of imagery within an obviously painterly context. Frankenthaler's *Mountains and Sea*, for example, contains descriptive imagery of a sort. However, her 1953 exhibition which included it was judged lacking on the basis of interpretations of her style. Her paintings seemed thin, decorative, and "uninvolved." Both she and Louis appear to have been bothered by this

Morris Louis. Untitled. 1956. Acrylic resin on canvas, 7' 10" × 9' 5".
Private collection

opposite above: Morris Louis. Untitled. 1954. Acrylic resin on canvas,
9' 8" × 6' 6¼". The Lannan Foundation

opposite below: Morris Louis. Untitled. 1955. Acrylic resin on canvas,
6' 8" × 52". Collection Dr. Ira Lewis, San Francisco

implication, judging by what happened subsequently. Both moved toward more painterly approaches in 1954 and in so doing tended to a combination of optical field painting and tactile gesture painting, to what was sometimes called Abstract Impressionism. It is to this second mainstream of New York mid-1950s painting that Louis's work between the two Veil series most closely belongs.

A March 1956 *Art News* article by Louis Finkelstein seems to have popularized the term Abstract Impressionism, but it was certainly in use by 1954.[49] It was used with reference to Rothko's work, but mainly for that of younger artists Philip Guston and Resnick, and at times for Frankenthaler, Mitchell, Dzubas, Ray Parker, and some others. Noland, it should be added, has acknowledged that his own paintings of 1956–57 were close to Abstract Impressionism.[50] Insofar as Impressionism itself is concerned, this trend was a response to the contemporaneous enthusiasm for the late works of Claude Monet. The Museum of Modern Art purchased a *Nymphéas* (Water Lilies) mural painting in 1955; Greenberg's essay, "The Later Monet," which began by acknowledging the Monet vogue, appeared in 1956. Finkelstein's article followed closely on the heels of Guston's early 1956 exhibition of his new painting, which did adopt an Impressionist-style brushstroke. It is clear, nonetheless, that Abstract Impressionism more crucially responded to a gradual revision of opinion on Abstract Expressionist field painting. Still, Rothko, and Newman were very little appreciated until 1955 and Greenberg's seminal essay, "'American-Type' Painting,"[51] and not until 1959 was Newman really taken seriously outside a small group of admirers.[52] However, a certain lightening of mood in gesture painting, which prepared for their appreciation, was already being noticed by critics in 1954.

Reviewing the 1954 annual exhibition at the Stable Gallery, Thomas B. Hess noted an "Abstract Expressionist detente" marked by an absence of shock and violence, an increase in figuration, and new "impulses towards elegance."[53] By late 1955, the first two exhibitions (at the Stable Gallery) that attempted to summarize and give shape to the complexities of Second Generation painting (Hess's *U.S. Painting: Some Recent Directions* and Kyle Morris's *Vanguard 1955*) were dominated by a relaxed, lyrical, and often coloristically infused form of gesture painting, with an approximate half-and-half division between abstract painters and those who employed recognizable imagery of some kind. The year 1956 saw the continued dominance of lyrical gesture painting and its codification in the narrower form of Abstract Impressionism. It was with this identity—as a blend of the painterly application of the Abstract Expressionist gesture painters and the color emphasis of the field painters—that Second Generation painting gained broader public acceptance during that year. At the same time, however, it was beginning to be obvious within the art scene itself that gesture painting was in decline. Hess's review of the 1956 Stable Gallery Annual deplored the "air of good taste and conformity" he found there. The next year's Annual would be the last. By then, when the museums were finally ready with their synoptic exhibitions, it was evident that the patterns had changed. In *Young America 1957* at the Whitney Museum of American Art and *Artists of the New York School: Second Generation*, organized by Meyer Schapiro with Leo Steinberg at The Jewish Museum, not only was there a clear plurality of lyrical over expressionist gesture painting but a preponderance of figurative over abstract styles.

This, however, turned out to be virtually the swan song of painterly figuration as such; The Museum of Modern Art's 1959 exhibition *New Images of Man* came too late to check its decline.

In 1957 Rivers and Robert Rauschenberg codified their novel forms of figurative painting, but they eschewed full painterliness for a version of the soak-stain technique, to which Frankenthaler had returned the previous year. There had been, since about 1955, a slowly growing interest in collage and assemblage art (which found its apotheosis with the appearance of Jasper Johns's *Target with Four Faces* on the cover of the January 1958 *Art News*), and also in geometric abstraction (Ad Reinhardt and Ellsworth Kelly both had seminal exhibitions in 1956). But it was mainly lyrical abstraction, coupled with a growing recognition of the importance of Abstract Expressionist field painting, that occupied center stage when, on November 5, 1957, Louis opened his first one-man show in New York at the Martha Jackson Gallery.

This history is worth recounting for several reasons. First, it would seem, even from the few repudiated paintings that remain, that Louis had independently worked through some of the same issues that concerned New York painters, coming close to a form of Abstract Impressionism in 1956–57. This meant that his art was topical enough to gain a New York showing. He had paintings accepted in a group exhibition at the Leo Castelli Gallery in May 1957. Greenberg then mentioned him to Martha Jackson, who in turn mentioned him to the French critic, Michel Tapié de Ceyleran, who visited Washington and encouraged Martha Jackson to give Louis the one-man show, for which he wrote a catalogue introduction.[54] It also meant, however, that Louis was topical enough to realize, from his visits to New York in 1957, that his art was fairly conformist, if not indeed already *retardataire*.

Second, this history tells us that Louis was not alone in losing his way in the mid-1950s. Frankenthaler, albeit to a slightly lesser extent, did the same. And since we know that Frankenthaler helped Louis hang his November 1957 show, it is not unreasonable to suppose that Louis's sight of her new paintings, in which she had returned to the soak-stain technique, had a comparable effect on Louis to that of *Mountains and Sea* four and a half years before.

And third, Louis reestablished contact with New York, and with Greenberg, at the moment by which many of the debates about stylistic priorities within the New York School had subsided—and before, it should be added, new debates about truly radical alternatives to Abstract Expressionism had properly started. I refer here to those concerning Johns and then Frank Stella as well as to those that involved Louis himself. Not only had Greenberg's judgments about what was lasting in Abstract Expressionism been vindicated, but the artistic climate in New York was such as to be equally receptive to what Louis had been doing as to what he was then doing. Greenberg had lent the 1954 Veil painting, *Salient* (page 87), to the one-man exhibition and pointed out to Louis that it was far better than any of his later paintings. Subsequently, Louis destroyed every painting he had access to that he had made since the 1954 Veils.

A fourth, and final, reason for the preceding sketch of New York painting in the mid-1950s is that it helps to position Louis historically at that moment late in 1957 or early in 1958 when he returned to making Veils and thus finally found himself as a painter.

IT IS OFTEN REMARKED that Louis constitutes a bridge between Abstract Expressionism and the Color Field painting of the 1960s.[55] However, the situation is by no means as simple as this. The late date at which he consolidated his art—a full decade after Pollock—argues for the now less accepted viewpoint that he does, after all, belong with the Color Field painters, that he was, in fact, a frustrated Abstract Expressionist who, early on, had an inkling of an alternative

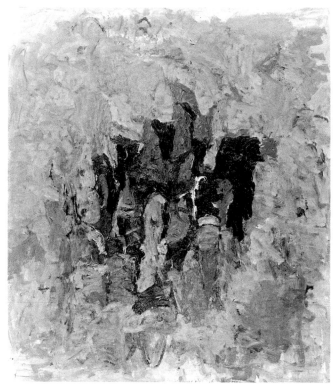

Philip Guston. *The Clock*. 1956–57. Oil on canvas, 6′ 4″ × 64⅛″. The Museum of Modern Art, New York. Gift of Mrs. Bliss Parkinson

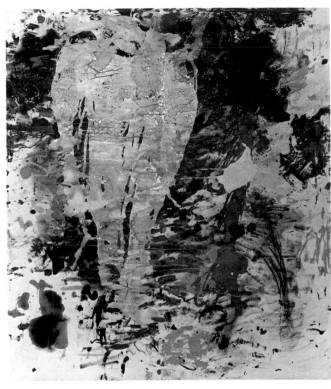

Morris Louis. *No. "1."* 1957. Acrylic resin on canvas, 7′ 9½″ × 6′ 8½″. Albright-Knox Art Gallery, Buffalo, New York. The Martha Jackson Collection, 1974

stylistic direction, lost his way, and then found himself in the late 1950s better prepared to launch the new direction of which he was the pioneer. And yet, that will not do either. Many of Louis's instincts were those of an Abstract Expressionist, despite all his reservations about Abstract Expressionism, and remained so, despite the later stylistic changes in his art. But he does not fit comfortably with the Second Generation artists. While his repudiated paintings are quintessential Second Generation paintings, they do not fit comfortably within his *oeuvre* (as Louis realized in repudiating them) as, say, Frankenthaler's nonstained paintings of the mid-1950s fit in hers. (If anyone was a bridge between Abstract Expressionism and Color Field painting it was Frankenthaler.) Louis's mid-1950s paintings were, rather, a lapse or a regression from which renewal finally came; and when it came it was more a renewal of Abstract Expressionism—of First Generation Abstract Expressionism—than a repudiation of it.

I do not want to exaggerate Louis's conservatism. Yet, it is worth noting that the nearest parallel that exists for Louis's particular relationship to subsequent art is Newman, another Abstract Expressionist who made an extraordinary inductive leap to maturity, then went underground, as it were, to reemerge as a seminal figure when the 1950s were coming to a close. That parallel, however, is not all that near, for Newman presents himself as someone more quickly convinced about what constituted *his* truth than Louis was. Louis's predicament is far more reminiscent of an early modernist like Matisse, another almost unwilling innovator until he got into his stride, and one who sought through innovation more to preserve than to oppose the traditions of the past. But, as I say, I do not want to exaggerate Louis's conservatism. Not only did he remake Abstract Expressionism in a way that had never previously existed, he remade abstract painting as he did so. He was simply the first artist to accept all of the implications of a purely abstract art, recognizing as nobody had quite done before that it was possible to make a superlative abstract art without an illustrated subject, without an *a priori* ideology, without evidence of the artist's personal touch, without the preconception even of a single style— working from the very medium of painting itself.

This is not to say that subject matter, ideology, personality, and stylistic unity are absent from Louis's art. Regardless of the fact that he would not talk about the content of his paintings, the evidence that they themselves provide shows him to be as obsessively striving for a state of illumination unattached to material things as any earlier Abstract Expressionist. Only he sought to do so with ever more reductive means, not out of any program in this regard but because the logic of his art, which is also to say, his inspiration, seemed to compel it. The risk he ran in terms of public acceptance was that the impressive loveliness of his art would not be recognized as a metaphor of spiritual meaning in the same way that the more severe forms of Abstract Expressionism were so recognized. This seems to have bothered him at first, and helps to account for important differences between the first and second series of Veils, as we shall see later. But once he got into his stride, it became a matter of indifference to him how his art was received. One of the main subjects of what follows is that his art comprises not so much a temptation of the senses as a deliverance *through* the senses, which is to say no more and no less than that is the condition toward which the best of modern painting has aspired.

2

Technical innovation and modern art; Impressionism,
Cubism, and Pollock's allover style; indebtedness
to Pollock and Frankenthaler; painting medium;
orientation of 1954 Veils; working methods

"TRADITION . . . cannot be inherited," says a renowned modern essay on this subject, "and if you want it you must obtain it by great labor."[1] Mid-way through this century, that "great labor," insofar as painting was concerned, came to involve reimagining what constitutes the art of painting—not simply producing new paintings, but new paintings whose very method of creation reformulated what the very act of making a painting comprised.

To an important extent, this has always been the case with truly original paintings, especially modern ones. The expression of new visions has often necessitated technical innovation, older methods seeming incapable of authentically carrying them. Equally, technical innovation itself has been a means of generating new visions, especially in modern painting. Whether the invention of Cubist collage and Surrealist automatic drawing, to mention the two most important technical innovations of twentieth-century art, were the cause or the result of distinctively new views of reality is incapable of demonstration. But it is indisputable that the realities they convey are inseparable from the technical innovations which manifest them.

Technical innovation itself can bring with it an extraordinary sense of liberation. Collage, in its very structure as well as in its materials, implied a distinctively modern break with the narrative continuity of the past; and automatism an equally, albeit differently, modern break with the past (including, in fact, the Cubist past), a release from its rational, public concerns into the freedom of the inner mind. For American artists at mid-century, technical innovation carried a comparable meaning. As Andrew Forge has written of Pollock, "Technical freedom was a powerful symbol for other freedoms—freedoms from the dominion of European taste, from the pressures of European art history; and, by extension, from history itself."[2] Louis, we know, spoke to his students in comparable terms. And yet, not only freedom from the past is involved here (if only because such a thing is never truly possible). More important is what David Smith once called the artist's "visionary reconstruction" of the past, through which tradition is simultaneously broken and repaired.[3] This is to argue, in effect, that the truly original artist, far from breaking with the past, breaks with present interpretations of the past, goes back into the past not to revive it but to renew it, making fresh discovery in the renewal of familiar values. Technical innovation itself, if it is to have more than novelty value, which is to say no value, necessarily renews something traditional to the art in which it takes place that can no longer be convincingly expressed by traditional techniques. Obviously, technical innovation is antitraditional in that it brings into question what had hitherto been taken for granted as necessary for securing the established limits of a particular art, if not always the limits themselves. But even here, tradition is defied only to be reinvigorated.

I begin in this way for two reasons. First, I will necessarily be discussing Louis's technical innovations and I want to make clear that neither his technical innovations nor the novel appearance of his art which resulted from these innovations is intrinsically important to the value or the individuality of his art. In saying this, I follow T. S. Eliot's classic argument (from which I quoted at the opening of this chapter) on the indispensability of the historical sense, namely that whereas we may be tempted to think of an artist's individual achievement as distinct from or contrasted with the achievement present in his sources, if we approach his work "without his prejudice we shall often find that not only the best, but the most individual parts of his work may be those in which the dead poets, his ancestors, assert their immortality most vigorously."[4] This is to say that we should not be looking for merely residual originality in an

artist's work. We quite rightly do value an artist's difference from his predecessors as evidence of his authenticity as an artist because it tells us that he is speaking frankly and directly, and not in impersonation of the past. At the same time, what we finally value has less to do with new styles or techniques and more to do with those primal conventions or possibilities of an art that cannot (like styles or techniques) be either invented or inherited; rather, the point of that "great labor" of stylistic or technical innovation of which Eliot spoke is to renew those primal conventions and keep them alive.

The second reason for beginning this way is that while the new renews the old, it necessarily alters the existing order of the old as it does so. Eliot's brilliant insight leads to the conclusion that when we address truly original art we are obliged, in effect, to rewrite history to some extent in order to accommodate it. In doing so, it is possible to give the impression that the new, yet-to-be-created work forms the hidden agenda in what precedes it. That, however, is not an entirely wrong impression, for the form of the new work is, in fact, immanent in that of its predecessors. More problematical, however, is that such a history might resemble either a thin red line that, shunning contact with anything that might deflect its progress, leads only and inexorably to this particular new work, or a thick, dense wedge that compresses all of value in the past into this particular new work. (And, of course, subsequent new work affects our understanding of the particular new work we are addressing, and its history.)[5] But even here, we know that there have been moments in the history of art when the future of one of its mediums did indeed seem to depend upon the possibilities compressed into the work of one artist. Just as Cézanne's work had such a pivotal role for the future of French painting at the beginning of this century, so Pollock's did for American painting at mid-century. The historical background to Louis's achievement, which follows, is principally addressed to an understanding of what Louis meant when he said that Frankenthaler "was a bridge between Pollock and what was possible."

THE PRIMAL CONVENTION of painting is that it is an art of surface. It became an art of flat surfaces, but flatness, as such, is a liability of painting as well as its natural attribute. To emphasize flatness is to emphasize both the tangibility of a painting as an object and the single property it shares with no other art. Flatness, however, can isolate the parts of a painting, leaving them separately stranded across the plane surface. It, therefore, can threaten the integrity and coherence of the separate pictorial world, creating the risk that a painting may seem no more than a special kind of object in a world of objects. Illusionism of some kind has been, since the Renaissance at least, the means of achieving pictorial coherence and thereby of enforcing the apartness of the pictorial world, and of separating painting as such from the purely decorative surface arts. Equally, however, if the form of the illusionism itself tended to imply that painting's pictorial world was no more than a mirror of the external world, various "internal safeguards against illusion"[6] were there to draw attention to the fact that the painting was, after all, a fabricated entity. Among those "safeguards" there were, for instance, unnatural color or proportions or details, quotations from earlier paintings, and composition or drawing or facture that neutralized the illusionism and emphasized instead the flat tangibility of the painted surface. The painter, in fact, has always sought to provide sets of contradictory clues that simultaneously achieve illusionism and suspend it.

Often, the very means by which the illusionism is achieved contains within it the pos-

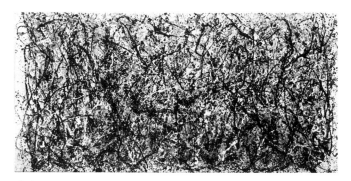

Jackson Pollock. *One (Number 31, 1950)*. 1950. Oil and enamel paint on canvas, 8′ 10″ × 17′ 5⅝″. The Museum of Modern Art, New York. Sidney and Harriet Janis Collection Fund (by exchange)

Morris Louis. *Russet*. 1958. Acrylic resin on canvas, 7' 8¾" × 14' 5½". The Museum of Modern Art, New York. Given anonymously

sibilities of its suspension. This was the case with fifteenth-century linear perspective. It was also the case with the most realist of illusionistic art, the art of the Impressionists. In the classic Impressionist paintings of the 1870s, the illusion of realist, open-air space is provided by a thickly painted modular pattern of brushstrokes whose facture and modularity are independent of what they describe. Here, the contradictory clues carried in the very method of paint application tend to separate surface and illusion, or the physical body of the painting from the illusion it contains. In Monet's later paintings, this aspect is exaggerated by his use of closeup, more-or-less evenly accented fragments of nature, seen at an oblique angle whose difference from the frontality of the surface of the painting itself pries art and illusion apart, as it were, to create works that are simultaneously flat, material things and incorporeal illusions.

"The revelation he received became an Impressionist revelation," was how Greenberg described the impact on Louis of the work of Pollock and Frankenthaler. It was also, Greenberg said, a "revulsion against Cubism." In effect, Frankenthaler showed Louis a way back to Impressionism through Pollock, a way that required him to discard those Cubist aspects of Pollock's style that coexisted with the Impressionist ones. Alternatively, whereas Pollock's interpretation of Cubism had returned him to Impressionism, Louis's interpretation of Pollock, made possible by Frankenthaler's interpretation, returned him to Impressionism more completely. Either way, the "bridge between Pollock and what was possible" provided by Frankenthaler led to the past as well as to the future.

Impressionism is the seminal modern art of surface; its facture and modularity, which, in turn, mean its avoidance of large shapes and strong tonal contrasts, emphasize the presence of the surface as a continuous, spread-out sheet or skin to a greater extent, even, than had Edouard Manet's 1860s style which preceded it. This being so, color as a natural property of surface becomes more perspicuous. Not only is color freed from sculptural modeling, it is also freed to a large extent from being read as part of a structure of tonal contrasts; but not entirely, because in such a white-infused, close-valued style, shifts of color tend also to read as shifts of tone, and because any degree of spontaneity in color handling tends to reassert tonal contrasts by disrupting the modularity of the surface and thereby the often precarious relationship between the surface and the illusion. In fact, tonal contrasts are as natural and normative to Western painting as is surface flatness; all the elements of painting's language, unless checked, tend to suggest volume.[7] For all pre-modern colorists, certainly, mastery of dispersing tonal contrasts was inseparable from mastery of color. And to the extent that the Impressionists reduced the range of tonal contrasts in their paintings, the risk they ran was of visual monotony. As long as the illusions they provided referred to the natural world, the absence of depicted volumes in their pictures was more than compensated by their opening onto that world remade as a locus of visual pleasure. Color released from the confines of drawn shapes to spread openly into aerated fields could provide a new version of nature as liberated from man's works. But when the illusion became more generalized, descriptive more of dusky atmosphere than of clean open air, the sacrifice seemed, to subsequent artists, too great; for what seemed to have been lost was the traditional stability and gravity of painting. This has been the hazard of all later motif-free abstraction based on the Impressionist model, Louis's included. The development of Louis's Veils shows him to have been deeply concerned by it.

Louis's early education as an artist certainly brought him into contact with Impressionist

paintings. His residence in Washington since 1947 also meant that he had access to those at The Phillips Collection and the National Gallery of Art. But there is nothing Impressionist about any of his own early work. Even when he came close to Pollock's style in his Charred Journal paintings of 1951, it was to ignore the Impressionist aspects of Pollock and exaggerate the Cubist aspects. That is to say, the interpretation of Pollock's allover style offered in the Charred Journal paintings is of Pollock as a painter of tonal contrasts.

This interpretation is by no means unwarranted, for Pollock's classic allover style of 1947–50 is based on Cubist models. When the Cubists returned sculptural illusion to painting to recover the traditional stability they believed the Impressionists had lost, they so emphasized the methods of their illusionism, so exaggerated the contrasts of light and dark in their mono-chrome paintings that these rose to the surface as fractured patterns in a shallow frontal space rather than as whole volumes within a deeply hollowed space—to such an extent, in fact, as even to suggest a two-part reading of open, linear drawing giving the identity of the motif set against a painterly, illusionistically modeled ground. By 1910, representation as a function of line, and illusion as a function of modeling, were separated from each other, then were reassembled to produce an image that contained them both. This two-part Analytical Cubist structure of line drawing and generalized shading—in particular, its polarization by such later artists as Klee and Miró so as to make line and surface plastically independent—formed the basis of Louis's interpretation of Pollock in 1951.

In fact, line in Pollock's allover pictures is not separable from surface in the way it is in Klee and Miró, nor does it read as something tangible. Pollock's classic style did, in a sense, pick up from where Picasso and Georges Braque had left Analytical Cubism,[8] but only after Pollock had worked through a version of the Synthetic Cubist style, and escaped it with the help of Surrealist automatism. One of the reasons Pollock's classic allover style seems so utterly pivotal to its time is that it is a great mid-century synthesis of currents deriving from collage, through Synthetic Cubism, and from Surrealist automatism, itself a descendent of the organic, metaphorical drawing of Wassily Kandinsky, Jean Arp, and earlier Symbolist art. While other artists, notably Klee and Miró, had overlaid surfaces of a tangibility and flatness derived from collage via Synthetic Cubism with freely generated, organic drawing, no previous artist had so bonded these forms and currents as did Pollock. In doing so, he also combined the assertively constructional idea of picture-making that collage had bequeathed to Synthetic Cubism with the autographic, symbol-making emphasis of automatic drawing, thus producing an art that was both fabricated and "materialistic," and removed from reference to the material world.

While making a series of pictures in the early to mid-1940s based on schematically flat totemic images, Pollock gradually began to eliminate the opaque, ultimately Synthetic Cubist planes that constituted the images, and from their broken outlines, as well as from the hiero-glyphic symbols which originally overlaid the planes, he developed an allover painterly style that was ultimately Cubist, but more palpable and more broadly drawn, hence tending to produce works larger than Synthetic Cubist pictures could be without seeming thin and hollow. Despite the power and urgency of these pre-drip pictures, they nevertheless achieved these qualities at the expense of a certain feeling of claustrophobia. This is largely attributable to the fact that so many marks had to be built up on the surface to achieve the desired balance of lights and darks, and the extent of each mark was limited to the amount of paint that could be loaded onto the

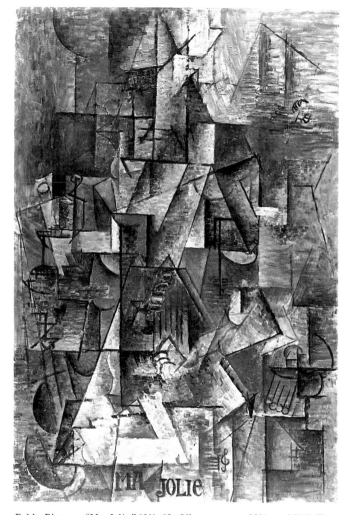

Pablo Picasso. *"Ma Jolie."* 1911–12. Oil on canvas, 39⅜ × 25¾". The Museum of Modern Art, New York. Acquired through the Lillie P. Bliss Bequest

Joan Miró. *The Beautiful Bird Revealing the Unknown to a Pair of Lovers*. 1941. Gouache and oil wash on paper, 18 × 15″. The Museum of Modern Art, New York. Acquired through the Lillie P. Bliss Bequest

brush. The drip technique itself, achieved after experimentation with squeezing paint directly from the tube, miraculously opened Pollock's pictures, affording a comparable density to that in earlier work but without packing or crowding the surface, and a comparable palpability without closing or sealing it off.

Four principal aspects of Pollock's allover style of 1947–50 were of crucial significance for Louis, once he recognized them. First, Pollock's shift from totemic image-making to his unique version of Surrealist automatism did not bring with it any change in his basic understanding of drawing—both approaches are symbolic and metaphorical, not descriptive or perceptual—but it produced a crucial change in the character of his drawing. While the symbolic drawing of the pre-drip pictures was "freed from delineating a thing, and functions as a thing in itself,"[9] its own thingness nevertheless alludes to that of physical bodies. In the allover drip pictures, by contrast, drawing is effectively purged of its denotive function and figurative character. Line neither defines images nor can it be perceived as the boundary, contour, or edge of anything—not even as a thing in itself. Because of its flow and interlacing, it can only rarely be read as figure against ground. In these respects, it is unlike any earlier form of drawing.[10] Indeed, its very linear character is challenged in the completed work, which constitutes an allover, unbroken molecular continuum as luminous and disembodied as the drawing itself is dense and tactile. Image, in effect, has been softened into illusion, and drawing names not things but space.

Second, in Pollock's pre-drip pictures, as in Analytical Cubist pictures, line and modeling were relatively independent. That is to say, the two basic functions of drawing, image-making and the creation of sculptural illusion, which had been joined in pre-modern, traditional drawing, remained separated and counterposed. While the drip pictures do negate traditional drawing, they also, however, recombine the two traditional functions of drawing to the extent that line itself is the agent of illusionism—but a kind of illusionism from which the sculptural is expelled. Pollock's means—black, colored, and aluminum "lines" of paint—are, in effect, the abstracted and isolated components of traditional modeling—shadow, color, and highlights—which he recombined in such a nonhierarchical way as to dissipate the sculptural from illusionism, atomizing lights and darks and bunching together the value contrasts that remain to the lighter side of the tonal scale. This is aided by his reversal of traditional hierarchies of texture and tonality: broad marks form the background and are seen through microscopic details, while recessive spatial color is superimposed on solid frontal color. Thus, the traditional components of background and foreground are reversed.[11] The Cubists' separation of image and illusion brought with it a sense of competition between reality and its representation. The disengaged images upon the surface make conflicting claims upon our attention as signs for objects in the world and as autonomous painterly units. In Pollock's pre-drip pictures, as in other Cubist-derived art, there remains a comparable sense of painting's own alienation from the very reality it seeks to express. While the drip pictures are, indisputably, extremely radical works, they nevertheless afford a feeling of traditional harmony regained, an almost remedial feeling. Technically, it is Pollock's use of conflicting pictorial clues to defeat the Cubist separation of image and illusion that accounts for the sense of liberation from conflict that characterizes his finest work.

Third, Pollock's liberation from Cubism returned him to Impressionism: the regained harmony of his work is, to an important extent, an Impressionist harmony. The allover pictures are not compositional, and eschew specific shapes for a continuum of painterliness achieved by a

modular method of paint application that develops across the surface, its close-valued color informed by a "slow" inner light. At the same time, however, the relationship of illusionism to the allover painterly surface in Pollock's work is very different from Impressionism. For a start, the allover surface "image" is difficult to locate spatially. If anything, it seems to hang just in front of the resistant plane of the canvas (as befitting its Cubist origins), causing that plane to seem to dissolve into transparency. But the drawn skeins do have substance, they are palpable, so that the planarity of the surface is restored in paint. That is to say, as in Impressionism, the material continuity and alloverness of the surface is established as paint. However, as in Analytical Cubism, the surface comprises an openly composed painted image held in tension against the literal body of the picture, its actual flatness and its geometrical shape. It really does seem as if Pollock began with the resistant flat surface of Synthetic Cubism, then went back to the collage idea of multiple layering and physical construction, but did so using a version of open Analytical Cubist drawing derived from the more relaxed and spontaneously applied draftsmanship of the abstract Surrealists, thereby reaching a kind of illusionism and surface treatment reminiscent of Impressionism but without being completely Impressionist. The very synoptic nature of Pollock's style made it a rich source of future possibilities. However, the exactness and individuality of the synopsis made access to it very difficult.

Fourth, and finally, Pollock's very method of creating these pictures, through "collaboration" with his materials, in particular through poured skeins of paint, allowed him to make larger, and hence seemingly less tangible and enclosed pictures than hitherto. It also allowed pictures with a new emotional vividness, not expressionistic but concentrated, not merely free but frank and candid, as if emotion has been conveyed with the least possible interference of the medium, which is also to say, as if the emotion were generated in the medium itself.

All these things were crucial to Louis. But it was not until Pollock's style changed, and Frankenthaler further developed and altered it, that Louis gained access to any of them.

Frankenthaler's *Mountains and Sea*, which so impressed Louis and Noland, drew part of its inspiration from Pollock's 1951–52 pictures done in thinned black enamel on raw canvas. In these, he repudiated the "nonfigurative" drawing of the allover pictures, as well as their uniformity of articulation (and with it, of illusionistic space), to make what are indisputably images set against grounds. However, since the linear drawing that composes the images is stained into the canvas surface, the lack of textural change between image and ground retains a sense of alloverness. But now, alloverness is given in the visibly continuous materiality of the canvas surface, rather than, as previously, in that of the paint applied to the surface. This is why the paint as such is able to depart from alloverness to create more varied and specific configurations without compromising the evenness of pictorial intensity across the surface which Pollock had previously achieved. What is more, staining gave alloverness and flatness in one act. Staining itself asserted the flatness of painting, and therefore its nonillusionary, tangible character. This meant that illusionism could be given greater sway; and Pollock's drawing, both in its image-character and, particularly, in its exaggerated tonal contrasts, became less local to the surface than before. In some of the more spare pictures where the thinned-down enamel spreads from lines into areas, the limits of these areas refuse to be read as boundaries, seeming rather to have been generated from inside; as a result, they refuse to be read as drawn, and the pictures that contain them seem as devoid of tactility as the allover drip pictures, while possessing an

Jackson Pollock. *Number 3, 1951* (*Image of Man*). 1951. Enamel on canvas, 56 × 24″. Collection Peggy and Richard Danziger

extraordinary openness of surface—not painted surface but the literal surface of painting itself.

The importance to Louis of *Mountains and Sea* lay in the access it gave him to Pollock as well as in its own unique combination of color, facture, and drawing or design. Frankenthaler had seized on the fact that once areas, not lines, were created by staining, color could be given new prominence in a Pollock-derived style, indeed, that color itself rather than tonality (variations of hue rather than of light and dark) could become the organizing structural component of picture-making in a new way. By diluting the paint more than Pollock had, Frankenthaler was able to soak thin washes of color into the surface, thus literally identifying figure and ground and, thereby, allowing color to spread uninterruptedly across the surface as pure hue (even when shaded), unimpeded by the tactile associations that figure-ground divisions normally create. Given the thinness of the paint, the whiteness of the surface breathes through the color, bringing depth to its flatness. It also functions as color itself, and gives to the colors soaked into it something of its own disembodied form, creating an open surface, like that of the 1951–52 Pollocks, but coloristically leveled down in an Impressionist, close-valued, and seemingly allover space, like that of the 1947–50 Pollocks. And since the color in *Mountains and Sea* forms images as it floods the surface, that painting also combines the figurative quality of the 1951–52 Pollocks with the spread out tonal homogeneity of the 1947–50 Pollocks. Unlike anything in Pollock, however, and equally influential for Louis, is the way that the color in *Mountains and Sea* seems to expand visually and open out across the surface; it seems slower and more sensual than Pollock's energetically drawn skeins, though equally immediate as physically manipulated paint.

"The question we always discussed," remembers Noland of his talks with Louis, "was what to make art about. We didn't want anything symbolic like say, Gottlieb, or geometric in the old sense of Albers. The Abstract Expressionists painted the appearance or symbol of action, the depiction of gesture. We wanted the appearance to be the result of the process of making it—not necessarily to look like a gesture, but to be the result of real handling."[12] In this respect too, Frankenthaler "was a bridge between Pollock and what was possible."

AS NOTED in the preceding chapter, the earliest of Louis's 1954 Veils may well have been those where he used the stain technique to produce Kline-like and then de Kooning-like broad planes: works which (to use Noland's terminology) give "the appearance or symbol of action, the depiction of gesture." The de Kooning-like *Terrain of Joy*, in particular, gives the appearance of having been made from swathes of intense color flung down onto the canvas in overlapping patterns, the form of the swathes reflecting the movement of the artist's arm and hand, and the overlapping of the swathes reflecting the sequential, temporal method of the painting's creation.

Veils of this kind clearly reflect Louis's knowledge of the layering technique of Pollock's allover pictures as well as of Frankenthaler's soak-stain method. However, because Louis seized upon the possibilities of heightened color he found in Frankenthaler, he was forced to compose in terms of the tonal contrasts that the use of areas of high-intensity color inevitably provides. As a result, the layering approach did not achieve the optical intermingling of parts it did in Pollock but remained, rather, a form of Cubist layering. Furthermore, it defeated the possibility of the canvas being read as a coordinating element in the way it did in Frankenthaler's work, where the colors are placed side by side and where, therefore, each separate color we see is identified with the canvas, which runs through them, as it were. In Louis's, by contrast, the canvas still reads if

not quite as a traditional ground then as something transparent; the imagery is simply less local to it than in Frankenthaler's work.

Louis's creation of the fully realized 1954 Veils involved two related insights into the work of Pollock and Frankenthaler. First, he recognized that the coherence of both *Mountains and Sea* and Pollock's allover pictures depended upon the fact that although they were composed of distinct colors the effect was not what might be called Fauve color (or the juxtaposition of intense hues). Pollock's work, as we have seen, appears to be monochromatic, informed by a disembodied interior light. *Mountains and Sea* is a rather pale picture, of delicate, washed-out colors kept close in value to the color of the canvas, and also luminous in effect. The second recognition concerned the side-by-side arrangement of Frankenthaler's color, and also the awareness that Pollock's superimposed webs of paint were layered extremely frankly—repetitively, in fact. Close-valued color and side-by-side or repetitive methods of paint application both have a common modern source in Impressionism. And this is part of what Greenberg meant when he said that the revelation Louis received from Pollock and Frankenthaler became an Impressionist revelation.

Louis was able to combine Pollock's layering and Frankenthaler's side-by-side color juxtapositions by pouring waves of thinned-down, transparent paint of different hues down the surface of the canvas "so as to mute their separate intensities into so many neutral and ambiguous shades of a single low-keyed color"[13]—in effect, by working, like Pollock, from repetitively superimposed colors, but, like Frankenthaler, with areas not lines of color laid down side-by-side, overlapped, and then veiled over. The result is pictures wherein automatically generated drawing creates a holistic image, as in Pollock, but with a heightened, richly nuanced color made possible by virtue of Frankenthaler's example. Different, however, from either Pollock or Frankenthaler, is Louis's conception of painting as the creation of flooded homogeneous fields of color, identified with the surface and developed across the surface without any underpinning in the form of a tonal armature. The openness of his work is not the ultimately Cubist openness of Pollock or Frankenthaler, where imaginary space is articulated, reticulated even, by a pattern of lights and darks; rather, it is the spreading, surface openness of an ultimately Impressionist conception of painting as an unconstricted, aerated, colored field.

"The crucial revelation he got from Pollock and Frankenthaler," Greenberg said, "had to do with facture as much as anything else." He continued: "The more closely color could be identified with its ground, the freer would it be from the interference of tactile associations; the way to achieve this closer identification was by adapting watercolor technique to oil and using thin paint on an absorbent surface. Louis . . . [leaves] the pigment almost everywhere thin enough, no matter how many different veils of it are superimposed, for the eye to sense the threadedness and wovenness of the fabric underneath. But 'underneath' is the wrong word. The fabric, being soaked in paint rather than merely covered by it, becomes paint in itself, color in itself, like dyed cloth: the threadedness and wovenness are in the color. Louis usually contrives to leave certain areas of the canvas bare. . . . It is a gray-white or white-gray bareness that functions as a color in its own right and on a parity with other colors; by this parity the other colors are leveled down as it were, to become identified with the raw cotton surface as much as the bareness is. The effect conveys a sense not only of color as somehow disembodied, and therefore more purely optical, but also of color as a thing that opens and expands the picture plane."[14]

Georgia O'Keeffe. *Evening Star, III.* 1917. Watercolor on paper, 9 × 11⅞". The Museum of Modern Art, New York. Mr. and Mrs. Donald B. Straus Fund

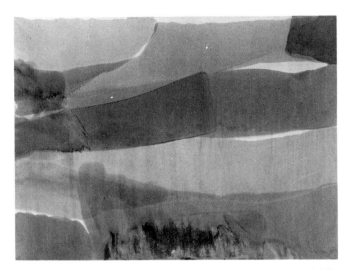

Morris Louis. Untitled. 1954. Acrylic resin on canvas, 6′ ½″ × 8′ ½″.
The Lannan Foundation

There are plenty of modern precedents for the adaptation of a watercolor technique to oil painting, and it is not necessary to go into them all here. Cézanne, obviously, is the most important pioneer in this regard, and it is relevant to know that Louis was interested in Cézanne's watercolors, whose influence on the 1953 painting *Trellis* is apparent. He was even more interested in Matisse, who also consistently used thin paint in order to exclude anything that might detract from the sheer visibility of color. And it is tempting to see Louis as part of the distinctly American watercolor tradition that includes artists like Georgia O'Keeffe and John Marin, whose work he could have seen at The Phillips Collection, as well as in relation to Klee, whose work certainly affected Noland's when Louis and Noland first met. It is also worth mentioning at this point that Louis's technique bears comparison with a form of painting conceptually opposite to the intimacy of watercolor, namely fresco painting. The physical bonding of color to a white surface through tinting has long been a method of accentuating its purity, and also of achieving the difficult coherence of a large-size, muralist art—as earlier modernists interested in such an art (or in an art that approximated its effects), among them Monet and Matisse, had already realized. The soak-stain technique that Louis adapted from Frankenthaler combines these opposite traditions: the first, intimate, tending naturally to lyricism, highly dependent on the artist's individual touch, and having the candor and immediacy of a sketch; the second, public, tending to the epic and the monumental, involving suppression of the artist's touch, and having the distanced aloofness of architectural decoration. One way of distinguishing Louis's 1954 Veils and those he began in 1958 is to say that he shifted from the first toward the second of these traditions.

Louis referred to the 1954 Veils as manifesting "the continuity of simple pattern and slow motion." This might be paraphrased in the following way: The components of the simple pattern, namely the individual, repeated "reeds" of the fan-shaped image, are usually clearly expressed, but as the eye reads across them, the continuity of unbroken color both affirms the wholeness of the pattern and causes it to seem to expand in slow motion, like the opening of a fan. The continuity of the surface is achieved by the pouring of color into color, by the dark veiling on top of the purer hues, and by the stain technique itself, which dematerializes mass and drawing because it allows the surface to release light. The disembodiment, bareness, and openness which Greenberg described as characteristic of Louis's use of the stain technique also contribute to the sense his pictures provide of being freed from material substance. Their linear quality is subsumed as it is in Pollock's paintings, but here in a poetic *sfumato* effect,[15] even more abstracted and generalized than Pollock's atomized space because the surface itself is identical with the space evoked by color; and it is color itself more than paint that seems transient, fluid, and—organically—to breathe and expand.

Noland, we remember, said that he and Louis "wanted the appearance to be the result of the process of making it—not necessarily to look like a gesture, but to be the result of real handling." The appearance of Louis's Veils suggests that by this Noland meant that their pictures should not be merely a record, or depiction, of how they are made. It is not just a matter of having the appearance of the paint recall the actual process of painting but, rather, that the appearance of the picture should reflect the *modalities* of the painting process, its forces and movements, flow and direction, growth and becoming.

These modalities might be said to form the subject of all Louis's Veils just as the symbolic

release from the bounded and the substantial into an illuminated state of the immaterial might be said to form their content. This is an unsatisfactory way of putting it, implying as it does that these aspects are separable, and that the subject of Louis's painting is circumscribed by his pure involvement with painting while the (undemonstrable) content exists more in the realm of idea. While it is true that, in one sense, the subject of such painting is painting, it is not, as Jack Flam has pointed out, "in the usual sense of 'art for art's sake' with which this phenomenon is sometimes confused, but in the sense that the subject matter of such paintings has to do with process or becoming, and since the act of painting is painting itself's most typical or inherent process, the process of painting becomes the most integral and natural metaphor that painting itself can use."[16] Additionally, the modalities of painting that Louis uncovered and explored in his pictures necessarily evoke our experience of the world outside painting. Louis's Veils do not, of course, reproduce our view of nature, but they confirm it. They do not enter the world of physical things, but they do remind us what the experience of that world is like—at least, how we remember that experience, abstracted from the physical things of the world that engender it. This takes us from the "subject" to the "content" of Louis's pictures, for the layers that each occupies are as fused and continuous as those in the pictures themselves.

Louis's medium, it should be noted at this point, was an oil-miscible acrylic resin paint called Magna, which contains pigment, an acrylic resin vehicle, and small amounts of bodying and stabilizing agents to keep the pigment and resin bonded. It can be thinned with turpentine or with additional doses of resin. The turpentine method tends to create a matte surface and, if excessively used, to cause separation of the pigment in the form of surface granules; the use of resin creates a more glossy surface. Louis used this paint in tube form prior to 1960, when its manufacturer, Leonard Bocour, changed the formula, adding beeswax to give it more body. Louis and Noland (who also painted with Magna) found this new paint difficult to use, so in April 1960 they had Bocour make a specially constituted form of Magna in gallon cans. This contained pigment plus a half-and-half mixture of resin and turpentine, of a consistency similar to maple syrup. When making the Veils and other paintings before April 1960, Louis had established the consistency of the paint himself, just as he had established the degree of absorbency he desired for the canvas surface; in the former case he controlled the amount and proportion of turpentine and resin thinner, in the latter the amount of sizing. (All of the 1954 Veils and only some of the 1958–59 Veils are on sized canvas. After 1959 he abandoned sizing entirely in order to allow the color to penetrate the surface more thoroughly.)

I draw attention to the technical properties of the paint to aid in understanding the appearance of the Veils, including the detailing they contain. Louis avoided small-scale drawn incident, especially the drips, splatters, and other signs of "accident" that characterize many Abstract Expressionist paintings. Generally, he seemed interested in effecting a sense of paint not having been drawn or acted on in any way.[17] Nevertheless, the surfaces of the 1954 Veils reveal an extraordinarily rich form of detailing which is not accidental in any other sense than that Louis could not predict it. But he could, and did, direct it, and he used this detailing to create a particularly intimate relationship between the closeup surfaces of these Veils and their distanced wholeness as images, and as pictures.

I refer here first of all to the sense of detail produced by the drawing of the swathes of poured paint. I noted above that their linearity is both manifested and subsumed in the

wholeness of the surface. This should now be rephrased to read: the manifest linearity of most of the 1954 Veils affirms the wholeness of their surfaces. The fanlike striations bind the inside to the outside of the veil shape so that the distanced apprehension of that shape is confirmed, closeup, by sight of its modular components. Moreover, in one of these Veils, *Intrigue* (page 95), the verticality of the striations additionally binds the inside of the veil shape to that of the side edges of the canvas shape. Here, the process of creating an image coalesces not only with the image itself but with the pictorial rectangle in which the image exists. This particular aspect of *Intrigue* was later developed in Louis's second series of Veils. But in many of the 1954 Veils, and most specifically in *Intrigue*, the expressed verticality as well as linearity of the swathes of drawn paint fulfills another function: it affirms the orientation of these pictures, the direction in which they hang.

This is a controversial topic for the reason that Louis himself, in Greenberg's words, "felt that his particular kind of art allowed for a new kind of latitude here."[18] Greenberg pointed out that while Louis made a definite decision about which side was the top before exhibiting a picture, he was reluctant to commit himself to it by signing the picture, being ready to allow for the possibility that he might later change his mind. Furthermore, "He was willing even to allow others to experiment with his pictures in this respect, in any case he felt that if a painting of his was good enough it would stand up no matter how it was hung." Greenberg prefaced these comments by the remark that this was the one aspect of his art about which Louis was at all permissive.

Louis's "particular kind of art" did allow for latitude with respect to orientation because the orientation of his pictures was not established before he began working on them, nor did his working on them necessarily establish their orientation. Since he did not work on stretched canvases or an easel, or even on flat canvases but, rather, on canvases loosely tacked to a stretcher, which he manipulated to control the flow of paint, it was only either in the creation of the picture or when it was completed that the question of orientation arose. The same is true of the decisions that Louis had to make about exactly what area of canvas constituted the picture. He did not proceed, as Noland and Jules Olitski did later, by selecting the picture, as it were, from what had happened while he was painting, but rather, like Pollock, by finding ways to make a particular thing happen.[19] Nevertheless, the precise size and shape of a picture were only finally established when the process of painting was over or, rather, the establishment of these constituted the final part of that process. "He agonized over the size and shape of his pictures, and did so all the more because he would find his way to the nuances of size, scale and shape largely in the process of finishing a painting."[20] Establishing the orientation of the picture would also seem to have been part of the process of finishing it, and in the majority of cases it seems that this was so.

Louis, as Greenberg explained, was not dogmatic about the orientation of his pictures and, while, in the case of the Veils, he established bottom-edge anchoring as normative, he nevertheless was willing to depart from the norm, on occasion, if a particular painting seemed to demand it. That norm, moreover, was only fully established when he began the second series of Veils, which consolidated the vertical emphasis of the 1954 Veils. And verticality, while obviously precluding such a picture being hung on its side, does not itself dictate that it be hung with the paint area anchored to the bottom. What does dictate it is the sense that the force of gravity on

the vertically poured paint leads to that direction. It was the acknowledgment of gravity—and, importantly, its opposition—as much as of verticality in the second series of Veils that established their normative direction.

In the first series, there are ten pictures that have mainly vertical or fan-shaped striations. Of these, eight are signed or initialed on the surface by Louis, and of these eight, the inscriptions on only two (one of them *Intrigue*) indicate that they should be hung with the paint area anchored at the bottom.[21] The others, among them *Atomic Crest*, *Iris*, *Salient*, and *Pendulum* (pages 85–89, 93), are clearly marked for hanging with the image descending from the top edge. Of these, *Iris*, *Salient*, and *Pendulum* are paintings whose verticality of internal detailing is less pronounced (the latter two, in fact, achieving such a fusion of poured "lines" as to read almost as single flat planes) and whose paint areas are sharply cut through by the framing edges. In these cases, an "upside-down" hanging softens the abruptness of that cut and lightens the holistic image, preventing it from being read as a flat plane standing against a ground. *Intrigue* is also sharply cut at its base and, therefore, could be hung "upside down" without suffering for it. But because of its expressed vertical detailing it does not need to be hung thus, as do *Salient* and *Pendulum*. The minimized internal verticality in *Salient* and *Pendulum* (whose title describes its orientation) means that if they were, in fact, hung with the paint anchored at the base, they would seem not to respond to the force of gravity but to oppose it. It is the internal detailing and not the image as a whole that acknowledges the force of gravity. Indeed, the image as a whole always seems to oppose it. In more typical, bottom-anchored Veils, the image as a whole seems to mushroom up, while the internal vertical detailing descends. This contradiction in reading is crucial to the more typical Veils, for gravity is thereby simultaneously acknowledged in the detailing of these pictures and opposed in their whole veil images. Part of the extraordinary, concentrated beauty of *Salient* and *Pendulum* is the way in which these aspects are conflated by being reversed; the image descends as if in response to gravity, but we see from the detailing of the paint that gravity is opposed.

Atomic Crest would seem to disprove my contention that vertical detailing dictates a normative hanging, for this, too, is marked for hanging the other way. In this case, however, the fact that the crest of denser paint which gives it its title (formed by the paint puddling at the base of the pour) is entirely inside the frame of the picture gives the impression that the vertical detailing is tangibly attached to that crest, even that it grows up out of it. An "upside-down" hanging, therefore, both liberates the image from gravity (by opposing the poured directions of the paint) and affirms the force of gravity (because, thus turned, the pourings actually look as if they descend from the crest at the top), while also tending to alleviate the sense of illusion as existing behind the framed surface, caused by Louis framing the surface within the painted surface of the veil.

I dwell on these details not only to understand what Louis's intentions seem to have been in making these 1954 Veils but also because they aid understanding of what became normative in the second series of Veils (pages 97–121). They explain why Louis turned "upside down" the more planar and uniformly painted of the so-called Italian Veils (pages 119–121) and why he similarly turned the painting called *Saraband* (page 111), in order that the vertical detailing might hang from a sequence of puddled marks like the crest of *Atomic Crest*. More importantly, they explain such things as why Louis generally neither left entirely visible that area of puddled paint (as in

Atomic Crest) nor cut it entirely off (as in *Intrigue*), but cut through it to form a base into which the vertical detailing falls and from which the image rises; why he generally emphasized vertical detailing to bind it to the shape of the picture support, at times in concert with the shape of the veil image, at times in contrast with it; and why he subsequently left bare canvas around the veil image so as to be able to play off the drawing of these three elements against each other and in order to oppose the mass of the veil image with the illusion of its detailed interior.

None of these details is in any sense subsidiary to the main thrust and impact of Louis's pictures: together these details *constitute* their thrust and impact. For all the automatism and enforced "impersonality" of his methods, the structure as well as the quality of his art depend very heavily indeed on the nuances of handling.

The drifts of granular pigment that lie on the surface of many of the 1954 Veils are very much to the point in this regard. They are not accidental accumulations caused by Louis's having made a mistake in mixing his paint. (They are so ubiquitous that his choice to size the canvas of these pictures and to thin the paint excessively with turpentine rather than resin must have been made with the aim of producing them.) Neither are they just secondary pleasures, irrelevant to the distanced, primary observation of the paintings. They are devices to hold the eye to the surface (lest the disembodied illusion seem to retreat beneath it) and to have color occupy the surface as well as soak into it. They thereby perform, closeup, a function similar to what the visible edges of the veil image and the exposed canvas around it do at a distance: hold that image to the surface. Thus, "what is seen from a distance is confirmed by closer inspection; this is associated with the fact that whenever there is any delay . . . in total comprehension [of a picture], the delay is so slight that Louis's procedure is close to Impressionist simultaneity."[22] That is to say, the image is given whole and at once, and the detailing, while indeed enriching what is seen from a distance, more importantly confirms it. The same reason lies behind Louis's decision to whiten with thinned-down paint the canvas margins of some of the 1954 Veils. At a distance, the soft whiteness accentuates the vividness of the veil image, as well as its color; closeup, it has a slightly gritty quality similar to that of the color of the image itself.

THE WAY THAT COLOR is carried in and dispersed by the liquidity of the medium is intrinsic to the structural logic as well as the beauty of the 1954 Veils. The pastel-like delicacy of surface of *Salient* and *Pendulum*, the dryer, more astringent quality of *Intrigue*, the looser and languid voluptuousness of *Iris* are features particular to these individual paintings and mark their individuality as separately conceived explorations of the capacity of open color to convey an extraordinary range of emotion. It is as if they have separate, unique subjects. They comprise a series, but not quite in the sense that Louis's later pictures do. Indeed, it was making this series that led Louis to the discovery of true seriality, where individual pictures are instances of a medium, or an automatism, somehow more powerful than any one of them.[23]

In Louis's bronze Veils of 1958, the pictures have more restrictions in common. The color of these pictures, the shaping of their images, their internal drawing, even Louis's willingness to accept the eight-foot width of the canvas as their given height, are all evidence of his limiting and thereby intensifying his pictorial vocabulary in order to get into a vein of working that could produce not only more pictures but more consistently realized pictures. For it was by isolating from the 1954 Veils the components he found essential that he established the more uniform

series of Veils in 1958. The pictures in that series are totally individual not in spite of but because of the restrictions imposed by the series; any difference from one picture to the next is heightened by their similarity and produces an entirely new picture, albeit of the same "subject," as it were. With the 1954 Veils, each new picture has individuality because we sense that it might have turned out differently if worked in another way, might have turned out to have a different subject if worked in another way. It is individual in spite of the restrictions imposed upon it by the series, for its individuality is the individuality of its subject matter, and that is not imposed by the guiding and controlling force of the series as it is in the later Veils.

The 1954 Veils more properly comprise a set of variations or a cycle of paintings than a true series. Each is an Impressionist "instantaneity" and each is descriptive of a unique subject. But to make each painting an instantaneity is to generate a succession of instantaneities, and to provide for them a common subject is to provide a stable and consistent structure for their creation and also to free their creation from subject matter.

But, as in Monet's series, the one subject in its multiple versions became actually more noticeable as subject matter because of its repetition. And, again as in Monet's series, it was a subject specifically chosen (or discovered) because it confirmed (or uncovered) what had been quintessential about the earlier paintings with a variety of subjects, including their instantaneity. Greenberg is correct when he writes that the configurations in Louis's pictures are not meant as images and do not act as images, and that "Louis is not interested in veils or stripes as such, but in verticality and color."[24] At the same time, the Veils (and later the Unfurleds and Stripes), as restricted images or subjects, are metaphors of a sort of the precise aspects of painting to which Louis's ambitions were directed.

It is important at this point to be clear about the fact that neither the consolidation of seriality in the second set of Veils nor the consolidation of Louis's art as a whole that this series represents necessarily makes the paintings of this second set of Veils superior to those of the first. The paintings of the first set are the most traditional of Louis's mature works. In many respects, they are the most rewarding of his mature works because of, not in spite of, their being the most traditional.

It is also important not to exaggerate the differences between the first and the second sets of Veils. The paintings of the first set are, indeed, separately conceived in a way that those of the second set are not, but only in a way. The second set comprises reimaginings of one conception not repeats of one conception. It is the extent and intensity of their commonality that distinguishes the paintings of the second set from those of the first, not their commonality itself. For the paintings of the first set do obviously have a common conception for all their differences. And what distinguishes the two sets is not only the greater conceptual unity provided by true seriality in the second set but also an actual change in conception. I have emphasized the way in which the later Veils emerge from and consolidate aspects of the 1954 Veils. (Neither before nor after the breakthrough achieved by the 1954 Veils did Louis begin a painting from nothing, without a subject; he worked from known entities, if only from the components of his restricted vocabulary.) At the same time, they oppose and jettison other aspects of the 1954 Veils—to such an extent, indeed, as to suggest an even greater separation of the two sets than I have yet argued. Before developing this point further, however, I want to say something about Louis's working methods. For, as I observed earlier, Louis's reimagining what actually constituted the art of

painting was integral to his achievement. Moreover, the automatism of his working methods, the way in which a procedure of painting generated paintings, is what firmly associates the two series, establishes the seriality that was consolidated in the second series, and affirms a commonality among all of the mature paintings that Louis made.

The chief difficulty here is that Louis worked in utter privacy. After the sessions of "jam painting" with Noland in 1953, nobody ever saw Louis paint, for nobody was allowed in his studio while he was working; and when he had finished working for the day, that day's work was dried with the aid of a large fan and rolled up, the studio cleaned, and everything tidily put away. There was nothing bohemian about Louis, either in his appearance or in his behavior or in his working environment; indeed, he was extremely impatient with any of the implications of that essentially Romantic idea.

His studio itself was tiny—only fourteen feet by twelve feet two inches. The former dining room on the ground floor of his modest Washington home, it was built out from the house so that three of its walls mainly consisted of tall windows, and it abutted a living room about twice its size in which Louis used to view completed paintings, removing the furniture and carpet in order to do so. This was necessary because it was obviously difficult for him to evaluate the completed paintings in the studio itself. In fact, some of his paintings were actually larger than the studio. Most of his paintings, certainly, could not easily be seen as distanced wholes while he was in his studio. These seemingly unbearable constrictions never, it seems, bothered Louis. His simple acceptance of them tells of his compulsiveness as a painter and also, probably, of his desire not to allow himself a distanced view of his paintings as he worked on them lest he fall back on his "previous knowledge of balancing and composition," as Anthony Caro characterized his own reason for using a similarly constricted work place: it prevented him "from backing away and editing the work prematurely."[25] "When I took the work outside," Caro said of his own approach, "it was a shock sometimes insofar as it looked different from sculptures that I was accustomed to." It is reasonable to assume that Louis had similar shocks when he saw his paintings outside his studio.

Furthermore, the small size of the studio encouraged Louis to work on his paintings in sections. I have referred to the balance of details and wholes in Louis's Veils. He clearly took some, and probably many, of the Veils back into the studio after looking at them outside, and reworked their surfaces to achieve the particular balance he desired. It is misleading to assume that every painting was the result of one session of work. But there is also, in the second series, a balance of parts and wholes that must certainly owe something to the smallness of his studio, while not actually being dictated by it. For example, the 1958 work *Loam* (page 101) was clearly made in two halves, which overlap at the center. As stretched, it measures roughly seven and a half by twelve and a half feet. It was obviously easier to work on a canvas of this size in sections, and Louis found new compositional possibilities in the part-to-part procedures the smallness of his studio encouraged. It is indisputable that these physical limitations contributed to the creation of the Unfurleds, where paint is applied only at the two sides of often a very large canvas, at times greater in length than the longest dimension of the studio.

Louis made his paintings with the canvas tacked to a stretcher made from inexpensive one-by-three-inch lumber. This was approximately twelve feet long by eight or nine feet high, which was as large as could be accommodated on the longest available wall of his studio. Until

September 1958 Louis used rolls of eight-foot-wide canvas, from August 1959 rolls of nine-foot-wide canvas. (No canvas receipts exist for the intervening period, but it is reasonable to assume, from the 1958 dates with which some larger paintings were exhibited by Louis at French & Company in 1959, that he moved to the larger size canvas late in that year.) The canvas was folded over the top horizontal strut of the stretcher and fastened there, at first using a hammer and tacks, then later (when pictures began to sell) a staple gun. For smaller pictures only part of the stretcher was covered with canvas. For others, part of the canvas must have been allowed to lie on the floor at the bottom. Some paintings were obviously either made with their sides extended beyond the limits of the stretcher or they were tacked very loosely onto it, for their widths are sometimes greater than that of the stretcher.

This should give some idea of what it meant for Louis to move and manipulate his often huge canvases, heavy with soaked paint, in that constricted studio space. With the stretcher leaning against the wall, he would pour rivulets of the thinned Magna down the often loosely draped canvas, controlling the flow by adjusting the angle to the wall at which the stretcher was placed, by tilting it from side to side, by using a large swab to guide the paint, by masking off (probably with smaller pieces of canvas) parts of the picture, and by manipulating the canvas itself. He would also pour the paint not only from the top of the stretcher but from various points within the canvas, directing it diagonally across the surface. With the Unfurleds, such diagonal pouring—begun at the side braces of the stretcher and directed inward—formed the entire basis of making these immense works. Here, the unpainted canvas at the center must have been gathered and folded (and possibly covered to prevent its being marred by accidental spills of paint), and the canvas at the edges pleated in some way, for the rivulets are roughly parallel in their flow and could hardly have been manually directed into the configurations that result.

Some of the 1958 Veils also show signs of pleating as well as carrying in their surfaces the impressions of vertical braces. In these so-called triadic Veils the position of the two uprights that divide the veil image is so particular and plotted—one in the center, the other three feet to the right—that no other reasonable conclusion is possible than that Louis deliberately sought to achieve that effect (see Appendix). In some of the works of this triadic series, Louis opened up wedge-shaped areas of bare canvas at the bottom of the two verticals by stopping the diagonal pours from one or both sides of these vertical braces a few feet short of the floor. This may have provided the inspiration for the so-called split Veils, where the veil is separated into distinct sections, either fingerlike images or broader fields.

As the paint was impelled by gravity to the bottom of the canvas, it pooled on that part of the canvas that rested on the floor, forming denser concentrations than appear elsewhere in the pictures. In many of the 1958, and some of the 1959, Veils Louis established the bottom edge of the picture as running through the center of this denser area, and used it pictorially to form a sort of base on which the veil image stands. (If the pooling left a cracked surface, or if for pictorial reasons—as in all of the Stripes—he did not want it visible, he simply cropped it off.) In the case of the Veils, the top of the picture was usually established by leaving a narrow band of canvas above the highest reach of the painted area. It was Louis's stated intention to establish the two sides of the picture in the same way. In some of the 1958 and 1959 Veils, however, he accepted Greenberg's advice that more bare canvas be allowed to remain. Greenberg subsequently realized that Louis was correct in not wanting to overemphasize the imagist quality of

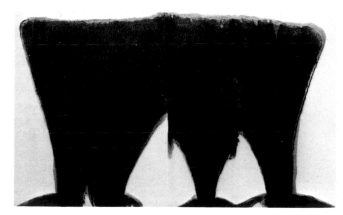

Morris Louis. *Dalet Aleph*. 1958. Acrylic resin on canvas, 7′ 6½″ × 12′ 6″. Private collection

the Veils by so strongly silhouetting them against areas of blank canvas, and that bringing in the edges of the picture just short of the painted area on three sides helped visually tauten the painted area, thereby returning its illusionism to the flatness of the surface.

Louis did not talk about the novel procedures that he had devised. He simply did not want his art to be judged by its methods, but by their results. This is not at all unusual; neither is it unusual for an artist to be unwilling to paint before an audience. Louis's personality may have been a lot more secretive than most, but this was part of his remarkable self-sufficiency (a self-sufficiency that one cannot help but see in his art too). One should be wary of attributing undue significance to the procedures in themselves. He did not submit his creations to the justification of method; for Louis method was justified in its submission to art. It is evident from the paintings themselves that the placement of the stained areas, the final dimensions of the canvases, and—in the vast majority of cases—the direction of intended hanging, as well as the general care and control of the medium are as precisely intended as in any painterly art.[26]

Louis's secretiveness may partly be held responsible for the mystery that came to surround his art and led to often egregious misconceptions about his artistic aims. Even now the full extent of Louis's control of his medium is insufficiently remarked. For example, it is obvious from his pictures that while Louis used mainly "automatic" painting procedures, he also made careful adjustments by hand. I refer here not only to the final dark scrim in the Veils, which was certainly applied using a swab, nor only to the precision with which it was applied, at times with areas of the surface masked out to allow the brighter colors underneath to show through, but also to such things as the way he would draw down streamers of darker paint and add stripes of brightly colored paint at the edges of the veil, and to the way he would go back to his pictures, adding touches and sometimes whole layers of paint to adjust their effect.

Details of this sort are not immediately apparent when looking at Louis's Veils—which is a measure of their successful use—but they are there to be seen, and I will refer to their use in specific paintings in the following chapter, where it will be seen that while the second series of Veils contains less purely phenomenal detail than the first, it actually contains more manually adjusted detail. Obviously, the fact that Louis used detailing of this sort does not make his pictures any better or worse. But, equally obviously I think, his actual use of it did make them better. It is often assumed that the stain method disallows correction. Louis's work proves that this is not so. In some of the Stripe paintings, even, Louis would redraw—or repour, rather—a stripe in a different color exactly on top of an existing one. The skill that this required is remarkable. But, again, it does not appear as such in the completed pictures. If it did, the pictures would seem incomplete.

It was not in Louis's procedures, then, but in his utter commitment to their purely artistic possibilities (to his unearthing of these possibilities)[27] that he found a freedom quite new in modern art. Even more than Pollock before him, he established not so much a new style of painting, nor merely a new process for creating paintings, but a new *medium* of painting. He discovered, as Greenberg has written, "that the ambitious abstract painter could no longer safely take anything for granted in the making of a picture, not the shape of its support, not the nature of its surface, not the nature of its paint covering, not the implement with which he applied the paint, and not the way in which he applied it."[28] Louis's method investigated the physical condition of painting's existence, inquired about the very identity of the art of painting itself.

3

Relationship of Veils to pre-modern artistic
traditions; 1958–59 Veils; Florals, Alephs, and
other transitional pictures of 1959–60

AFTER JUNE 1954, when Louis had completed the sixteen pictures that comprise the first series of Veils, it was not until three and a half years (and over three hundred failed pictures) later that he again found himself as an artist, indeed, that he established his identity as an artist, for such is the achievement of the second series of Veils. Begun in the winter of 1957/58 and concluded in the late spring or summer of 1959, it comprises about 125 pictures, of which 100 were probably completed or painted in 1958, the earliest being the nearly 50 so-called bronze Veils, which effectively constitute a separate group in themselves (pages 97–103). If the 1954 Veils present themselves as an oasis of languid beauty amidst an infertile desert of frustrated experiments, the bronze Veils, by contrast, form a far more substantial ground on which Louis was able to build. After completing both series of Veils in 1959, he underwent a new period of uncertainty, which lasted until he began the Unfurled pictures a year later, in the early summer of 1960. However, this period was very different from that which divided the 1954 and 1958–59 Veils, and produced some superb pictures based on implications contained in the more colorful 1959 Veils. The continuity of Louis's development as a mature artist, which began with the 1958 bronze Veils, was not disrupted as it had been previously but was maintained until it was suddenly cut short by his operation for cancer of the lung in July 1962, which prevented him from ever painting again.

The 1954 Veils had been painted in a time of ferment and irresolution, not only for Louis but for new art in general. When the 1958–59 Veils were begun, a great deal had changed. Pollock was dead, Rothko and Still (soon to be followed by Newman) were gaining in reputation, Frankenthaler had returned to staining, Noland's first one-man show had taken place and his work was developing quickly, and "gestural" Abstract Expressionism was all but exhausted as a source for new artists. By the time that Louis exhibited his new Veils at French & Company, New York, in March–April 1959,[1] it was fast becoming clear that Abstract Expressionism as a whole was being supplanted. By the end of that year, The Museum of Modern Art's *Sixteen Americans* exhibition (which included Johns, Rauschenberg, Stella, and Kelly) announced the directions that led to the Pop and Minimalist styles of the 1960s. Louis's stylistic change in 1959–60, from the Veils to the Unfurleds, similarly foreshadowed another quintessentially 1960s form, Color Field painting as practiced both in Washington and New York. All of these new forms were noticeably "clearer" and "cooler" than those which had dominated the preceding decade and, despite their obvious differences, stylistically more consistent too. The ambiguous meldings of different currents characteristic of the 1950s—indeed, the preoccupation with ambiguity itself which marks that decade—gave way to versions of a single style generally characterized by crisply and regularly drawn flat, heraldic layouts, high-keyed color, and clear, open design. Soon, even a realist painter such as Philip Pearlstein was led to observe, "The sensibility of the *first half* of the sixties has hardened. Pop art, constructions of all kinds, hard-edge abstraction, and my own kind of hard realism—it's all 'hard'—sharp, clear, unambiguous. In the fifties everything was ambiguous."[2] In the 1950s very little was "hard," and no single sensibility had managed to harden.

With the advantage of hindsight, it is possible to view even Louis's 1958 bronze Veils as part of this late 1950s shift from (in Heinrich Wölfflin's terms) "painterly" to "linear" styles and of the "cooling" of Abstract Expressionism which accompanied (and encouraged) it.[3] Their starkness, and severity even, as compared to the 1954 Veils; their bilaterally symmetrical, firmly contoured, clear "imagery"; their open fields punctuated by regularized, geometric drawing are all attributes

of the bronze Veils that relate them to the "Post-Painterly Abstraction" of the 1960s with which Louis's art after 1959 evidently belongs. And yet, they are still late Abstract Expressionist pictures, not only in their emphasis on monochrome rather than high-keyed color but also in their particular use of those very stylistic elements that relate them to the 1960s. They seem to represent Louis's attempt to achieve, after the lighter earlier Veils, an epic Abstract Expressionist style as serious and monumental as that of any established Abstract Expressionist; one that combines, in fact, the expanded drawing of Motherwell or Kline or Pollock with the field aspects of Newman or Rothko or Still, and thereby extends the life and emotional content of Abstract Expressionism in the synthesis of those hitherto opposed sides of the movement; and, more specifically, one that finally matches Pollock's, the only Abstract Expressionist style before Louis's to make fields from expanded drawing. It is with the bronze Veils that Louis at last came to terms with Pollock's achievement. Having done so, his development was entirely his own.

At least, his development was largely independent of his contemporaries. (There were times when he learned from Newman, Still, and Noland, but these lessons served to hasten the emergence of features already latent in his work.) Necessarily, it was not independent of the past. I began the preceding chapter by asserting that Louis's originality is not residual originality; rather, it lies in what links his art to the past. Before turning to the development of the 1958–59 Veils, I want to consider how our understanding of the character and content of these pictures, and of their difference from the 1954 Veils, might be informed by placing them in the context of certain general traditions of Western painting. I intend by this not to validate them by association, for any work of art whether great or small may be considered in this way, but, instead, to attempt to come to terms with the nature of their meaning, which is necessarily difficult to specify given the abstractness of Louis's work. Subject matter, obviously, is not the same as content; neither is the meaning of a work of art limited to or exhausted by its sources. Nevertheless, in considering works of art or whole bodies of work with (or ultimately derived from) illustrated subjects we can at least observe how artistic meaning has been developed from picturing things in the world that we too have seen and can at least gain clues about an artist's sensibility from the kinds of subjects he has chosen, subjects which infiltrate his work with their own associations and own history. With Louis's work, we can have no assistance from that quarter. Everything exists in a purely abstract state. "Louis's very imagination strikes one as radically abstract," wrote Michael Fried, "in a way that not just Pollock's but that of any modernist painter before Louis, except perhaps Matisse, does not."[4] The meaning of his work, therefore, would seem to be inaccessible except in purely abstract and artistic terms.

In practice, however, interpretations of Louis's work are frequently made in other terms, and there seems to be a general consensus on this issue, at least with regard to the Veils. Even Greenberg, who chooses not to address specifically questions of content (on the reasonable ground that nothing is demonstrable here), implicitly suggested what their content might be when answering Louis's requests to provide lists of titles for his pictures. Louis himself was not interested in titles but preferred them to numbers simply for reasons of convenience (nor was the series name "Veils" Louis's). Among Greenberg's titles are: *Terranean*, *Vernal*, *Russet*, *Bower*, *Aurora*, *Air Desired*, and *Golden Age*. These are organicist and idealist titles implicitly comparing the Veils to the moods of Romantic and pastoral landscapes and, ultimately, to the archetypal motif of the paradisal garden.

Much has been said in recent years on the Romanticist connection of Pollock, Rothko, and other Abstract Expressionists, and Louis has sometimes been introduced into this debate. Robert Rosenblum, notably, has referred to the Romantic vitalism and pantheism of Louis's work.[5] Without necessarily disagreeing with this interpretation, I nevertheless feel that to talk immediately of Romanticism (and this for Abstract Expressionism in general) unduly hardens and prejudices the issue, for it tends to prescribe investigation into the search for analogues between new and old Romantic art. A more disinterested suggestion would be that perhaps Romanticism and Abstract Expressionism share similar concerns and preoccupations of which they, as historical movements, are both instances. And if the real stumbling block in our appreciation of Louis's sensibility is the sheer abstractness of his work—the fact that it is so utterly part and parcel of the medium of painting—it is certainly worth inquiring whether this is so unprecedented as it appears at first sight.

The absolute visuality of Louis's work is without exact precedent. With any previous abstract artist, it is possible to discover some *a priori* subject or idea that informs understanding of the structure of the work. This is true of Pollock and Newman as much as it is true of Kasimir Malevich and Piet Mondrian. It is not true of Louis, who effectively made the first fully autonomous abstract pictures. There is, nevertheless, a long-standing tradition of painting especially responsive to the inherent possibilities and beauty of the painting medium. Part of Louis's originality was in his rediscovering and then purifying something that was not at first easily accessible to twentieth-century sensibilities, namely a particular kind of poetic painting that has its modern origins in the Renaissance.[6]

By poetic painting I mean this: when Renaissance theorists discussed the famous Horatian concept—*Ut pictura poesis*—that is to say, a picture is like a poem and should speak to the intellect rather than to the senses, they began to discover an alternative interpretation of the same phrase. Leon Battista Alberti, for example, contrasted ennobling pictures—those fulfilling the intellectual, didactic implications of Horace's idea—with pictures of an opposite kind, whose justification was that if painting is a kind of poetry, then it might be a specifically poetic kind of painting—a relaxing, harmonious kind of painting similar in its effects on the human mind to that of music—which would "help to restore the tired spirits of the man of affairs."[7] This is to justify a hedonistic, lyrical art devoted to pastoral subjects rather than (and besides) a moralistic, epic art devoted to ennobling subjects (also, in effect, to justify Venetian painting next to Florentine). Whereas the intellectual interpretation of the Horatian idea was fulfilled in an emphatically urban, civic art, expressive of the ordering of affairs in a rational, organized society (whose biblical archetype was the city of Jerusalem), the instinctive interpretation was fulfilled in a rural, pastoral art, which imagined an existence prior to and apart from society itself (its archetype being the paradisal garden). The two interpretations (and the polarities I am using to describe them), as manifested in the practice of painting, were never totally distinct, but in practice the intellectual interpretation produced a more heroic and proclamatory art of regularized accent and meter, and the instinctive, a more introverted and private art of increasingly asymmetrical and irregular rhythms. And while the former tended to idealization rather than to realism, both in terms of representation and in the use of the medium—that is to say, to the fullness and stability of form, and therefore containment of color and touch—the latter tended to the opposite in both these things.

The instinctive, moreover, by virtue of its functional comparison with music, was seen as potentially capable of evoking a highly generalized, universal harmony. It was Leonardo who first pointed this out, noting also that this kind of art was particularly open to technical experiment. The famous passage from his *Treatise on Painting* about discovering landscapes in stains on walls (the ultimate source of the automatist idea) is relevant here, as is Leonardo's famous comparison of the painter's very methods with those of the poet. If we were to rephrase his comparison in modern terms we would say that the painter like the poet induces his structures by experimenting with the basic properties of his medium. This is to justify a kind of painting that shows its artistic core most clearly.

A large part of this was, in effect, an attempt to produce a theoretical justification for the emergence of landscape painting; also, however, to produce a model for the unique possibilities of painting freed from the tutelage of sculpture in the sixteenth century. But both landscape painting and painting's freedom from the sculptural had been adumbrated earlier in the North, and it was in the Gothic North rather than the Mediterranean South that one of the pictorial traditions most relevant to modern American painting (including Louis's) developed. This was the luminous alternative to chiaroscuro painting wherein the illusionism of transparent color provided a volume surrogate by releasing an internal light, a light identifiable with (spiritual) content, as in the case of Gothic stained glass. As Sidney Tillim has pointed out, watercolor painting, being an essentially northern form, inherits the spiritual, Gothic ethos of Flemish luminism.[8] Even when secularized by its association with landscape subjects, and thereby finding common ground with the Mediterranean pastoral, it continued to evoke the spiritual. It was neither hedonistic nor ennobling, neither pastoral nor civic, but rather animistic or pantheistic, being removed from both the relaxing and the organizing aspects of worldly existence.

I referred earlier to the possibility of distinguishing the two series of Veils in relation to watercolor and fresco painting, the two traditions (more than just techniques) of painting that lie behind the soak-stain approach. The former is characterized as intimate, tending to lyricism, highly dependent upon touch, and having the candor and immediacy of a sketch; the latter is public, tending to the epic and the monumental, involving suppression of touch, and having the distanced aloofness of architectural decoration. This dichotomy exaggerates the difference between the two sets of Veils, but it does indicate the modalities toward which they tend, and explains what was meant earlier by an actual change in conception from the first to the second set of Veils. While the second set does maintain features of the first, the features that it maintains tend to be those that are associable with the muralist as well as with the watercolorist tradition. In one important respect, moreover, the second set uncovers, in this conflation, an aspect of the watercolor tradition not fully expressed in the lyrical and intimate earlier Veils, namely the original spiritual ethos of luminist art. There is a definite sense of stern Gothic verticality in the acute-arched drawing and jagged detailing of the bronze Veils. They have been compared to Monet's paintings of Rouen Cathedral.[9] The comparison was meant to point out their Impressionist connections. It does that; but it also reveals how Louis, by monumentalizing his art with the regular, drawn rhythms of Mediterranean muralism[10] (present even in some aspects of Monet), makes it seem actually more Gothic than before rather than less so—because what he monumentalizes is watercolor, thereby returning it to its origins in public Gothic art.

The Mediterranean mural tradition is emphatically worldly, given its civic nature. As such, it

tends to the epic and proclamatory. It does so, moreover, not only by virtue of its intent and function but also by virtue of its form, which necessarily is one of lateral expansion, the wall rather than the window (as in watercolor painting) being its architectural prototype and often its actual base. It therefore tends to narration rather than to illustration (as in watercolor painting); eventually to decoration rather than to illumination. Although its civic intent and function required that it present stable and hence sculpturally realized forms, its actual association with the wall tended to dissipation of the sculptural in favor of the flatly decorative, while maintaining, however, the regular "heroic" rhythms of a public art. Matisse's work offers the best example of modernism's adoption (and adaption) of this tradition.

What I am referring to here are norms and modalities of painting, not prescribed rules or insulated methods for making paintings. Neither the intellectual epic and the hedonistic lyric nor the watercolorist and the muralist approaches to painting were ever totally distinct. Louis's conflation of aspects of these is but one of the multitude of such conflations in the history of Western art. For it has always been the rearrangement and fusion of different and opposing norms and modalities of painting that have accounted for its important revolutions—or better, mutations—in form. It is possible, and justifiable, to trace the instinctive in modernism back from Dada and Surrealism to the essentially amoral art of the pastoral ideal; the urban, geometric side of modernism to the didactic classicist tradition; the abstract luminism in modern art to the internal light of watercolor and before that Gothic spirituality; and modern decorative field painting to Mediterranean muralist art. Nevertheless, it is the artists whose work most emphatically refuses categorization in this way whom we value as revolutionaries. For example, Joseph Mallord William Turner's break with the vocabulary of the Picturesque—one of the most direct descendants of the pastoral—was achieved by his avoiding Picturesque asymmetry and beginning to balance his pictures more classically across a central axis, while also breaking with classical conventions of light-and-dark modeling for a close-valued kind of painting that merged the luminosity of watercolor with the planar tangibility, and scale, of mural painting. This is of obvious relevance to Louis's art. So is Picasso's attempt, in *Guernica* (a picture Louis admired),[11] to ennoble the demonic pastoral ethos of his contemporaneous work by enclosing it, as it were, in a moral, civic setting marked by regular vertical rhythms, like classical columns.

But, again, it is Pollock who most emphatically anticipates the particular fusion of traditions that informs Louis's art. "Pollock," wrote Sidney Tillim, "was responsible for all the nobility Surrealism ever knew, since he gave automatism scale and set the stage for a heroic secularism in painting."[12] His form of Abstract Expressionism, Tillim observed, combines the northern impulse to dematerialization with the Parisian (Mediterranean) aesthetic of the flat, decorative plane. It also transformed automatism from an introverted, private act expressive of the artist's ego and his autobiographical self to an extroverted, public act expressive, instead, if not always of the artist's release from the specificity of such personal feelings then of his struggle to achieve that release. And when that release came, in the allover paintings, it was into an obsessively crafted form of "illumination." Louis's art, even more specifically than Pollock's, locates the illumination on "a very physical object that is nothing but color, a vast luminous pane through which light filters into the 'interior' of a secular cathedral without walls—the concretion of our utterly self-conscious and material intuition of the universe."[13]

COLOR, IN FACT, is muted and subdued to a mysterious half-light, neither dawn nor dusk but associable with both, in Louis's bronze Veils. It is the drawing more than the color of these works that asserts their "heroic secularism." Louis's Motherwell-influenced Tranquilities collages of 1952–53 adumbrate their regularly paced rhythms. But the way that these rhythms are coaxed from, and inherently belong to, the process of making paintings is entirely new.

The exact chronology of the bronze Veils—indeed, of the 1958–59 Veils as a whole—is unknown and is likely to remain so. We do know that the most characteristic, triadic, kind, which forms the vast majority, was being made by the spring of 1958.[14] Whether they were preceded, in the winter of 1957–58, by less fully resolved paintings, which Louis destroyed; whether they were preceded by those awkward triadic Veils where areas of bare canvas left within the shape of each veil at the bottom of the painting overemphasize the imagist quality of that shape; whether those paintings followed the classic triadic works and led Louis into the split Veils; or, indeed, whether Louis made different kinds of Veils concurrently are all questions which, if answerable, would help us understand the developmental logic (or conceivably, the lack of it) of the Veils. But we simply do not know.

We do know, however, that Louis used eight-foot-wide canvas until September 1958 and turned to nine-foot-wide canvas sometime before the end of that year, and continued to use it thereafter. So it is possible to establish a very rudimentary chronology on the assumption that the types of Veils painted on eight-foot-wide canvas preceded those painted on both eight- and nine-foot-wide canvas, which preceded those painted on only nine-foot-wide canvas. The chronology that follows is based on this assumption and on the assumption that the developmental stylistic logic of the Veils reflects the order in which they were made. But neither of these assumptions, however reasonable, can be proven.

In any event, it is certain that the triadic bronze Veils were among the first that Louis completed in 1958 (pages 97–99). It would seem that the earlier of these were the pictures with a simpler and duller surface and a less regularly formed veil shape and the later, the pictures with more complex drawing and color contrasts, a more lively, asserted surface, and a more firmly contoured veil shape. Certainly, the more authoritative pictures are those with the latter attributes. Those where the top of the veil shape is not trued to the horizontal, but dips and then peaks as it meets the two vertical "lines" within it, suffer because the functional relationship, thus illustrated, between the internal drawing and the external shape of the veil image tends to give it the appearance of a loosely flapping construction (something like a canvas windbreak) standing in front of the picture surface. Those where the sides of the image are not roughly symmetrical suggest that it is slipping from its moorings, even that the two sides advance and recede in opposite directions. Louis later found that the source of expressive power in the Veils lay in their outside edges. However, he was not able to tap that power until he established the veil image itself as a flat, heraldic, bilaterally symmetrical unit, firmly rested on the base of the picture and floated just free on the other three sides.

Color in these pictures, Michael Fried has astutely observed, "is much more closely and specifically answerable to figurative concerns and impulses [than in the earlier Veils], including the impulse to do away with figuration within the stained portion of the canvas altogether."[15] He refers to the fact that while the drawing is starker and apparently more traditional in its linearity, as compared to the drawing of the 1954 pictures, no sooner do we realize these things

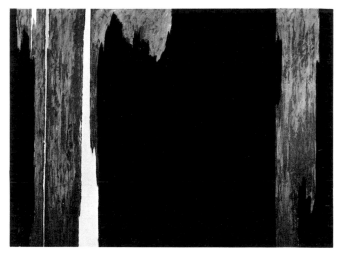

Clyfford Still. *1954*. 1954. Oil on canvas, 9' 5½" × 13'. Albright-Knox Art Gallery, Buffalo. Gift of Seymour H. Knox, 1957

opposite: Claude Monet. *Rouen Cathedral, West Facade, Sunlight*. 1894. Oil on linen, 39½ × 26". National Gallery of Art, Washington, D.C. The Chester Dale Collection

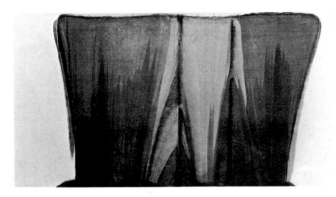

Morris Louis. *Turning*. 1958. Acrylic resin on canvas, 7' 8¼" × 14' 10¼". Private collection

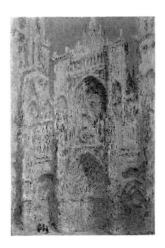

than we also realize that they belong to, and create, an unbroken continuum of color. Whereas drawing or figuration in the 1954 Veils is mainly the product of changes of hue, and the continuity of the surface is established by colors flowing across each other, fluctuating continuously across the surface, drawing or figuration in the 1958–59 Veils is mainly the product of readily apparent changes of tonality, and the continuity of the surface is established in the breadth of the painted field, which runs through the very regularly drawn tonal changes, whose function (like Pollock's latticework drawing) is to articulate the spread of color. The continuity of the surface in these Veils is in its uniform, dense extension. Its coloristic richness, as Fried observed, consists "not in the simultaneous presence of several more or less disembodied hues in the same portion of the canvas, but in the binding together in a single darkish tonality—often brown, bronze, or green—of the comparatively few, and for the most part clearly delimited, hues they comprise." Drawing, in effect, is present in a self-evidently traditional way, but its traditional (contouring and delineating) functions are subverted because the flat spread of the color which forms the drawing thus subverts it. The individual "drawn" configurations no longer seem to flow across each other, being laid down side by side, either beside each other or in interlocking jagged patterns. But the image as a whole is as procedurally, texturally, and coloristically uniform as a Pollock allover painting and, similarly, subsumes the linear quality of its drawing without sacrificing the sense of detailing that drawing provides.

Pollock's method of working meant that the breadth and evenness of the surface had to be striven for; Louis's was a more natural method of surface covering. It owes something to Still's paintings. Noland has observed, "Morris and I looked long and hard at Still, especially the way he could open up color and get it to flow across the surface."[16] Still's influence may be seen in the jagged drawing of some of the bronze Veils (and some later pictures too), which Louis achieved by pleating the bottom edge causing the color to flow to either side of the pleat; this also dictated the height of the spearlike image that resulted. In others, a comparable effect was produced by pouring paint diagonally from various points along the vertical marks that were created where the canvas rested on upright struts. To the extent, however, that the verticals themselves become dominant (which they often do), it is Newman rather than, or in addition to, Still who is recalled.[17]

The nature and variety of the internal detailing in the bronze Veils is truly remarkable. Some are relatively uniform and understated. In others, the stability of the triadic format is emphasized, at times to check and control very eccentrically drawn areas. A number counterpose the two verticals (one at the center; the other some three feet to its right) with a darker area to the extreme left of the veil of roughly the same size as the distance between the verticals. Yet others provide darker areas on both sides, which read as wings or framing devices. A very few, all most probably made at the end of the "bronze" group (say, in the summer of 1958 or even as late as 1959), dispense with the final dark veil to reveal resplendently gorgeous color, usually blue, and reminiscent in its detailing of butterfly wings and exotic crystals—whose gorgeousness, however, is checked by the very skeletal structure that provides the detailing and by the vein of icy coldness that runs beneath their warmly breathing surfaces. But these are exceptional. Others do carry mineral associations, but usually of less easily identifiable substances, none wholly alien and unknown but none entirely familiar either.[18] And the darkness of the vast majority of these pictures gives to them a mood less celebratory than contemplative of

the natural world to which they allude. At times, the darkness is elegiac, at times connotative of autumnal substances (which often amounts to the same thing).[19] More often, however, these pictures have the magnetism to attract and focus moods rather than create them. That is to say, they afford less an interpretation of the natural world, their subject, than a revelation of it. The natural world stands forth in these pictures, not pictured, certainly, not even expressed, but simply present to us, in front of us, in the silence of their facing fields.

In one sense, this is a familiar kind of nature Romanticism, a particularly American kind, and what Ralph Waldo Emerson said of Henry David Thoreau could be said of Louis: "His position was in Nature, & so commanded all its miracles & infinitudes."[20] This would be to place Louis with Arthur Dove and Augustus Vincent Tack (whose work he must certainly have known) and also with earlier American luminists, whose landscapes Robert Rosenblum has characterized as revealing "that silent, primordial void of light and space where material forms, whether animal, vegetable or mineral, are virtually pulverized or banished by the incorporeal deity of light."[21] Certain structural devices also link Louis to the luminists, "for luminist light largely derives its special quality from its containment within clearly defined geometries and sometimes, too, from the opposition of its brilliance to the ultraclarification of foreground detail."[22] It may even be argued that Louis's expressed belief that large-size painting was quintessentially American links his art to the luminists' nationalistic celebration of the scale of American scenery, its haunting openness and spatial freedom.[23] Certainly, there is a connection to be made here. I have already referred to Louis's place in the tradition of Gothic light, and American luminism is part of this tradition too. However, what distinguishes Louis's work from earlier American nature Romanticism (and distinguishes Abstract Expressionism as a whole), is its non-American inheritance. As modern art, more particularly, ambitious mid-century American modern art, it draws mainly and most immediately on European modern art—on Impressionism, Cubism, and Matisse. It may do so indirectly, but it does so ultimately, and that affects most emphatically the way it presents its world.

Beth Heh (page 97), for example, focuses a mood that is mysteriously relatable to, let us say, copper beeches, at least to some kind of richly colored natural substance or form. The arboreal association is probably attributable to the fact that the drawing in this picture (as in many) is reminiscent of an exotic wood veneer. As usual, the association is not limited to what the drawing or color specifically evoke, when they do that, but rather involves a broader sensual recall akin to Proustian remembrance. And the fact that the association begins in, and is grounded in, a pattern on the surface and recalls a similar pattern on another surface, making immanent the memories associable with that similar pattern, shows how from start to finish, when the mind is released from the locality of its stimulus, everything is returnable to the surface and belongs there. This should serve to demonstrate how Louis's work partakes of the European-derived sense of there being a tangible, resistant, flat picture plane, which far from opening onto an immaterial void opens instead onto the viewer's space, not leading us into an imagination of nature but locating us, rather, in front of a version of nature that exists independently of us and elates us, as nature does, by virtue of its independence from our hold.[24] However, if it does not serve, then a more prosaic association provoked by the same graphic patterning should do so. It is also highly reminiscent of the drawing in Analytical Cubist paintings.

Among the aspects of the Veils that associate them with Analytical Cubist paintings made

after the summer of 1910 are their frontality, their shallow tonal overlappings, the geometrical and often triangular drawing resting on the bottom edge of the picture, the almost *passage*-like function of the drawing in articulating the surface but allowing the eye to pass over it, the very poetic and mysterious way that the drawing seems to emerge and submerge within the monochrome space, and the sense of inner light as if it were emanating from the folds of a sculptured drapery suddenly opened and stretched flat.

And yet, while the staining of Louis's pictures makes them seem even flatter than Cubist ones, their luminism gives them also greater depth. In Cubist art, the symbiosis of the depicted drawing inside the picture and the literal drawing of its edges brings into the picture the compressing and tautening effect of the edges. In Louis's art, as in Newman's, it works in the opposite manner, unfolding the inside of the picture and opening it out, causing its pictorial space "to leak through—or rather, to seem about to leak through—the framing edges of the picture into the space beyond them."[25] In Louis's case, the limits of the pictorial space are defined (without quite being enclosed) by a version of that same drawing placed close to the framing edges of the picture, that is to say, by the emphatically drawn contour of the veil shape itself. This serves to tauten the space that it contains; but since it is held free of and in tension with the framing edge itself, and since the flat materiality of the surface passes through it, the effect is of tautness without enclosure. In the 1954 Veils, the limits of the veil shape are relatively fluid, thereby producing a Pollock-like effect of interior incident slackening in intensity toward the framing edges. In the bronze Veils, however, the limits are so firmly established as to suddenly break the intensity of the interior incident and create an image that is wrenched free from the framing edges. This contributes to one obvious difference in feeling between the two sets of Veils. The earlier evoke insubstantial phenomena, indeed resemble insubstantial phenomena; the later evoke substantial things, but things whose substantiality is so illusory as not to resemble anything in the world. If William Hazlitt's famous description of Turner's pictures is appropriate to the earlier Veils—"pictures of nothing and very like"—then the later Veils are pictures of something and very unlike.

The form of the veil silhouette is particularly important for the success of these pictures. If kept too far inside the framing edge or if highly irregular in contour, the image tends to read separately from the ground, at times to highly dramatic effect but an essentially sculptural effect that is foreign to Louis's best work—at least, foreign to it unless checked and counterposed. For, as Kenworth Moffett has pointed out, the silhouetted veil image is ineluctably sculptural.[26] One of the greatest achievements of the Veils is that they preserve the power and plasticity of the sculptural, but also subvert it, rendering it illusory and pictorial, accessible to eyesight rather than to touch.[27] The veil images do not read as tangible things; all that is tangible about them is the flatness they have in common with their support. This is why they are very unlike things in the world. And yet, they do partake of the traditional seriousness and gravity of the sculptural. Just as Pollock rearranged the components of traditional modeling to dissipate the sculptural from illusionism, so Louis does. He does it in part by forcing tonality and monochromy to read as color, in part by refusing to let the detailing of his pictures be perceived as figuration independent of color, and in part by the flattening and disembodying produced by staining itself. But the drawing of the outer limits of the veil image is especially crucial in this regard. By concentrating his attention on these limits, Louis discovered there much of his paintings' expressive power.

With *Loam* (page 101), the gently tapered sides of the image define a bilaterally symmetrical plane frankly divided down the center, the vertical of that division repeating the verticality of the picture's edges. Drawing placed near the edges of a picture is more inherently abstract than that placed within the picture since it has less room in which to be read in a referential way. Here, the abstractness of the picture's edges is brought into the dead center of the picture itself, and the drawing that marks the limits of the veil image is close enough to the picture's edges to be read abstractly, yet not so rigidly aligned with them as to make the picture seem either inert or overly contained. It was important that the sides of the image be pulled in to form a shape geometrically different from that of the pictorial rectangle. In *Bower* (page 105) and a number of other so-called monadic Veils, which followed the bronze Veils, Louis accentuated this shaping by using images with steeper edges. Because there is less drawn incident within the shape of the veil, Louis was prevented from recalling the picture's edges there. He therefore set the shape of the image against the drawing of these edges; by diagonally bracing the image against them, and throwing the weight of its drawing out toward them, he made them a part of the picture in another way. (This method has obvious implications for the Unfurleds.)

While the image in *Bower* is symmetrical in shape, that symmetry is opposed by the denser and darker right-hand section of the image, then restored by the exposed red-orange margin at the extreme left. Louis frequently used exposed colors at the edges of the darker veils (creating them either by stopping the dark scrim just short of the limits of the brighter colors underneath or by adding them after the scrim had been laid on). They function as drawn accents to direct the focus of the eye, and they soften the darker, monochromatic edges they abut—in both respects, performing like Cézanne's multiple contour drawing to mediate between the inside and outside of the shape. In *Golden Age* (page 99), trails of dark pigment hanging down from the sides of the veil fulfill a similar function. Michael Fried is correct in saying that Louis need hardly have bothered about softening the contours with this kind of incident since even the most firmly drawn contours do not read in a tactile way.[28] Nevertheless, their accenting function is an important one. In *Golden Age* Louis carefully wiped (even conceivably brushed) the collected pigment at the bottom of the veil so as to form a sequence of similar accents there. They function as headstones from which the Gothic arched drawing in the interior of the veil seems to rise. Louis frequently provided bases for the veils from the spreading pigment itself. This can be seen in *Beth Rash* (page 107), where Louis also stopped the dark scrim just short of the top of the veil image (as he did in many such pictures), leaving a radiant multicolored fringe visible there. While this represents the point at which he began pouring the paint, the effect is opposite, for as the veil image seems to rise from its base it ends with the freedom of water at the height of a fountain.[29] In some of the monadic Veils and the later Italian Veils, like *Italian Bronze* (page 121), where the paint was poured in more regular stripes, the effect of the round-topped exposed colors is of delicate "dawn-lit hillocks"[30] that open an ethereal space rather like that in Chinese landscapes.

The use of darker wings or frames for the Veils, as I said earlier, was a particularly fertile approach. We see it in *Golden Age*. These darker side panels establish a firmly silhouetted contour for the whole veil image, but they also serve to disengage the interior of that image from its external silhouetted contour, for the interior therefore does not have an external contour. They also function as stabilizing posts with the exposed colors along the "lintel" of the veil

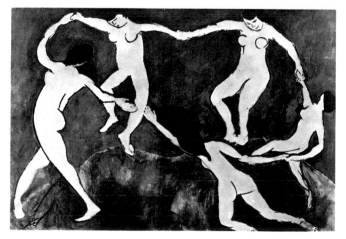

Henri Matisse. *Dance (first version)*. 1909. Oil on canvas, 8' 6½" × 12' 9½". The Museum of Modern Art, New York. Gift of Nelson A. Rockefeller in honor of Alfred H. Barr, Jr.

dancing between them. Just as important, however, they serve to flatten and tauten the veil image, not only by directing the eye to its opposite limits but also by replicating the effect of very bright illumination falling frontally on a form in nature, which causes it to be flattened as well as lightened. In such instances, the effects of shading and chiaroscuro are minimized, relegated to the very boundaries of forms, which therefore seem to be pushed out and extended by the stretching brightness and flatness of their frontal interiors; and their darker contours, juxtaposed with the even greater brightness outside, seem to hesitate in the definitions they provide. A similar sense of sculptural form dissolved by illumination is characteristic of Louis's Veils. Where earlier luminism depicted such an effect, Louis's version embodies it.

It was probably the use of wings in the bronze Veils that led Louis to begin to think of their surfaces as modular, which in turn led him to new kinds of veil pictures. Before following their development, however, I want to address the most important method that Louis employed to subvert the sculptural quality of the veil image while maintaining its plastic force, which he derived from Matisse. It is usual to see the impact of Matisse as coming later in Louis's development, when he began "uncovering" the bright colors that went down first in making the Veils, but Kenworth Moffett has astutely observed that a most basic lesson of Matisse's art (as basic even as its construction by color) actually lies in the silhouetted darkness of Louis's Veils.[31]

Matisse's art came to maturity when he blended Impressionist luminism and Symbolist flat color painting in such a way as to generate light through thinly applied intense color (thus also blending Gothic spirituality and Mediterranean decoration). The specific clues he took from the classicist Pierre Puvis de Chavannes and from Neo-Impressionism (the first modern style to blend luminism and decorative flatness, albeit with an echo of closed, modeled form) led him to a frescolike conception of painting (of tinting color on white). Unprecedented, however, is the form of illusionism that Matisse achieved. While it is an openly dispersed illusionism, affording an allover sense of luminosity, as in Impressionism, it is not identified with the paint surface. The paint surface, as paint, is more modestly given by diluted pigment to allow greater color saturation and color intensity, and to allow light to be generated in the optical dazzle produced by the contrasts of saturated, intense colors. And, most importantly, the paint surface, as surface, is never entirely aligned or identified with its color. The contrasting colors that provide the illusion of light are spatially dislocated one from the next, thereby prying away the illusionism from literal identification with the flatness of the surface. This sense of spatial dislocation between areas of color is partly innate to Matisse's use of high-intensity color, which necessarily accentuates the tonal contrasts in color. But Matisse dramatized this dislocation by means of the extremely sculptural form of drawing by which he established the boundaries between adjacent colors. Most noticeably in the great "decorative" period around 1910, in pictures like *Dance*, he used sculptural contour drawing to contradict the flatness of the color areas on each side of the contour, pulling illusionism away from the surface in the contrast between a sculptural contour and its spatially discontinuous (flat) interior, and then returning it to the surface as one's eye carries over the contour to the flat exterior beyond. As Moffett observed, this was precisely Louis's method in the Veils.

It was a method that linked Matisse to the Motherwell of the Elegies and to the Pollock of the black stain pictures, both of whom also used the contradiction of sculptural contours and flat surfaces to open space in flatness and to provide the traditional authority that imagery brings,

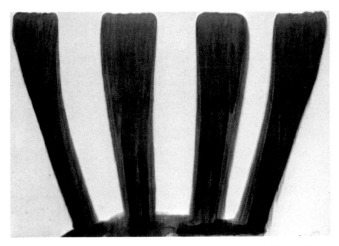

Morris Louis. *Crown.* 1958. Acrylic resin on canvas, 8′ 3″ × 11′ 11″. Private collection

but without isolating the imagery on top of that flatness. Louis must have used masking of some kind to establish the firm contouring of his images. Their interiors tend to read as if slightly behind the surface. The firmness of the contouring advances them to the surface. At the same time, the flattening effect of the staining counteracts the plasticity of the contouring, for staining permitted Louis "to describe a firm and regular edge without having it become a *cutting* one as it would on a non-absorbent surface: the slight, hardly visible bleed left by soaking serves to deprive an edge or contour of sharpness but not necessarily of clarity or firmness."[32] Besides, the canvas is perceived as running continuously through the contour. As a result, whole sets of polarities coexist in these remarkable pictures: clarity and complexity, three-dimensionality and flatness, rigid frontality and soft depth, imagery and alloverness, mass and luminosity, linearity and space.

THE MODULAR IMPLICATIONS of the bronze Veils with dark panels at each side led Louis to produce what might be called panel Veils, where the veil shape is broadly divided into four or five upright zones. In making these, Louis abandoned the diagonal and jagged drawing of the bronze Veils and poured paint only from the top of the canvas, thereby providing a form of vertical drawing comparable to that of the broadly divided triadic bronze Veils but without their linear qualities. If the panel Veils are less successful than the preceding ones, it is not only because they contain less rich incident. It is also because Louis had difficulty knowing quite how to articulate the interior of each panel. If too evenly and individually filled it would tend to separate from its neighbors; if the opposite, it would seem somehow too tentatively formed. Two different, but parallel options existed: either assert the separateness of the panels by actually pulling them apart, or assert their similarity by multiplying them and keeping them together as a whole. The first option produced split Veils where as many as four narrow panels are pulled apart from each other with more bare canvas in between, their tops usually rounded, and their lower extremities set on a puddled-paint base. These are extremely dramatic paintings. However, they suffer from seeming too much to be images, while additionally reinforcing the fact that the success of Louis's art crucially depends on his avoiding an identification of mass and line. Once he began consistently pouring lines of paint, it became extremely important that these lines did not appear to have mass. They do in the split Veils. Their darkness and density make them problematical.

The panel Veils were painted before September 1958, the split Veils both before and after that date. Before continuing to look at the other option suggested by the panel Veils (multiple striping), let us consider another development from the bronze Veils, prior to September 1958. In this development, instead of emphasizing their modularity and verticality, Louis effaced them by making holistic, monadic Veils. Again, the paint was poured only from the top, but was allowed to fall in jagged patterns. The most successful are those where there are sufficient poured layers to give density and richness to the single plane (but not so many as to make it opaque) and where the sides are sharply pulled in to emphatically shape it. Those with fewer poured layers suffer from the same tentativeness as some of the panel Veils. Those with more gently sloped sides insufficiently disengage the planar image from the rectangular plane of the canvas. In both cases, the potential problems with these kinds of pictures are associable with the singleness of their images, which had either to be dramatized or divided to avoid visual monotony. In a few pictures, among them *Bower* (page 105), Louis darkened the right-hand quarter of the veil to

modify its spatial evenness, thereby also adding weight and dignity to these quietly contained works; and in others, he emphasized their singleness with high-keyed color, reducing the density of the covering dark scrim in order to reveal it.

At this point, Louis conflated the allusiveness of these streaked and atmospheric pictures with the modular order of the panel Veil conception in a group of monadic Veils made from the multiple striping of either parallel pours of paint—as in *Beth Rash* (page 107)—or parallel flamelike configurations, achieved by pleating, contained by a dark scrim. What is unusual about these extremely poetic works is that the spatial position of the scrim is actually expressed as lying on top of the image formed by the multicolored stripes or flames. Whereas in the bronze Veils (and in other monadic Veils), the scrim can only very exceptionally be perceived separately from the veil image—for it is what binds together that image and the detailing it contains—it now seems to comprise "a cascade of thin mist that pours from the figure, obeying the force of gravity which the figure defies."[33] Since the modular pours of paint so exactly comprise the image, they seem to rise with it. Louis therefore provided another surface of paint *on top of* the image, in which the force of gravity is reasserted. The misty quality of this layer is attributable to the aerial thinness of its application, which allows the bright colors underneath to show through more, while blurring them atmospherically at the same time. The pictures of this type mostly date after September 1958.

Once again, two options suggested themselves, which Louis pursued late in 1958 and (mainly) in 1959. One involved development of the layering idea. In a group of large 1959 paintings—including three great masterpieces: *Number 1–89*, *Mem*, and *Saraband*—he drastically reduced the density of the scrim, allowing extraordinarily rich and emotive color to show through.

Number 1–89 (page 115) uses the jagged, base-pleated drawing of a bronze Veil like *Loam* (page 101). Freed from the containing, stiffening darkness, its drawing appears to flare up the surface: the "wall of gaseous yellow expands like a giant flame."[34] The organic metaphors suggested in all of the Veils by Louis's manner of working here assume transcendental aspects. The picture evokes the first fires of creation or some molten core of natural energy. It has been compared to Turner's late pictures,[35] and also bears comparison with Still's work, seeming, in effect, to be an X-rayed Still. Whereas the most intense color in the bronze Veils was often reserved for the sides and top, here the top of the veil is cropped off and the most intense color appears at the sides and bottom. The scrim is carefully applied so as not to cover the vivid flames at the base of the work, and since it comprises not a black or brown but a reddish purple scrim, it is carried just beyond the sides of the veil where, sedimented on the surface of the bare canvas, its own high-keyed color becomes most noticeable.

Mem (page 117) returns to the side-paneled format of a bronze Veil like *Golden Age* (page 99). Here, however, the interior of the veil is left exhilaratingly open, and spatially warped by the unequal pressure of the dark uprights at the sides. More than in any previous picture, the image quotient is effaced to produce what reads as a wall or sheet of color that is stretched and pulled outward. Nevertheless, the grandiose symmetry and heraldry of its design, showing through the glowing wall, reasserts its iconic force. Like all the other Veils, it evokes both a thing in nature (a cliff or an aurora, perhaps) and a vitalist "becoming" of nature, while refusing the specificity of either association—refusing the first in its mural-like spread, which resists centralization, and

therefore the containment and density of worldly things, and refusing the second in its own intrinsic tangibility as a painted thing.

Saraband (page 111) reasserts the sense of detailing provided by the bronze Veils. It may well be contemporaneous with the unveiled triadic picture known as *Blue Veil* (page 109), for they share loosely flapping wings at the sides—also reminiscent of those in a 1954 picture like *Salient* (page 87). In both *Saraband* and *Blue Veil*, Louis seems interested in redefining the relationship of the veil image to the sides of the support by pouring waves of paint into the picture from the sides. In *Blue Veil* they are broad, few in number, of the same blue color, and produce an irregular contour; in consequence, they function similarly to those in *Salient*: that is to say, suggesting a Pollock-like slackening of intensity of incident toward the edges. In *Saraband*, however, they are narrow, multiple, multicolored, and sweep into the picture one directly above the other down the sides; in consequence, they function similarly to the side-placed uprights in *Mem*, that is to say, suggesting an intensification of pictorial force toward the edges. They are somewhat more densely covered by the scrim that covers this picture—or, rather, as Michael Fried has observed, that seems to billow in front of it.[36]

As I said earlier, the chronology of the Veils is not certain. However, it is reasonable to assume that their development in 1959 led increasingly to the use of modular striping. Certainly, the last distinct group of Veils, the smaller pictures known as Italian Veils (because they were first exhibited in Italy),[37] is based on that method. And the method was subsequently extended in those pictures of late 1959 or early 1960, where Louis finally dispensed with the covering scrim, revealing linear pours of intense color either overlapping each other, as in *While Series II* (page 125), or laid down side by side with narrow crevices of bare canvas between them, as in *Where* (page 127). The Italian Veils retain the scrim. However, they use it discretely. Whereas earlier monadic Veils with modular striping had emphasized its atmospheric properties in order to soften the underneath structure, the Italian Veils emphasize its flattening potential, and with it the relationship of the veil shape—as a flat plane—to the flat plane of the support. This option to layering which emerged from the modular monadic Veils also produced some expressively shaped veil images—among them, the marvelous vertical, *Beth Chaf* (page 113)—but it tended, by and large, to lead Louis away from the steep-edged images that had dominated his art since the conclusion of the bronze Veil series. Almost all the Italian Veils contain images more rectangular in shape than in any previous picture.

I referred earlier to the danger in this approach: that the image might seem insufficiently disengaged from the rectangle of the picture itself. In making this group, however, Louis strove for greater congruity of image and support, using the verticality of the internal detailing and of the sides of the image to tie both inside and outside of the image to the picture's edges—even to the extent of asking us to read the strips of bare canvas that abut the picture's edges as parts of the module from which the image is composed. In this respect, they relate to Veils like *Mem*, where Louis also sought to dissipate the imagist aspects of the veil format. Unfortunately, it did not quite turn out that way in some of the Italian Veils, which tend to read as discrete planes standing on the bottom of the picture surface, even in front of the picture surface. This is partly a result of the very rectangularity of their imagery, which the eye quickly picks out as a surrogate picture plane, disengaging it from the actual picture plane, which falls transparently away; and partly a result of their smaller size, which means that they can be more quickly grasped as

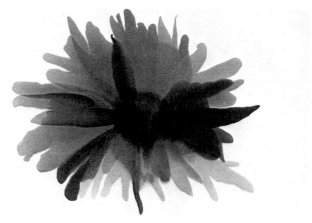

above: Morris Louis. *Spawn*. 1959–60. Acrylic resin on canvas, 6 × 8′. Collection Lady d'Avigdor Goldsmid, London

opposite: Kenneth Noland. *Flutter*. 1960. Oil on canvas, 67 × 67¼″. Collection Agnes Gund

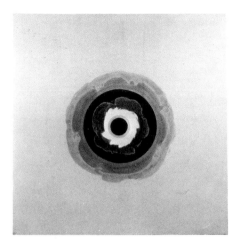

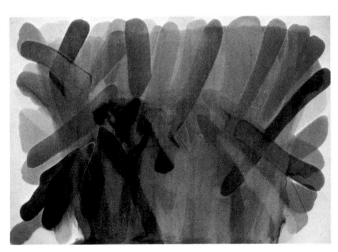

Morris Louis. *Number 99*. 1959–60. Acrylic resin on canvas, 8′ 3″ × 11′ 10″. The Cleveland Museum of Art, Cleveland, 1968

discrete images than pictures which occupy more of the visual field.[38] It was probably to compensate for the sense of tactility that accrues to them for these reasons that Louis lightened some visually by the simple expedient of turning them upside down.

The best of them, in any event, are not only as authoritative as any earlier paintings but also more inherently abstract. The symbiosis of image and support, when successful, together with the sheer simplicity of the conception—which allowed Louis to set down colors very frankly beside each other and bind them together in vivid, luminous sheets—produced pictures whose logic seems somehow more purely visual than almost any since the 1954 Veils. As in the earlier series, this meant that Louis could work on a smaller scale. While more modest pictures than the grand, epic works that preceded them in 1958 and 1959, the Italian Veils are extremely concentrated pictures. Not only do they conclude the second Veil series, but they also mark the point at which Louis can no longer be considered an Abstract Expressionist artist.

And yet, the temptation to draw too firm a dividing line in Louis's career after the Veils should be resisted. If the development just recounted shows anything, it is that no single conception dominated Louis's art after he finished making the bronze Veils. He, in effect, dissected, redistributed, and reordered features latent in the bronze Veils.[39] This led him into several parallel directions, which he began to explore in the Veils he made after the bronze group, and which he continued to explore after his first French & Company exhibition in New York in April 1959 until the summer of 1960, when the first Unfurleds were made. After April 1959 he explored them with a greater freedom than hitherto, which is also to say with less discipline. This led him into more directions, a number of which were dead ends, and none of which were as productive as those he had recently explored, until he discovered the format of the Unfurleds.

I referred earlier to the pictures where Louis uncovered, in effect, the linear pours of intense color that lay beneath the modular monadic Veils. One of the earlier of these, *While Series II* (page 125), comprises colored "fingers" laid down on top of, as well as overlapping, each other to produce, purely from these modular units, something akin to the spatial layering created by the covering scrim in earlier modular monadic Veils. It is known that pictures of this kind were in existence by the spring of 1960; whether this one was painted before or after the Floral series is a matter of speculation. But the Floral series does develop this kind of spatial layering, accentuating the tangibility of its modular components in the process. Louis began to build constructions, as it were, from these modular components, crossing and interlocking them, at times leaving them anchored to the bottom edge of the picture but more often allowing them to drift in toward the center. In this respect, they recall some of the 1954 Veils formed by overlapping gestural pours of paint roughly centered across the canvas. The best of them are glorious pictures, coloristically extremely rich and full of dramatic incident. However, they do suffer for the same reason as the comparable 1954 pictures; the overlaid pours are inescapably Cubist because each can be separately read as a shape, and are inescapably physical because they are self-evidently flung on the canvas, for which reason they seem also somewhat arbitrary (alternatively, somewhat contrived).

In order to bind them more decisively together, therefore, Louis drastically accentuated their centering, influenced in this respect by Noland's 1958 concentric circle pictures. Some of the Florals were shown at Louis's March–April 1960 exhibition at French & Company.[40] It was presumably after that exhibition, then, that Louis made the generally superior Aleph series

pictures. Here the poured swathes of paint seem to radiate from the center rather than drift in toward it, this effect being emphasized by the broadening of the swathes near the edges of the picture, by the Noland-like suspension of the whole image, and by Louis's marking the center by an oval-shaped veil of darker paint from which the colored swathes seem to emerge, just as they did around the perimeters of the Veils themselves. In some of the pictures, however—for example, *Aleph Series V* (page 133)—the image is not floated but anchored to the bottom edge, with colors emerging on only three sides. Here, the comparison with the Veils is even more evident. It was possibly at this time that Louis made the imposing picture called *Beth* (page 129), which conflates the effect of a highly colored 1959 Veil and of a bottom-anchored Aleph by covering the roughly centered earlier pours of paint with a vivid red veil shape.

If the chronology of these pictures is as I have presented it, Louis, having begun by attempting to uncover color from the Veils and structure his pictures purely from juxtapositions of color, had returned to a method close to that of the Veils. While the Florals are generally less successful than the Alephs, some of the simpler Florals (page 131) do make color perspicuous and present to us in a way unlike any previous Louis picture. Color spreads openly across the surface as flat surface color, reflecting rather than exuding light, and impresses less by its homogeneity than by its contrasts and differences. This ultimately Matissean concept—construction by means of color—was the one to which Louis subsequently tended. And while Noland's use of intense color undoubtedly helped Louis in this direction, he was more specifically helped by the influence of Newman and Still. Most of the remaining 1959–60 transitional pictures can be categorized according to their dependence on one or the other of these influences—and according to how these pictures are extrapolated from the Veils, although they emphasize color in a way that the Veils did not. The Newman-influenced works developed the modularity of the Veils and the regularity of their drawing; the Still-influenced works, their layering and the jagged irregularity of their drawing.

Newman's March 1959 French & Company exhibition immediately preceded Louis's. But Louis had already met Newman prior to that date, and if he had not seen Newman's paintings in the original before then he most probably saw them reproduced in the summer 1958 issue of *Art News*. Newman's influence can be seen in the deadpan division down the center of some bronze Veils, in the monochrome planarity of the later Veils, and in the repeated columns of Veils like *Mem*. However, these are subdued and absorbed influences. What followed in 1959–60 was very different indeed.

The explicitly Newman-influenced works emerge from pictures like *Air Desired* (page 123), a late 1959 symmetrically split modular Veil with extremely regular drawing. In a sequence of pictures which presumably began immediately after this one, Louis ran through a whole set of compositional variants. He further opened the center by pulling the two veil elements to the sides, discovering a tripartite format with a veil-like tapering shape of bare canvas between two multicolored wings. He tried flattening the side shapes with the same evenly applied color, then filling in the center shape too with a different color. He tried further dividing a picture into five tapered zones, then filling in the zones with more loosely applied paint. He compressed the center zone and regularized its drawing until it became a stripe or a band of bare canvas between two differently colored planes. He multiplied these colored planes in irregular bands of color running down horizontal canvases, at times contouring the bands with Still-like jagged

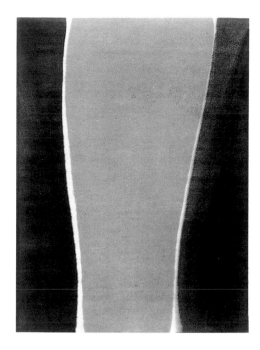

above: Morris Louis. *Taper and Spread*. 1959. Acrylic resin on canvas, 8′ 9″ × 6′ 4″. Private collection

below: Morris Louis. *Roseate*. 1960. Acrylic resin on canvas, 6′ 10¼″ × 8′ 9¼″. Greenville County Museum of Art, Greenville, S.C. Acquired in memory of Betsy Dew Ashley with funds provided by her friends and The Liberty Corporation and a donation by Dr. Marcella Brenner

opposite above: Morris Louis. *Ambi III*. 1959. Acrylic resin on canvas, 7′ 4″ × 11′ 8″. The Fort Worth Art Museum, Fort Worth. Gift of Marcella Louis Brenner

opposite below: Morris Louis. *Omega IV*. 1959–60. Acrylic resin on canvas, 12′ × 8′ 8⅜″. Private collection

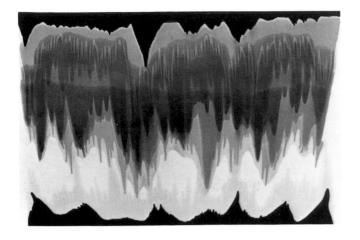

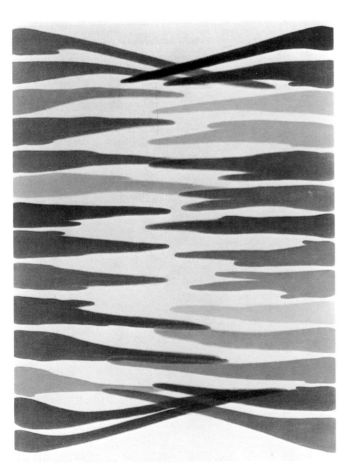

edges. He oriented some diagonally across the pictures. And, simplifying them, he returned to the tripartite, Newman-like format of a centralized band, but reversed the figure-ground relationship. Instead of providing a band of bare canvas between two colored planes, he laid a single colored band down the center of an otherwise bare canvas. This band was constructed, in fact, from a few separate pours of the same (or very similar) color paint, which overlap to produce the effect of an extremely narrow monochromatic veil. In some of these Column pictures, Louis accentuated this effect by leaving the top of the column of paint just visible below the top framing edge. In most, however, he cropped into the column along both top and bottom edges. And in some of the pictures of both types, he cropped in the sides leaving only narrow margins of canvas to the left and right of the column. A selection of the earlier works of this whole series was included in Louis's spring 1960 exhibition at French & Company. The Column paintings, however, were probably made after that date. Louis first showed them to Greenberg in August of that same year.

The Columns are undoubtedly the best of these Newman-influenced pictures, and of very great interest for our understanding of the genesis of the Stripes, including their use of active cropping for compositional purposes. And yet, they are hardly inspired pictures. They show Louis addressing an alternative form of centering to that of the Alephs. By confrontationally facing the viewer, the centered column both locks his spatial entrance into the picture and causes the picture to open out laterally by rendering the side edges less conspicuous.[41] That, at least, is the logic of Newman's use of the device. With Louis's pictures, however, the stained columns seem too separately contrasted against the bare ground, whose side edges tend simply to disappear visually. He attempted opposing two columns across the center of the picture, placing each close to the framing edge, and in a related development opposing two sets of twined columns in a similar way. But in these, the spacing of the columns and their relationship to the side edges seems chosen not willed. Like the Column paintings themselves, they lack that sense of inevitability that marks the best of Louis's art.

If Newman's influence led Louis to make some dull paintings, Still's led him to make some outrageous ones. According to Greenberg, Louis's interest in Still amounted to an obsession at times. We have noticed its effect on the jagged drawing of the bronze Veils and of later, highly colored Veils like *Number 1–89*. As part of Louis's 1959–60 dissection and analysis of the Veil format, he began exaggerating the sharpness of Still's drawing and the layering of the paint areas it bounded. The Fantasia-like pictures, now known as the Saf and Ambi series, that resulted are undoubtedly failed works. Greenberg has stated that Louis repudiated them as firmly as he did those made between the 1954 and 1958–59 Veils.[42] Their only interest is historical in showing how Louis, as he unveiled the highly colored jagged layers ranged one above the other, discovered that their peaks appeared to point both down and up the picture. From this realization emerged the Omega series in which individual jagged pours of paint, ranged side by side down opposite edges of the picture, symmetrically face each other as they reach into an open center. It seems certain that they were originally conceived in a horizontal format (which associates them with the Ambi series) and that Louis was dissatisfied with this orientation, for he considered cutting one in half, which would have produced two pictures similar in some respects to late works like *Where*. None were exhibited in Louis's lifetime, so the vertical orientation now accepted for them is necessarily conjectural. However, not only does it make for better paintings but it was the only

reasonable alternative left to Louis other than keeping them horizontal or cutting them in half.

Although by no means of a class with the finest of Louis's pictures, the best of the Omegas are not only interesting historically.[43] The range of separately applied colors combines and intermingles the earth tones of the earlier veil shapes and the more high-keyed hues that appeared at their edges, and adds new pastel shades which serve to mediate between them. The eye is carried both up and down the parallel pours and from side to side across them; during the latter movement, the surface of the picture seems to swell outward because of the perspectival effect of the drawing. The idea of opposing two roughly symmetrical groups of roughly parallel elements so that the center remained open was certainly a compelling one. Along the edges the separate identities of the colors are most visible; nearer the center they optically vibrate, dissolving their separation as they do so. And yet, once more, there is something not quite inevitable about these pictures. The cropping of their sides seems somewhat arbitrary; the horizontality of their drawing over-echoes the upper and lower edges, visually compressing them; and their color, while finely paced and articulated, is somewhat bland in its total effect.

These pictures probably date from the winter of 1959/60 or the spring of 1960. Throughout this period, Louis seemed concerned with finding a format that would allow color a truly structural role in his pictures, one that would permit multiple tonal changes in his use of color, which is the necessary result of color applied in high intensity. Whether or not the later Veils like *Where* preceded or followed the Still-influenced and Newman-influenced developments just recounted, both of these developments carried Louis hardly any further along to making color-structured pictures than these last Veils. But they did suggest new compositional possibilities.

At this point, the chronological logic of Louis's development is especially difficult to fathom. He tried reversing the centered Aleph format and conflating it with that of the Omegas by pouring points of paint into the picture from all sides, leaving an open center. He also tried opening out the components of the twined columns by pouring streamers of paint into the picture from the sides and from the outer limits of the top edge so that they twined very loosely together around an open center. And, possibly thus reminded of how he had treated the sides of *Saraband* by pouring in paint diagonally, as well as recalling the format of the Omegas, he began isolating sequences of parallel diagonal pours by laying them down in single sets of four or five lines; putting two such sets down side by side, reversing the direction of each set to form a tepeelike image, arranging two sets so as to form one diagonal direction with a blank vertical strip of canvas between them, pointing two widely separated sets toward the opposite bottom corners of the canvas, and any number of combinations of these methods. Then, having almost exhausted the options available to him, he poured two such sets down and into the canvas, one from each side.

It is impossible to know if this solution was the last he arrived at or if it was arrived at independently of the others. (It could have simply been noticed in some of the more complex permutations of other approaches: for example, in the center portion of a picture that comprises two tepee-shaped configurations.) In any event, it was an inspired solution. Instead of worrying about composing, about integrating the various banks of drawn paint, and instead of seeking a centered lock to hold them together, Louis effectively dragged the components of his pictures apart and left it to the framing edges to keep them together. Louis considered these pictures, the Unfurleds, his most ambitious works.

4

Conception, development, and Symbolist
associations of Unfurleds of 1960–61; conception
and development of Stripes of 1961–62

THE VERY WORDS we use to describe fully realized works of art—unity, wholeness, cohesion, integration—refer to the addition of their components, whether many or few, in such a way that they combine as one. They also carry moral implications: whatever is made whole has integrity, soundness, honesty. Insofar as many modern works of art present themselves as parts tangibly assembled to make a whole (rather than, as in earlier art, a somehow preexistent whole made up of parts), their integrity is manifested simultaneously with their structure. The object of their structuring—its subject, even—is the creation of that integrity. This is one of the ways in which aspects of technique assume heightened importance in modern art. While technique is also important because it can actually act as a means to inspiration, its significance in the sense I refer to here is different, though not unrelated. Insofar as we recognize in the structure of the work of art that it is a hand-fabricated thing, technique evidences its very humanity: the working hand is the moral center of the art.

This helps to explain why Cézanne's block-building conception of painting, for example, has exerted such a powerful hold on modern art. It seems intrinsically more serious, more humanly manifested, than forms of painting where we are given less visible evidence of how the picture is made, including the time taken to make it. In this respect, it offers a modern equivalent of the seriousness traditionally imparted by sculptural modeling, which, by dissection and reassembly of its components, Cézanne attempted to match in seriousness. It also helps to explain why overtly expressionistic art periodically asserts a fascination. Here, the actual struggle of building a picture is expressed, a struggle whose combatants are not only the parts of the pictures but, more broadly, the personality of the artist and the artistic, impersonal means at his disposal. In addition to revealing the constructional and temporal aspects of the picture's creation, it reveals peculiarly mortal aspects, which pertain to the fragility as well as specificity of the artist's hold on his expressive means and to the evanescence as well as literalness of personal feeling itself.

It may even be said that this struggle constitutes the modern equivalent to traditional subject matter, that it replaces the pre-modern dilemma of how the work of art can possess the outside world with the modern dilemma of how an artist's feelings can be possessed in the making of art. And yet, this is to draw too firm a dividing line between modernism and the past. It also neglects the fact that modernism frequently conflates these dilemmas—as in Matisse's desire to possess in works of art his feelings for the outside world when modernism in art was emphasizing the autonomous identity of art and therefore its (and the artist's) alienation from the world (and from the artist in the world, too). In this respect, overtly expressionistic art is a representation of the terror of this isolation, as Stanley Cavell put it, rather than "a representation of the world from within the condition of isolation itself."[1]

Louis's art does manifest the outside world. It does so from within that condition of isolation to which Cavell referred. It also clearly manifests, in the self-evidence of its fabrication, that it is a man-made, humanly felt art. And yet, very often the constructional, temporal, and mortal aspects of pictorial creation, which most clearly assert its moral seriousness as a humanly felt manifestation, are minimized, even effaced, in Louis's art. The Unfurleds and Stripes are especially problematical in this regard. We do see that they are constructed, that they are temporally constructed, and that they are mortal constructions. But none of these features has particular aesthetic or pictorial significance when we see them. Indeed, the very integrity of the Unfurleds and the Stripes, even more than of the Veils, depends crucially upon Louis's suspending

our perception of these things. It is precisely because their part-to-part structure is "nowhere evident, or nowhere self-declaring" but, rather, "self-cancelling,"[2] because the temporality of the process that created these works is not perceived as such but sublimated in the instantaneity of their reading; and because they show no evidence of struggle between the demands of art and of personal feeling but, rather, assert the abstractness of their inspiration,[3] that the best of them succeed as fully realized, integral works of art.

In the Unfurleds (pages 135–145), even that most basic correlative of integrity—the holistic bonding of parts—is utterly opposed. Instead of integrating the picture by putting the parts together, Louis separates the parts, throwing two opposing banks of multicolored rivulets against the opposite sides of the picture.[4] Wholeness (and thereby integrity) is discovered in this method, but it is a method so contrary to most earlier procedures that the kind of wholeness is necessarily different from that achieved by earlier art. Certainly, these were the most radical, most extreme paintings to have been made since Pollock, Newman, and Still developed their characteristic styles. In many ways, these are more radical and extreme. They do not contain anything that can be considered imagery, not even in the way that configurations within Pollock's, Newman's, and Still's paintings—or Louis's own Veils—can be so considered. There is nothing *within* these pictures at all: their centers are literally empty.

None of this, of course, makes them intrinsically better or worse pictures than less radical ones. While it is true that innovation is regularly called for in any art in order to maintain its expressive possibilities, it does not therefore hold that it can always maintain them at the same intensity. In modern art, moreover, what sometimes seems most avant-garde is actually academic (Symbolist painting was the first example of this), and what seems conservative is sometimes more deeply original than the avant-garde styles that surround it (Matisse's painting in the 1920s was the first clear example of this). In fact, it simply cannot be assumed that important art will look new and remarkable. To say that it tended to look that way until the end of the pioneering days of modernism and tended to look that way again when modernism was drastically overhauled in Abstract Expressionism is, I know, tautological. And yet, it is to suggest a distinction between the kind of innovation that truly reorders and reimagines the traditional expressive possibilities of the past and the kind that, by seeking simply to escape the tradition of the past, is doomed merely to copy it. For to actually set out to break with tradition requires an arrested notion of what tradition is, and such an approach inevitably leaves tradition untouched: it never opens it to revision in the first place.

I have hitherto argued for the traditional nature of Louis's art. At the same time, I feel free to turn around and say that the Unfurleds break drastically with tradition, but they do so not as a matter of program or intent. We have already seen how their format was intuitively discovered in the sequence of options that Louis explored after the Veils. The question remains whether or not they successfully match, in their extremity, what Louis had already done, not to mention what had been done by others before him. Greatness suggests something deep as well as intense; at first sight, the Unfurleds (and perhaps the Stripes even more) may seem too concentrated, too circumscribed, to qualify. All art, however, imposes restrictions, and modern art especially has often made its restrictiveness into a virtue; isolating a narrow field of inquiry, it mines it deeply, reminding us that, in the end, it is intensity not multiplicity of meaning that counts.

It is indisputable, nevertheless, that much modern art, including much modern abstract

art, does seem to be thin and impoverished when compared to the art of the past. In an essay called "Abstract, Representational, and so forth," written in 1954, Greenberg suggested that if we do feel dissatisfied with abstract art, this dissatisfaction has its source not so much in our nostalgia for the representational as in our regret for the absence of three-dimensional illusion, an abstract picture seeming "to offer a narrower, more physical and less imaginative kind of experience than the illusionist picture."[5] He continued, however, by saying that perhaps the literalness of modern abstract art may come to be seen as offering an equally imaginative experience, if not one of more "human interest" than the extrapictorial references of older illusionist art; and, also, that the illusionism of older art may come to be seen as "aesthetically valuable *primarily* because it enabled and encouraged the artist to organize such infinite subtleties of light and dark, of translucence and transparence, into effectively pictorial entities."

Viewed historically, this argument provides a justification for the post-Cubist aspects of Abstract Expressionism, whose new form of illusionism cast new interpretive light on older illusionist art. The commonality of aesthetic intent, thus justified, between older and newer illusionism may be extended to include Louis. At the same time, there may be an alternative source of dissatisfaction in abstract art in that, after all, we do miss the multiplicity of meaning offered by earlier art and that we do so to the extent that abstract art is purely abstract. As I observed earlier, what differentiates Louis's pictures from previous modern abstract pictures is that their meaning cannot readily be traced back to forms beyond their own perimeters. Their pictorial elements do not refer to the world to tell us of their derivation, as is the case with even the most abstract Miró, say, and (ultimately) with every Mondrian—even every Pollock or Newman or Still, which also have worldly sources, although they cannot be readily apprehended except through knowledge of these artists' early, immature work.

It would seem to follow that the range of meaning in Louis's art is narrower as compared to these, but in practice this is not the case. The actual experience of the work of these artists— except Miró—is very little different insofar as perception of their worldly sources is concerned. Indeed, it even seems that while their work is more distanced from the world than Miró's, it returns us more quickly to a whole world because it does so less specifically. Meanings therefore accumulate not around the pictorial elements themselves but around their configurations and interrelations, and do so to the extent that individual pictorial elements actually refuse to be read as meaningful in themselves. When successfully realized, abstract works of art of this kind can make us forget the older method of accumulating meaning, indeed, can make us rejoice, in its absence, in the largeness and singleness of their view of the world.

This brings us back to Greenberg's emphasis on illusionism, in particular to the disembodied illusionism of post-Cubist forms of Abstract Expressionism, wherein the absence of sculptural modeling effects a sense of release from the tangibility of specific things into the wholeness of a spatial continuum. It takes us, in fact, even further back to Impressionism, when suppression of tonal contrasts and emphasis on color were first established as the principal modern methods of remaking the world as whole. Since then, avoidance of tonal contrasts (which identify and separate things in the world, and in art dramatize them) and concentration instead on color (which masks tonal contrasts in the world, and in art recovers the world from dramatization) has been the often precarious path to achieving aesthetic distance from the practical world and to representation of the wholeness of the world, simultaneously.

Wholeness, however, and its corollary—meanings accumulated around the interrelationship of pictorial elements—are precisely what Louis's Unfurleds challenge. Their absence of holistic bonding removes them from possessing the older kind of pictorial integrity and moral seriousness; and the even more absolute abstractness of the Stripes offers only the most tenuous and generalized of worldly human meanings. To reply that the Unfurleds react historically to the way in which integrity and seriousness could be, and were, faked in late 1950s forms of Abstract Expressionism—and that the Stripes consolidate their emphasis on the aesthetic (which takes them further from the practical world)—is only part of an answer, and not a lasting part. So is the reply that no kind of art is invariably or intrinsically superior or inferior to another kind.[6] The questions remain as to whether the new order of the Unfurleds and the new abstractness of the Stripes do, in practice, produce as telling kinds of art as what preceded them, or art as capable of being sustained. Both questions are inextricable from additional ones concerning our perception of the quality and feeling conveyed by the works at issue—which is also to say, our perception of whether they do accumulate meaning—and of their historical position.

THE UNFURLED SERIES comprises approximately 160 pictures (if one includes the 26 "proto-Unfurleds" where Louis discovered the definitive Unfurled format and 40 pictures he destroyed because the blues were not fast) made sometime between the early summer of 1960 and early 1961. They were certainly not begun until after Louis's March–April 1960 exhibition at French & Company, nor until the end of the sequence of transitional pictures described in the previous chapter (most of which were also presumably made after that exhibition). In April 1960 Louis first obtained his Magna color in newly formulated batches in gallon cans; the syruplike liquidity of the new paint undoubtedly facilitated the production of the Unfurleds. While he was already moving toward linear, rather than area, staining before he obtained the new paint (for example, in *Where*), it is likely that the liquidity of the paint encouraged him to move further in this direction. (After this, he never mixed his colors, but only added resin or turpentine thinner to control their saturation from pale or transparent to intense or opaque and to vary their texture from matte to glossy, thereby enlarging the range of the twenty-two colors he used.)[7] In July 1960 he began complaining to his canvas suppliers about the dark flecks that marred the whiteness of the cotton duck. This suggests that the Unfurleds (or at least, the proto-Unfurleds) were begun by then. (He subsequently used an expensive cotton duck that was of higher quality as well as of lighter weight and therefore more absorbent.) In August 1960 Louis first showed the Unfurleds to Greenberg, who chose two of them for an exhibition of Louis's work at Bennington College that October. When Greenberg next visited Louis's studio, at the end of April 1961, he was first shown the Stripes.

The two Unfurleds chosen for Bennington—*Alpha* and *Delta*[8]—were the only two to be stretched in Louis's lifetime. Louis did not attend the exhibition. In fact, he never saw one of these pictures stretched.

The two Bennington pictures are the most painterly of a group of about a dozen pictures where four or five roughly parallel, graphically drawn pours (as in the proto-Unfurleds) stream diagonally into the canvas from its opposite side edges, the innermost pourings beginning just on or just slightly below the points of the top corners, and ending (in this group) approximately one quarter of the way in along the bottom edge. For reasons I will explain in a moment, the very

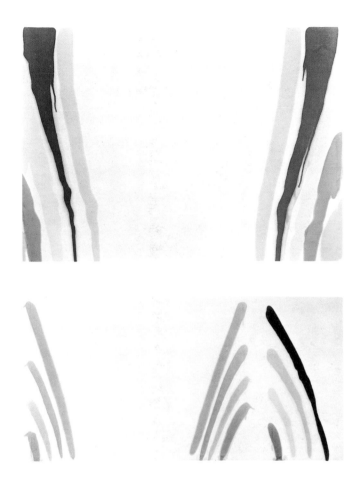

opposite: Barnett Newman. *The Beginning*. 1946. Oil on canvas, 40⅛ × 30⅛″. The Museum of Modern Art, New York. Given anonymously

above: Morris Louis. *Alpha*. 1960. Acrylic resin on canvas, 8′ 9⅝″ × 12′ 1″. Albright-Knox Art Gallery, Buffalo. Gift of Seymour H. Knox, 1964

below: Morris Louis. *Delta Upsilon*. 1960. Acrylic resin on canvas, 9 × 22′. Private collection

graphic drawing in this group of pictures tended to be less successful than the rivuletlike form in later Unfurleds. But when it is successful, preeminently in *Gamma Pi* (page 135), it somehow abstracts and intensifies the very intentionality of drawing as a product of human will in a way that the more automatic drawing of later Unfurleds does not, and in a way that would be even further intensified in the Stripes.[9] The tenseness of drawing in *Gamma Pi* is of rods bent and forced away from verticality, or imprisoning bars pulled open to allow escape into dazzling white freedom.

Pictures of this kind established the basic form of the Unfurleds: a frontal, bilaterally symmetrical composition whose painted elements abut an empty center resembling the negative image of a veil shape. The resemblance is emphasized in proportion to the evenness and tautness of contour of the elements, especially of the two innermost elements. When evenly drawn, they can be read as looming up and out (like a veil) as well as falling down and in. More specifically, once we acknowledge the upward reading in one bank of elements and visually cross the picture to confirm it, the innermost elements in confirming it carry upward the white space between them. At this point, the direction of flow at the sides seems to reverse itself, moving downward in opposition to the upward movement of the center.

The effect is not unlike that produced in the Veils by the contrast between the contour of the veil shape and the drawing of the elements within it. But here, the elements contrasted with the contour of the (now negative) veil shape are outside it, and the effect spreads to occupy the whole picture. To this end, the taut contour of, especially, the innermost stained element is crucially important since it holds each bank of elements together as a patterned, multicolored block separated from the blank, white, uncolored space of the interior. On each side, the contrast hinges on the taut inner contour of the innermost element, which visually swings back and forth between belonging to the element itself (and therefore the bank of elements it bounds) and to the space inside. It functions as does the contour of a veil; as such, it carries sculptural intensity, a fact which Louis capitalized on in later Unfurleds.

The way in which the innermost elements (and often their inner contours) meet the upper corners of the picture is also important, as can be seen from a very unusual work, *Alpha*, where the innermost two on each side fall within these corners. *Alpha* is an extremely imposing picture, reminiscent in some respects of a dramatic early Newman like *The Beginning*. Louis did emphasize the upper corners, but he did so by *spanning* each of them with the strongest tonal contrasts (of black and yellow) the picture contains, possibly because he felt the need to harness in the traces of his drawing the top as well as the side edges of the picture. If that was his intention, it seems fair to say that he need not have bothered. Simply marking the corner fulfilled that same function more economically, in fact, more precisely, for the innermost elements of *Alpha* tend actually to disengage the drawing from the very explicit relationship to the shape of the support achieved in typical Unfurleds, while causing the top edge of the picture to seem somewhat arbitrarily cut.

A few of the Veils, among them *Bower* (page 105), and a few transitional 1959–60 pictures contained drawing that reached out to mark exactly the uppermost corners. In the Unfurleds, Louis makes them even more important structurally than the bilateral symmetry of the drawing that engages them "as if symmetry alone were not sufficient to provide the explicit structural logic which the paintings themselves . . . seem to demand."[10] Whereas symmetry relates the

drawn elements to the shape of the picture support only at one remove, "the corners are nothing short of first-hand, immediate, physical features of the picture-support itself." With the Unfurleds Louis began explicitly to bond the drawn elements of his pictures to the shape of the picture support, finding new expressive possibilities in the lucidity, indeed the obviousness of this method. Its lucidity and obviousness make it reminiscent of Newman; so does the extent to which the quality of the works it produced lies in their conception.[11]

Many of the proto-Unfurleds had been painted with pale, rather disembodied colors, as if in an attempt to dematerialize the tangibility of their drawing, which looks right back to Louis's Miró-influenced pictures of the late 1940s, and beyond to Surrealism itself in the biomorphic connotations provided by its swelling and contracting along its length.[12] (Some of the elements in these pictures resemble tadpoles.) In the crisper, more regularized drawing of the Unfurleds, the elements call less individual attention to themselves and allow, individually, less associative readings. But since the Unfurleds are more intensely colored, the tangibility of their drawing is necessarily more evident—at least, in *Gamma Pi* and other pictures of that first group of Unfurleds where contours are extremely even. This is exaggerated when we see these pictures in reproduction, where it is difficult to see either the very slight bleed at the outer edges of each drawn element or the way that the paint (and the resin seeping beyond its edges) flattens the nap of the canvas, placing it literally below the level of the unpainted canvas. Nevertheless, the tangibility of the drawing in the first group of Unfurleds often causes it to seem merely implanted on the canvas and therefore potentially separable from it, and the pictures themselves to seem somewhat bland and inert in the sheerness of their symmetry, frontality, and interlocking of drawing and picture support. *Gamma Pi* only succeeds by the forcefulness of its drawing and by the equal spacing of its elements and the bare strips of canvas between them, an equality of darks and lights which both opens and closes the pictorial space and imparts a lively optical sparkle to each side of the mute interior.

In the more than thirty so-called broad-band Unfurleds (pages 135–139) which followed this first small group, Louis obviated the tangibility of their drawing by both broadening the elements and breaking the regularity of their contours, allowing them to run, as rivulets, more naturally and automatically down and across the canvas. As with the first group, they must have been made by somehow pleating the canvas to form parallel troughs along which the paint could run. Here, the troughs were obviously shallower, and presumably tapered toward the bottom of the canvas, for the bands nearly always become narrower as they descend. The subsidiary streams that divide from the main ones were presumably caused by the rush of descending paint partly spilling out of the narrowing troughs. Louis seemed able, to some extent, to control this effect by the degree, abruptness, and place on the canvas of the tapering, and by the amount and viscosity of the paint he put into each pour. He may well have also used a large swab to reach into the canvas and guide the streams of color. But it was a trickier method than that used in the first group; at times, one senses that it is not entirely under Louis's control, at others, one knows that it must have gotten out of hand. When it does work, however, the results can be breathtaking. Huge rivers of color flow easily over the surface, flatten into the surface, and color as color (as hue) is simply manifested in a way Louis had never previously achieved.

The four bands at each side of *Alpha Alpha* (page 137) contain two colors unique to each side and two shared with the opposite side. To the right, the two unique colors (green and red)

Morris Louis. *Alpha Eta.* 1960. Acrylic resin on canvas, 8' 8½" × 17' 7". Private collection

Morris Louis. *Alpha Epsilon*. 1960. Acrylic resin on canvas, 8′ 10″ × 19′ 4″. The Museum of Contemporary Art, Los Angeles. Gift of Robert A. Rowan, 1982

are from opposite sides of the spectrum and are paired below the shared colors (black and blue). To the left, the two unique colors (orange and purple) are from the same side of the spectrum (both associable with the red and dissociable from the green) and sandwiched between the shared colors. It is a wonderfully rich and evocative picture for all its starkness and simplicity. *Alpha Beta* (page 139) uses only two colors: two identical yellows surrounding a green on each side. Here, very exceptionally, the innermost bands descend from the top of the canvas. But since their yellows are tonally close to the color of the canvas, the eye tends to lock onto the greens below them whose top edges descend from just a fraction below the corners; and the innermost yellows float weightlessly, seemingly balanced and suspended not from the top but from some point midway down the surface where the bands come closest together. Color seems utterly nonphysical, purely visual, in this extremely limpid composition.

These, however, are among the very finest of the broad-band Unfurleds, which vary enormously in quality and contain only a few fully realized pictures. The problem, once again, was in their drawing. In the previous group, each element seemed drawn, but the limits of each element did not. Now, each element seems the product of natural forces, and therefore not drawn, but the limits of each element, being more noticeable than before, do seem drawn. Staining alone is not enough to offset their extremely graphic, stencil-like appearance. This becomes particularly bothersome toward the bottom of those pictures where the streams of paint split into branchlike configurations or enclose small pockets of bare canvas, calling attention to themselves and to the fussy optical flickers they create. In such instances, color loses its vividness as hue and is transformed to become part of a pattern of tonal contrasts. However, when Louis broadened the bands of color throughout—thereby accentuating color as hue by making it more visible—the pictures tended to become stiff and inert.

It may well have been at this moment that Louis briefly returned to a compositional variant that he had used in the proto-Unfurleds: arranging the two sets of diagonal pours so as to form one single diagonal direction with a blank vertical strip of canvas between them. These so-called Japanese banners bring the broader part of each element to the middle of the picture, and in so doing make color as hue literally more central to their reading. But these, too, seem somewhat overcalculated, as well as unduly dependent on the presence conferred by sheer size. (The best of this group approach twenty feet in length.) The same is true of the broad-band Unfurleds on an over-size format, which Louis probably made around the same time.

It was at this point that Louis was faced with a unique dilemma. He had finally found a format that allowed color to speak directly as hue in natural, automatically generated configurations. And yet, to the extent that he emphasized color, his pictures tended to become static. But if he applied the paint with greater freedom, to offset this effect, tonal contrasts reasserted themselves to such an extent as to hinder the visibility of the color. Additionally, more freely applied paint tended to be read only as falling down and into the pictures, thereby losing the possibility of creating that opposite movement which more evenly contoured elements could provide. But more evenly contoured elements are read as drawn, tangible things; they also sacrifice detail, which creates a static effect, albeit one in which color is more noticeable. In effect, Louis had to choose between giving either color or drawing full sway. If he chose color, it had to be at the expense of drawing; it meant using a form of drawing that called very little attention to itself. If he chose drawing, it had to be at the expense of color; it meant that

individual colors, their harmonies and contrasts, would receive less attention. He opted for drawing. However, the way in which he did also made color a more visually active part of his art than ever before.

In the so-called narrow-band Unfurleds (pages 141–145), each rivulet remains more-or-less constant in width as it descends the canvas, in this respect resembling those in the first group of Unfurleds. The width of each rivulet, however, is closer to that of the narrower, lower parts of the rivulets in the second group, and the kind of optical flicker produced in the lower parts of those pictures is produced by each bank of rivulets as a whole, which now contains not four or five rivulets but thirteen or fourteen. Louis accepted—indeed, capitalized on—the tonal contrasts produced by closely positioned, extremely graphically drawn bands of color interspersed by crevices of bare canvas approximately the same widths as the bands themselves. In many cases, he accentuated them by using tonally contrasted colors within each bank of rivulets. And whereas in the broad-band Unfurleds each pour of paint changes in configuration individually as it descends the canvas, in the narrow-band Unfurleds the whole group of thirteen or fourteen pours in each bank change configuration as a whole, dipping momentarily from the diagonal to the vertical, then resuming their diagonal movement at, usually, a slightly shallower angle until they meet the bottom edge of the picture, where each bank of colors occupies approximately one third of its width at each side. The effect is of two fluctuating multicolored zones silhouetted against the blank white center, which is mobilized by the drawing of the color that surrounds it, seemingly warping and billowing by the pressure applied along its perimeters.

One of the most remarkable aspects of these huge paintings—they average eight and a half by fourteen and a half feet—is the finesse with which Louis organized the multiple and meandering rivulets, never fully fusing them lest they appear a block or shape of color nor keeping them so far apart lest they speak as single and uncoordinated voices. They are orchestral in their effects. About a dozen of the approximately forty pictures in the group do contain rivulets that touch or overlap to varying degrees. These waterfall Unfurleds are phenomenally dramatic, but when the colors meet—especially when spectrally adjacent colors meet—they seem almost to describe adjacent sides of volumes, thereby forming individual clusters that disrupt the continuity of the banks of rivulets in which they occur. A sense of volume is suggested by the warp of the rivulets in the more typical pictures; however, it is suggested by each bank of rivulets as a whole. And while each rivulet is quite individual in its drawing, it is sufficiently like its neighbors to read in a modular way. Louis enforced such a reading by repeating colors within each bank, often calling attention to the repeat of the innermost color by sandwiching it between two darker or spectrally opposed hues. When he did place spectrally adjacent colors together it was to use their similarity to provide the effect of a rising or descending scale; and then he would abruptly end that movement with a tonally opposite or a complementary color, or with a sequence of such colors, at times only to reintroduce the scale (possibly in a reverse movement)—always preventing a single directional reading either in or out of the picture. It was important that the colors in each bank seem nonhierarchical in their arrangement, as if uncomposed, and that their structure be a "self-cancelling" structure "nowhere evident, or nowhere self-declaring." Otherwise, the holistic bonding of each bank would be compromised.

At the same time, Louis had to prevent each bank from seeming monotonously composed. Two, or sometimes three, colors in each bank were therefore usually allowed to jump visually by

Morris Louis. *Gamma Mu*. 1960. Acrylic resin on canvas, 8′ 6″ × 13′ 10½″. Stedelijk Museum, Amsterdam, 1970

opposite: Paul Cézanne. *Forest Scene.* c. 1900. Watercolor and pencil, 17¾ × 12½″. Private collection, Lausanne

Kenneth Noland. *Morning Span.* 1963. Acrylic resin on canvas, 8′ 7¾″ × 11′ 10½″. Private collection

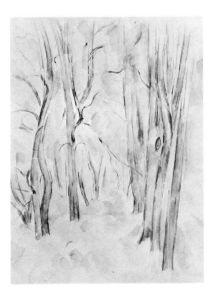

sharply contrasting them, either tonally or spectrally, with their neighbors. By and large, Louis used the same color—often yellow, because it was closest to the color of the canvas—to provide these breaks. Their pacing was important, and Louis usually dispersed them so that one occurred close to the inside of the picture, where the colors outside of it could be counted on to pull the eye over the break. In any case, they could not be overdone lest too many tonal contrasts overpower the force of the color. Yellows could not be allowed to dominate pictures for the same reason, and yellow became especially problematic when Louis used it for an innermost band since it tends to disappear visually, failing to cut out the blank center with sufficient clarity on the side where it appears, producing a somewhat lopsided picture. When Louis did use yellow in this way, he usually opposed it with a dark innermost band on the opposite side so as to force each bank of colors spatially apart, increasing the illusion of warp in the bare canvas between them. He was more successful, however, when he achieved this effect by the use of opposed, complementary hues for the innermost bands—as with the blue and ocher of *Sigma* (page 145) or the green and orange of *Alpha Lambda* (page 141)—and he achieved it most dramatically when he opposed the hues of the whole banks of color, as with *Beta Kappa* (page 143), where the reds and oranges of the left side face the greens and blues of the right, with only two greens on the left, two reds on the right, and two or three yellows on each side to hold them together.

Because the white canvas of these pictures is dominant, and because it infiltrates the banks of color, it could be made to unify often very complex relationships of color. The color, that is to say, could be as various as possible, and benefited from being so. Louis increasingly used earth and natural colors (like ochers, umbers, and leafy greens) among the prismatic ones. This brought new weight and authority to his pictures. The earth and natural colors broaden the affective range of these works and add an evocation of the outside world to the more artificial prismatic yellows, reds, and oranges especially. Black appears occasionally; only white was intrinsically unusable, for it would have undermined the white of the canvas as color, making it seem dull and shadowy. The white of the canvas functions between the other colors much as it did in Matisse's Fauve pictures (and Cézanne's late, watercolor-influenced canvases before them), as a breathing, unifying continuum. But the way that color is used across its whole emotive scale is more reminiscent of Matisse's work after 1914, including that of his Nice period. When Louis uncovered color from the Veils, he attempted to match the more decorative aspects of Matisse. But to follow the decorative Matisse in a purely abstract format is to risk simply glorifying color—something possibly ironic; certainly redundant.[13] Instead, in the narrow-band Unfurleds, Louis found his way back to those aspects of Matisse where color was far more obviously a means than an end. Fauvism, Matisse always insisted, was more than merely bright color. "That is only the surface; what characterized Fauvism was that we rejected imitative colors, and that with pure colors we obtained stronger reactions—more striking simultaneous reactions; and there was also the *luminosity* of our colors."[14] Louis, in effect, found his way back to those aspects of Matisse that link his art most closely to Impressionism, where light before color is the aim of representation and the unifying agent of picture-making. In the broad-band Unfurleds (as in Matisse's "decorative" pictures), light had been produced by contrasted areas of color; now (as in Matisse's Fauve and Nice pictures) color was submitted to light itself. Or rather, the narrow-band Unfurleds combine, in their effect, the simplicity and scale of the decorative Matisse with the optical vibration and luminosity of the Impressionist-influenced Matisse.

Very like the decorative work of Matisse is the bold tripartite division and expanded, unimpeded feeling these pictures possess. The eye slides across their centers with literally nothing to pin it down, then across the contours that mark their sides in the same Matissean way that the contours of the Veils mark their interiors. Whereas the center is large, open, and monochromatic, the sides are smaller, divided, and multicolored. Each is reminiscent of the Fauve Matisse, who said, "I was able to compose my paintings by drawing in such a way that I united arabesque and color," achieving "expression through drawing, contour, lines and their directions."[15] As in Matisse's Fauve pictures, the color arabesques retain the graphic bite, the optical vibrancy, and the rhythmical movement of drawing. They also retain drawing's innate capacity to suggest volume in their directional inflections—but a kind of volume (as in Matisse) from which the connecting tonal tissue has been removed. I referred earlier to how Pollock's allover drip pictures isolated and abstracted the components of traditional modeling—shadow, color, and highlights—in their black, colored, and aluminum skeins, and recombined them in such a way as to dissipate the sculptural from illusionism. The narrow-band Unfurleds do something similar, except shadow and color combine: the colors stand for shadows, lights are colorless, and color is submitted to the disembodying intensity of light. Shadow, as such, is ironically absent in these huge, magnified blocks of hatched shading. And in its absence (once again, as with the Fauve Matisse), we are given the colored skeleton of a painting, a loosely articulated skeleton held together only by the white light of the canvas surface, which, showing between the colors—and energized by them—seems to pulsate and breathe in pace with their rhythms and have almost a dazzling effect of its own.

The intense and vibrant luminosity in each of the two side zones is counterposed by the blank screen of the center, and the coherence of the three zones is secured by their common flatness and frontality and by the bilateral symmetry of the format, locked to the framing edges of the support. And yet, it would be wrong to suppose that these elements of cohesion merely stabilize the activity of the parts and thereby join them. As I said earlier, the Unfurleds are not holistically bonded pictures; they are centrifugal not centripetal in their implied movement. Hence, while we know that the rivulets do invade the pictures from the side edges, they also appear to push out the pictures to the edges. The edges do bind each picture together but they do not contain it or enclose it or bound it or even (if the picture's proportions are correct) frame it. If the picture is either very long or very square in shape, not only does its composition seem either attenuated or cramped, its side edges can seem arbitrarily cut—as if each bank of rivulets was a judiciously framed segment of a larger whole. But in the large majority of cases, the side edges are neither so distant from each other that the color banks can be seen entirely separately nor so near that they can be seen quite simultaneously. As a result, the side edges stay curiously unobtrusive; not concealed, merely withdrawn and uncompressing in effect, resisting continual focus. Louis stretched out the edges not to some indeterminate point of visual concealment but to the precise point of visual unity.

The three zones of each picture are physically joined by the innermost rivulets which define the center but emphatically belong to the sides; the center is therefore neither a positive shape nor exactly a negative ground. What we see is not a simple figure-ground reversal. A large part of the force of each picture is attributable to the fluidity, not stability, of relationship among the three zones. The color rivulets compress the center area at its base, then expand and release it

at the top. They also pull down the top, like guy lines securing a load, exerting different pressures according to how taut the rivulets are at each side. The straighter and denser they are, the faster their trajectory, and the more sharply and strongly they pull down the top edge at their side. At times—because the diagonals seem to rise as well as fall—the reading is reversed, and the top edge is apparently braced, and then forced upward by the pressure. But however we read the direction of the pressure, it is sometimes so unequal on each side (as in *Beta Kappa*) as to cause the top edge even to shift visually near the center, producing an apparent break in its continuity as our eyes refocus from left to right (something like the effect of Cézanne's misaligned far edges of tables). When this happens—even when this seems about to happen—the banks of rivulets shift visually too so that one side seems actually lower as well as lighter than the other. The relative intensity of color on each side also contributes to, and complicates, this effect, as does the way that the drawing of the rivulets causes the central space to billow, while their own billowing is countered by its tautness.

THE MOST ASTONISHING, most radical feature of the Unfurleds is the sheer emptiness of their centers. Most writing on this subject, one critic has complained, "seems slightly defensive, as if it must be proven that there is 'really' something there . . . that there must be something 'in' a painting" for it to be a painting at all.[16] The point is well taken. Nevertheless, to say that the Unfurleds are radical pictures because their centers are perfectly empty is an oversimplification, for while the centers are indeed empty they are nevertheless pictorial. In this regard, there are some general precedents for what Louis achieved. The edge-linked elements of certain Impressionist pictures come to mind. Pierre Bonnard's insistence that a picture be composed around a hole or empty section—and his radical method of working on canvases tacked to the wall and subsequently cropped—produced pictures controlled by the edges and shaped from outside. (It is possible that Bonnard's *The Palm* in The Phillips Collection may have directly influenced Louis.) But what such precedents finally demonstrate is just how much more extreme is Louis's method.

And yet, the result is not unprecedented, only its degree. The confrontational aspect of the Unfurleds, produced by their flatness, frontality, and bilateral symmetry, recalls Newman. However, we are not only faced by a Louis Unfurled but tend to read it from left to right and back again. As we do so, the empty center affords an extraordinarily dramatic break between the two sides, a kind of visual aposiopesis that allows reflection on what we have seen and adds urgency to what follows. But, despite its physical size, the break is so slight in our actual perception of the picture that while it is true we cannot focus on each side simultaneously we nevertheless discover the whole picture almost instantaneously. The delay in total comprehension is so slight, it has been suggested, that Louis's procedure is close to Impressionist simultaneity.[17] And yet, it is a delay—so the simultaneity, or instantaneity, appears in our very perception of the picture, and is renewed each time we look at it. This is not quite the effect of Impressionist pictures, where the instantaneous is depicted, and where the depiction refers, necessarily, to a temporary moment, to a moment that has passed. The instantaneity of the Unfurleds is here and now, not there and then. Of course, Impressionist pictures make the past present to us when we see them, bringing into the present the instantaneity they depict. But the delay thus alluded to only accentuates their temporality. With the Unfurleds—paradoxical though this may seem—the

instantaneous is released from its moment to become permanent, and permanently present.

Elwyn Lynn, the perceptive writer on Louis who noticed the closeness of his procedure to Impressionist simultaneity, also observed how color in the Unfurleds "has an organic growth and presence that suggests something akin to an Impressionist notion of the painting's identifying itself with the vibratory nature of the atmosphere." And he added, "The Unfurleds are about symbolic, organic functions, of a homogeneous implied or concealed growth that pervades the whole surface, which is the pigment-stained canvas."[18] This, in fact, is to join an Impressionist association to a Symbolist one, and the Unfurleds do indeed combine the Impressionist model of a work of art as a vibrating continuum, like nature, with the Symbolist model (refined from Romanticism) of a work of art as having a life of its own, independent of its maker and corresponding to, rather than imitating, the organic self-sufficiency of nature. One might even go further than this and notice how the very form of the Unfurleds surrounds with Impressionist vibrations the quintessentially Symbolist blankness and whiteness of the interior. The Unfurleds are virtually diagrammatic of Stéphane Mallarmé's famous conception that "the intellectual core of the poem conceals itself, is present—is active—in the blank space that separates the stanzas and in the white of the paper: a pregnant silence, no less wonderful to compose than the lines themselves."[19]

It was Michael Fried who first drew attention to the Symbolist connections of Louis's art, noting how Symbolist ideas concerning the "elocutionary disappearance" of the artist and the artist's aim as seeking to reveal "certain spiritual illuminations" usefully inform our understanding of the "impersonality" of Louis's pictures and the "absolute" experience they evoke. To this he added that a Symbolist vision of art informs "the non-temporal, and as it were instantaneous, presentness" of Louis's work.[20] In stating my agreement with this, I should make clear (as Fried does) that no actual, direct influence of Symbolist doctrine or art on Louis's work is implied by it. Nevertheless, the extent of Symbolist influence on our modern conception of the nature and function of a work of art (as Frank Kermode, notably, has explained) is very considerable.[21] In Louis's case, there is in fact a mediating influence that links his art to Symbolism, namely Matisse, of whom it may be said (following what Sidney Tillim said of Pollock) that he was responsible for all the nobility that Symbolist painting ever knew since he gave its "idea" scale and set the stage for a heroic spiritualism in painting. Louis's symbolism is based mainly on this Matissean model.

Since the aim of Symbolist art was to "objectify the subjective (the exteriorization of the idea),"[22] the objective, autonomous existence of the work of art was stressed—not for its own sake but so that art, freed from the unnecessary details of nature, could more readily symbolize the artist's idea of nature's order. The Unfurleds are less obviously pictures that allude to the natural world than the Florals or Veils. By 1960–61 when they were painted, avant-garde art as a whole had shifted away from such allusions. And yet, the natural world is presented as the theme of these pictures: not only in the organic flow of their drawing and in the growth or "becoming" that pervades them but also in their whiteness itself.

Main-stream Symbolist painting—whether by Odilon Redon or Edvard Munch or Paul Gauguin or Gustave Moreau—in emphasizing the exteriorization of idea, tended to conceive of the medium of painting in the communications sense of that word as an agency through which the idea was transmitted. Symbolist poetry, however, conceived of it more in the biological sense

of a substance within which something is grown, a culture. In any case, poetry is intrinsically closer to idea than painting is, a poem being less of a thing than any other work of art, so the actual objectification or materialization of idea is less of an issue than it is for painters.[23] The best Symbolist painters did approach the conception of the poets in locating their idea as much in the handling of their pictures as in their illustrated subjects, but they felt compelled to maintain a sense of disjunction between the idea and its material embodiment lest they fall into mere decoration. As Robert Goldwater pointed out, this may be most noticeably observed in the different functions allocated to line drawing in Gauguin or Munch, say, as compared to Art Nouveau.[24] It was left to Matisse (taking clues in this respect from the late work of Cézanne) to realize that idea could be more intrinsically bonded to its material embodiment if it were located not only in the illustrated subject and not only in the handling but in the actual pictorial support. For Louis, just as for the late Cézanne and for Matisse, the blank whiteness of the support becomes the medium of a picture's existence, an almost living tissue that is at once the final arbiter of pictorial coherence and the embodiment of the idea of nature the picture presents— an uninterrupted, nonobjective continuum of light.

Light is to the Symbolist painter what silence is to the Symbolist poet—where the intellectual core of his art is to be found. As such, it is necessarily an idealized, disembodied light situated in an unlocatable space, never fully defined in its relationship to the objects or shapes that appear in it, as Cubist space, say, is always so defined. An early critic of Louis's art observed that "what Louis was after was an *idea* of space rather than an illusion of space."[25] That this was not meant as a compliment takes nothing away from its acuteness. Light, certainly, in the Unfurleds is that "very pure, non-material light" Matisse also sought, "not the physical phenomenon, but the only light that really exists, that in the artist's brain."[26]

The specific light referred to above by Matisse is the harsh white light that he saw when he visited America, and which dominates his late paper cutouts.[27] Louis was working with the same glaring American light. Matisse's late cutouts combine, in effect, the emphasis on whiteness as a coordinating continuum, typical of his Fauve pictures, with the broader rhythms and more emphatic flatness of his decorative period. Louis's Unfurleds offer a comparable synthesis. But whereas Matisse's cutouts use the harshness of American light to tauten their surfaces, Louis followed the earlier Matisse (of both the Fauve and decorative periods), and ultimately Cézanne, in maintaining a certain looseness and pliability of surface despite, and within, its tautness, thus allowing his pictures to seem to breathe. In Matisse's late work, American light is transplanted to Europe to emphasize Mediterranean flatness as never before, to produce a noble decorative art that communicates a feeling of harmony and well-being. Louis's work has that quality too. But his transplantation of Mediterranean flatness to America had, finally, a different effect; joined to American luminism, it produced a new amalgam—one that is decorative and evokes the breathing plenitude of nature but also one that has something of nature's more extreme, primordial, and even vertiginous aspects. Louis was never truly a field painter interested in creating totally harmonic unities.[28] Even the atmospheric Veils involve contending forces in their dramatic contrast of image and ground. The Unfurleds, however, cast off the cythereal qualities of the Veils for a more concentratedly charged expression, which billows through their calm centers. But the centers are calm in contrast to the active sides. As with the old Symbolist image of the vortex, stillness and reflection are discovered at the very heart of the vibrating world.

THERE WAS apparently no break at all between the Unfurleds and the Stripes. Sometime early in 1961, with exemplary decisiveness, Louis simply stopped making Unfurleds while their method was still a productive one and immediately embarked on a new series without any of those hesitations and false starts that separated the Veils and Unfurleds.

And yet, the format of the Stripes was not entirely new to Louis's art, for it returned to that of the 1960 Columns. Having followed through to its conclusion in the Unfurleds the Still-influenced development of the transitional pictures of 1960, Louis went back to pick up the Newman-influenced development, just as he had gone back in 1958 to pick up from where he had left the 1954 Veils. This, at least, seems the only logical explanation for the speed at which he consolidated the format of the Stripes (pages 147–175). However, the Stripes are not so distinct from the Unfurleds as this might imply. It is as if the kinds of color adjustments to be found on one side of the Unfurleds were made the entire subject of these pictures, and as if the sense of color as disposed on an enormous page in the Unfurleds is concentrated in such a way that the pictures actually analogize a page. It is also as if the colors that are separated, and breathe, on the white page of the Unfurleds, whose interposed coolness allays their heat, are compressed into pillars that smoulder and glow; become yet hotter because of their velocity; and burn channels through the ambient surface, whose whiteness is sometimes warmed by their heat and sometimes seems icy in contrast.

Recognizing that the Unfurleds represent a grand synthesis of earlier aspects of Louis's art, a number of commentators have viewed the Stripes as evidencing a total change in mood, seeing them as more detached in the sensibility they reveal and therefore comparable to subsequent 1960s striped paintings, Noland's particularly. In this comparison, they have been found lacking, having neither the subtlety of harmonized hue adjustments nor the sense of absolute congruity between surface and striped image that characterize Noland's pictures. This, however, is essentially a hindsight reading and a mistaken one, for Louis's aims were different from Noland's. Louis's Stripes maintain his interest in the contrast of image and support; it is crucial to their success that the Stripes do not totally identify themselves with the surface and that they do not totally depend on subtly harmonized hue adjustments.

In each picture, the stripes as a unit do seem to be more local to the surface than in any of Louis's previous pictures. This is partly because the geometry of their drawing bonds them more securely to the shape of the support and partly because the smaller size of these pictures makes the weave of the canvas more visible as a unifying factor. As a result, the color seems right in the weave as never quite before and the surface that much more intact. At the same time, however, this very intimacy of color-image and support means that it can be disrupted more easily, that nuances of color, handling, and composition can disrupt it. And Louis consistently does disrupt it in these ways. The color-stained surface may remain intact as surface, but the color changes its visual identity. Far from harmonizing the individual stripes by color, Louis usually vibrates them, creating an illusion of painterliness in their optical flicker that is reminiscent of the effect of color at the sides of the Unfurleds. At times, as in *Third Element* (page 153), they present the illusion of an almost corrugated surface, until the visible weave of the canvas tautens it, pulling out its creases, as it were. (In this respect, the effect is reminiscent of the internal detailing in the bronze Veils.) More frequently, Louis simply breaks up a harmonized sequence of close-valued, usually warm hues by punctuating them with one or two stripes that are darker, as in

Number 2–64 (page 157), or are from the opposite side of the spectrum, as in *Equator* (page 175), or, with a sequence of such punctuations, even at times to such an extent as to incorporate the blank canvas between two blocks of stripes, as in *Biplane* (page 165), into an allover optical flicker.

Color is now no longer a part of painting, no longer services and pictorializes the empty canvas. The canvas no longer is space or atmosphere. The paintings are almost all color, and Louis finds in color itself such a plenitude of experience that, virtually alone, it evokes pictorial space with hardly any help from other pictorial components—in the juxtaposition of different hues, values, intensities, temperatures, and so on. And yet, the bonded coherence of the colors cannot quite be explained in terms of these juxtapositions. I said that the stripes are not harmonized by color. When Louis attempted that approach, the surface tended to dissolve or to remain too decoratively flat. In those pictures which tended to the harmonic (especially those with broader stripes, whose more widely spaced edges disrupt far less the harmonizing effect of the visible canvas weave), he therefore varied the tactility of the stripes by using differing amounts of turpentine and resin thinner so that some are more shiny and others more matte, and some are more transparent and others more opaque. This may be observed in *Castor and Pollux* and in *Albireo* (pages 159–161). The effect is to render each color less local to the surface, to wrest it away from the surface, giving it an almost sculptural identity—certainly an individual identity. The colored stripes, then, are not neutral modules that combine homogeneously to form a multicolored sheet or field, as in Noland's work, but things with identities. Louis's choices of color (of hue and of tonality) and his handling of color (of its relative tactility) were designed not only to visually combine the stripes but to preserve their identities within that combination.

The same is true of his choices of format or composition. The very coherence of the colors is not quite a matter of actual color relationships, but more a matter of the multiplicity of individual colors.[29] In a sense, this returns Louis to a visibly additive, block-building conception of picture making. But these pictures are really more fasciated than fascicular: the stripes are not merely bundled together, they are compressed together and grow together. This is attributable to the sense of velocity they convey. In this respect, the Stripe pictures recall the looming upward movement of the Veils, and may be thought of as combining the format of the Veils with the color of the Unfurleds, not as a break from what Louis had previously achieved but as a synthesis of it.

Almost certainly, the earliest of the Stripes were the half-dozen or so waterfall type, such as *Number 11* (page 147), which maintain (even exaggerate) the sense of self-generated figuration of the Unfurleds, and the Veils before them. These can be quite breathtaking in the streaming blend of individual colors as they fall down the canvas. Here, the whole blended image is contrasted against the white canvas in much the same way as in the Veils. The sculptural outer edges tighten the softness and fluidity of the interior, holding it to the surface, while simultaneously enforcing its silhouetted separation from the surface. In about half of these pictures, the stripes can be seen to separate into narrowing flares at the top. These were caused by trails of paint running down that part of the canvas folded over onto the back of Louis's stretcher as he began each pour on the top edge of the stretcher. (The horizontal mark of the stretcher and even marks left by stapling the canvas onto it can often be seen running through the painted area at this point.) The irregularity of these appeared to have bothered Louis; and they are bothersome

in the waterfall Stripes because their closeness to the Veil format calls for a more regularly horizontal top, just as in the Veils. In pictures like *Number 11*, therefore, he cut through the painted area at the top as well as the bottom as part of finishing the work. This more active cropping helps to further disembody the color of the painted area, which now comprises part of the ground, not an image set against the ground. It improves pictures of this kind not only by removing the bothersome flares but also because it checks the extremeness of the directional force within the painted area, which otherwise tends to produce too literal an image (of a waterfall). By cropping the canvas in this way, Louis maintained a dynamic equilibrium of image and surface.

Once Louis discovered a way to maintain the separate identities of the colored stripes as they descended the canvas, that sense of a literal image was allayed. How he painted these pictures with discrete stripes is more difficult to understand than the methods he employed in previous works. The horizontal line running through the painted area just below the top of a number of them tells us that they too were painted tacked on a stretcher and that their figuration was therefore gravity-induced. Louis must have used his cheesecloth-covered swab to help draw the stripes, as well as (probably) pleating of some kind. Noland infers that he poured a thin ribbon of syrupy paint down the center of the intended stripe, then spread it to its desired width with a knife.[30] But it is hard to tell how the very regular contours of the stripes could have been produced in this way. (Possibly some form of masking was used.) Moreover, close inspection reveals that a number of the stripes (especially in the 1961 pictures) do taper slightly, which suggests that a gravity-induced method produced their contours as well as their length. No less remarkable is the constancy of color intensity that Louis maintained even in the more transparent stripes. Such technical virtuosity, though amazing, does not itself make these pictures better. But they are better for it, if only because it makes the stripes seem not merely drawn but simultaneously drawn (even harder to understand technically) and not merely drawn by hand but impersonally or automatically drawn, and therefore as if they had sprung into existence instantaneously of their own accord.

In the nine or ten months in 1961 that Louis worked on the Stripes, he produced between sixty-five and seventy-five pictures. At first, the pictures were painted dead center on the canvas. (One of the early Stripes is symmetrical in its color composition too.) Pictures of this kind have a quiet monumentality to them, and Louis used this quality at times (as in the waterfall *Number 11*) to soften their activity. But as he learned to draw the stripes more regularly as well as more independently, he began to vary the symmetry of their placement in order to mobilize that regularity. In some cases, he painted the pictures off center; in others, he painted them in the center then afterward found their shape in cropping them asymmetrically. The care with which he did this is not noticeable in these pictures but can be discovered in them. For example, the wonderfully limpid picture called *Burning Stain* (page 149) is energized by Louis having cropped it so that the most vivid color contrast (of the complementary red and green) falls exactly down the center. In *Number 9* (page 151), the color block itself begins at the very center, so that the compacted, hot reds and oranges to the right of the center counterpoise the open, uncolored, bare canvas to the left. Moreover, the vivid complementary cool green that bounds the hot color block to the right of the center, insulating the bare canvas from its heat, is repeated to the right of the even cooler blue that centers the color block, thereby checking the rightward movement of

the block—which is checked further by a repeat of the blue, until it slows to a halt with an intense orange-red. And that orange-red on the far right is complementary to the green on the far left, at the center of the picture, to which we are thus returned. Many of the Stripe pictures offer readings of comparable complexity and results of comparable lucidity to this one.

When Greenberg first saw the Stripes toward the end of April 1961, he and Louis discussed the question of cropping and found they were in agreement that the pictures were better when Louis did crop actively at the sides, reducing the amount of bare canvas to focus and strengthen the painted section.[31] Louis increasingly did so; by 1962, the canvas at each side (more often than not) constituted a margin somewhat in the same way as in the close-cropped Veils. However, no matter how close Louis came to the painted section, he almost invariably kept the composition asymmetrical. Most of the double-stack Stripe pictures of late 1961 have more generous margins, but these are emphatically asymmetrical. With some of them Louis repeated the narrow canvas gap between the two stacks as one of the margins, thereby holding the stacks together to the shape of the support. Some of the 1962 pictures with broader stripes make one of the margins the same width as one of the stripes. Both *Number 2–64* and *Castor and Pollux* show this (pages 157–159); the double-stack *Number 33* (page 155), which contains both broad and narrow stripes makes one margin the width of a broader stripe and the internal canvas gap the width of a narrower one. All of these strategies also serve the purpose of asking us to read the canvas itself as colored in the same way that the stripes are. The wonderful picture known as *Albireo* (page 161) contains a precisely centered block of broad stripes with a block of narrow stripes in its right margin. That narrow block is the same width as the space that divides it from the centered block, and the margin to its right is the same width as one of its own components. Repeats of a similar yellow at the left of each block disguise the exactness of these relationships because the yellows blend somewhat with the color of the canvas. They also serve to return to the left the rightward movement of the picture.

With the usually very closely cropped narrow-stripe pictures of 1962 (first shown to Greenberg in late March of that year), a kind of symmetry is reestablished. Even here, however, Louis usually left one margin wider than the other, and again often made the narrower margin about the width of one stripe, as in *Number 19* (page 163), and occasionally splits the stripes into two blocks with a one-stripe width of bare canvas between them, as in *Biplane* (page 165), causing that thin "stripe" of bare canvas to most definitely read as colored. In one picture only, *Number 1–99* (page 167), Louis uses three sets of stripes. Widely dispersed and beautifully orchestrated in color (using repeats, in three different combinations, of two reds, yellows, and greens at the outer edges of each set) to hold them together, the three sets of stripes less divide than open the surface in a way that is reminiscent of Monet's paintings of poplars.

This picture is unusual in two other respects. First, it uses most of the canvas surface that Louis had attached to his stretcher. After the early 1961 Stripes, as Louis's pictures became narrower, he took to painting not one but eventually as many as four or five pictures on one canvas, then marked the canvas for cropping into separate pictures. One result of this was to vastly increase his output. Whereas in the nine or ten months he worked on the Stripes in 1961 he produced between 65 and 75 pictures, in the six months he worked on them in 1962 he produced between 155 and 165 pictures, approximately 6 a week. The second way in which *Number 1–99* is unusual is that the painted area is cut through at both top and bottom of the picture. Whereas

Louis and Greenberg agreed in 1961 about the usefulness of active cropping at the sides of pictures, they did not agree about the treatment of top and bottom. Louis felt that his pictures were better when cropped along both of these edges. Greenberg felt that Louis would do better to leave a margin of canvas at the edge of the pictures where the stripes ended in plumes or flares of paint. After Louis's death, however, he came to the conclusion that the artist's original intentions were invariably correct.[32] But Louis took Greenberg's advice; of the total of 230 Stripe pictures from 1961 and 1962, only 26 (or about ten percent) were cropped, or marked to be cropped, according to Louis's original intentions.

What are we to make of this? We must obviously choose between deciding that Louis simply capitulated to Greenberg, trusting that Greenberg was correct even though he himself felt otherwise, or deciding that Louis came to the conclusion that Greenberg was correct (even though Greenberg himself eventually felt otherwise) and benefited from his advice in the cropping of these pictures. I am convinced by the latter explanation; not only is it more consistent with Louis's personality insofar as I understand it, the pictures themselves demonstrate it. Whereas the waterfall Stripes are better cropped top and bottom (for reasons already explained), most of the others are not. It is true that some of the pictures with plumes or flares of paint at the top would benefit, like the waterfall Stripes, from having a regularly drawn top edge. With others, however, this incident helps mobilize them pictorially and (especially in the very close-valued pictures) gives the whole image a welcome hint of tactility and body. And if Louis had cropped off this incident, he would have been forced to alter the side margins of these pictures in compensation, more often than not, to reduce them. Where he did reduce the side margins of his pictures, the plumes of paint often become bothersome because now the image can seem too tactile a thing within a close-bound container. At the same time, to totally remove them and drastically reduce the margins at the side can too closely identify the image and the support, making the whole picture seem a kind of color-striped tactile thing, a kind of sculpture.

Many of the very close-cropped narrow-stripe pictures suffer for precisely this reason. By the time that he made these works, Louis had so perfected his technique of getting clearly contoured stripes to exactly touch but not overlap down their full lengths (and was even able to repaint a stripe exactly on top of a previous one) that he seemed infatuated by his own virtuosity. As a group, these pictures vary more greatly in quality than any previous important group of Louis's pictures. Very many of them are over controlled, over-stabilized in their relationship of image and support, whether their painted areas are cut through at both ends or just one.

What is important, then, is that the image formed by the stripes be kept in tension with the support as a whole, neither too independent of it nor too closely identified with it. By the end of 1961, Louis had found a method of achieving this which followed Greenberg's advice in not cutting the image at both top and bottom but which eliminated the bothersome plumes. He managed to terminate each stripe at the top with an inobtrusive rounded end. Thus regularized (in a way that recalls the hillocklike effect of the tops of the later Veils), the block of stripes assumes a tauter relationship with the shape of the support. The whole image (as with the Veils) is a self-contained painterly block, whose vibrating interior is opposed, and flattened, by the bare canvas around it, but (unlike most of the Veils) an image that belongs by virtue of its drawing to the shape of the canvas as a whole. The intimacy of image and support in these pictures (as well as their crispness of drawing and high-keyed, often unexpected color) recalls Noland's work of

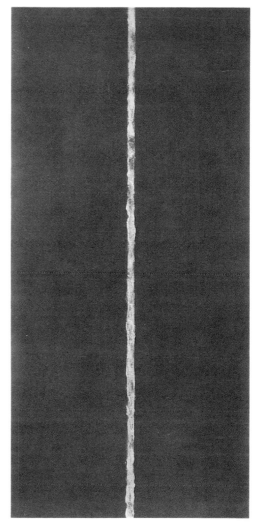

Barnett Newman. *Onement, III.* 1949. Oil on canvas, 71⅞ × 33½″. The Museum of Modern Art, New York. Gift of Mr. and Mrs. Joseph Slifka

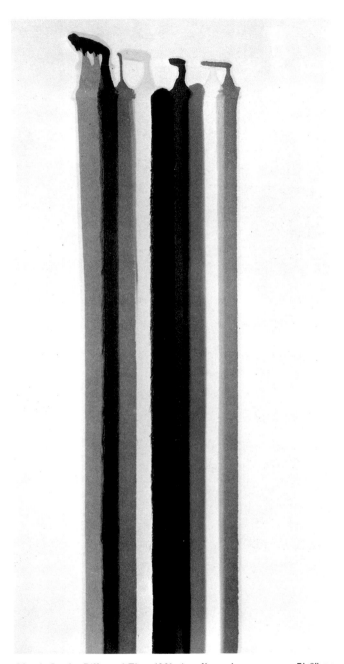

Morris Louis. *Pillar of Fire.* 1961. Acrylic resin on canvas, 7′ 8″ × 47⅝″. The Abrams Family Collection, New York

1961. However, it also looks back to Louis's earlier pictures (including the Italian Veils), while the opposite disjunction of image and support they simultaneously convey is certainly Louis's own.

The directional emphasis of the Stripe pictures is crucial to their unique relationship of image and support. I said that Louis found a way to terminate the stripes by means of rounded ends. In fact, this was when he began them. In Louis's first exhibition of Stripes in October 1961, he showed ten pictures, all with noticeable plumes or trails on their stripes. Greenberg, together with André Emmerich (at whose gallery Louis had begun showing), suggested that Louis consider hanging them with these plumes or trails at the bottom, partly because they assumed that the pictures had been painted that way.[33] Louis agreed to such a hanging for some of them, and many of the Stripe pictures have been exhibited thus, which does indeed cause their stripes to seem to fall down the canvas, ending in drips of paint. Greenberg and Emmerich now realize that Louis's original orientation for these pictures was the correct one, and it has been observed that hanging them with the stripes descending alters Louis's carefully paced color adjustments by reversing their horizontal reading. This may be true. And yet, in many of the pictures, while it alters them it does not destroy them, for what is important (as I have argued) is the interaction of the colored stripes as individual things, both with each other and with the bare canvas around them, and not their color relationships themselves. (It does greater disservice to reverse a Noland stripe picture than a Louis.) The interaction is preserved even if the color relationships are not.

Far more problematical is the exaggerated velocity of the stripes created by a reverse hanging. Except for pictures with broad blocks of stripes cropped fairly closely to their free ends,[34] the velocity of the stripes is such as to separate them, as images, from their support. Hung correctly, their top edges float, relaxing the impetus of the stripes, which seem to gain in speed toward the bottom edge until one notices the abruptness of that edge, which brakes them to a halt. But, as with the Veils, they enforce no single direction in their viewing, seeming both to respond to and oppose gravity singly and as a whole. This is especially the case with the stripes with rounded ends. And here, it becomes clear that they are oriented not so much to gravity as to the uprightness of the canvas itself. Previously, Louis had enforced this uprightness with the help of gravity. It meant, however, that the bottom edge carried an immense pictorial weight. In the Veils, narrow sheets of color were balanced on top of this edge. In the Unfurleds, banks of color were braced against its secure foundations. In the Stripes, however, it needs to carry far less of a burden. The vertical stripes seem to siphon off some of its collected weight, like capillary tubes carrying up moisture from their roots.

Weight thus relieved from the bottom edges is dispersed into the color, which seems as tangible as the picture as a whole—no more and no less tangible when the pictures succeed. They seem weightless, disembodied and transfixed, yet also colored things. But the blocks of stripes themselves are no more known things than are the veil images. Since the canvas weave is so evident and their color, therefore, all the more in the surface (and the surface in them), and since the drawing of their edges does not call attention to itself, they do not seem circumscribed as things are, not even drawn. They do, however, seem intentional (just as the first group of Unfurleds do) and in this sense they do seem if not actually drawn then, as Michael Fried put it, products of the intentionality of drawing, of the will to draw, of the will to take possession of a plane surface by drawing.[35] As Fried observed, their sheer simultaneous velocity, which precludes their being read as the product of an act of drawing, reaches such a pitch in the narrow-band

Stripes that each stripe amazingly appears to have contact with every other. We can, and do, read them horizontally across their colors, thereby discovering individual color relationships, but we have to fight their velocity to do so. In the vertical reading enforced by their velocity, we grasp their colors simultaneously, as a sudden, intense surge or strobe of color, an experience more associable with light than with paint. The Unfurleds, I said earlier, follow Pollock in isolating, abstracting, and then recombining the components of tonal modeling, except that color stands for shadow, lights are colorless, and color is submitted to the disembodying intensity of light and, in its juxtapositions, creates light. In the Stripes, Louis takes this a step further. His vocabulary is intensified to such an extent that the light of the canvas is now in the color, and it is not the components of tonality but of light itself that are decomposed, then realigned. It is as if Louis rearranges the spectrum at will, and presents us not with stripes of color but a multicolored beam of light.

In 1962 Louis cropped fifteen of the narrow-band Stripe pictures so as to leave generous areas of bare canvas on all sides, and turned them into a horizontal plane, causing the stripes to float, unanchored by anything except the flatness of the canvas itself. Michael Fried suggested that the horizontal orientation may have been Louis's way of eliminating the sculptural, objectlike quality that many of the narrow-band pictures possess.[36] It does lighten them. And, as Fried observed, those with two stacks of stripes—like *Horizontal VIII* (page 169)—which form the vast majority, create the impression "that each stack of stripes suspends the other by a kind of mutual attraction or repulsion rather than that both are suspended, as if by an outside force, in the blank field." However, when this effect does not occur, the stripes can seem to float too lazily within the white ground, which tends to read as a field or even a space in a way that it never does in the fully realized Stripe pictures. Louis, we remember, had very rarely actually suspended anything in an expanse of blank canvas, and was never wholly comfortable with such an approach,[37] which was really more Pollock's than his own. *Horizontal VIII* succeeds so well, to a large extent, because the two stacks of stripes enforce that ever-important sense of contending forces by being near enough to each other to interact and by being cropped so carefully as to engage and mobilize the canvas around them as well as between them. (The two stacks together are exactly centered on the canvas but the actual center is exactly at the base of the top stack.) *Horizontal I* (page 171), with its single stack, miraculously works just by floating extraordinarily sumptuous color, supported (or elevated, rather) by disembodied yellows above the bottom edge, where it levitates. The velocity of the color increases toward the center, now that both ends of the stripes are exposed, only to rush outward again, and slow at the edges. This very large, nearly ten-foot-long, picture is probably the closest that Louis came to achieving the miragelike floating feeling of a Pollock while remaining indisputably his own.

After his July 5, 1962, operation for lung cancer, which ended his painting career and led to his death some two months later, Louis arranged to have three canvases that he had painted with floating stripes stretched as squares with the stripes running diagonally across them.[38] Even more than with the narrow-band Stripe pictures, the eye needs to fight the direction of the stripes (because it is diagonal) to register their color, while their diagonality braces and opens the pictures in a way that is reminiscent of the Unfurleds. (Indeed, Louis hoped that the diagonals would prepare the way for the Unfurleds to be exhibited.)[39] And since their colors, when registered, offer more in terms of their hue, they seem richer, more opulent, more generous

pictures even, than the narrow-band Stripes. They evoke not a single multicolored beam of light but parallel frozen beams of colored light. It is colored light rather than just color that seems to shoot across the surfaces of these pellucid works of art.

Hot Half (page 173) contains a single block of stripes; the others, including *Equator* (page 175), two blocks. In *Equator* especially, the exposed band of canvas that exactly meets the corners reads more definitely as color than in any previous double-block Stripe picture.[40] Indeed, all of the exposed canvas in all of these pictures reads more definitely as color than ever before, and largely because these pictures seem composed as never quite before. The absoluteness of the square canvas, divided by the opposing diagonals, forces us to read them as composed. These, Louis's last paintings, are probably the most open and certainly the most dynamic of the Stripes, seeming more the beginning of something than the end—in their new explicitly relational involvement with the shape of the support and with securing that shape by the force of their color and drawing.[41] But it is impossible to talk as if color and drawing are separate elements. Their force is simultaneous.

In their own way, these are as transcendental in feeling as any of Louis's pictures. The transcendental was once expressed through particularized images, symbolizing mankind's freedom from earthbound things. These images were of elements not entirely controllable by man, necessary to his worldly existence but unreachable, beyond his grasp. Louis's Veils, Unfurleds, and vertical Stripes allude to these elements: to water, to air, and to fire, and to the light that makes them visible to us. His final pictures allude to all of them, compressing and intensifying their meanings as they do so. But they mainly allude to light, and to light as something that possesses those other elements; light as something that is liquid, aerated, and burning in its intensity; light that is actually palpable and not only illuminates but surges with illuminating energy. Painting has always concerned itself with the unreal things in the world that give it visible substance, intangible things like color, shadow, and particularly light. Its subject is the unreal and the attempt to realize it, and its ultimate justification (outside of decoration) is the tangibility, the reality, with which it does so. These last pictures by Louis give to light a kind of plasticity previously unknown to painting except through tonal modeling, and a kind of intensity that bleaches out anything that is shadowy or obscure. They are extraordinarily optimistic, as well as candid, pictures. They had, of course, no successors.

PLATES

IN THE CAPTIONS, titles enclosed in brackets
were given to the paintings after the artist's death.
All works are acrylic resin (Magna) on canvas.
Dimensions are given in feet and inches
and in centimeters, height preceding width.
An asterisk at the end of a caption
indicates that the work will be shown
only in New York;
two asterisks indicate that the work will not
appear in New York.

IRIS
1954
6′ 8¾″ × 8′ 10″
205.1 × 269.2 cm
Collection Mr. and Mrs. Eugene M. Schwartz

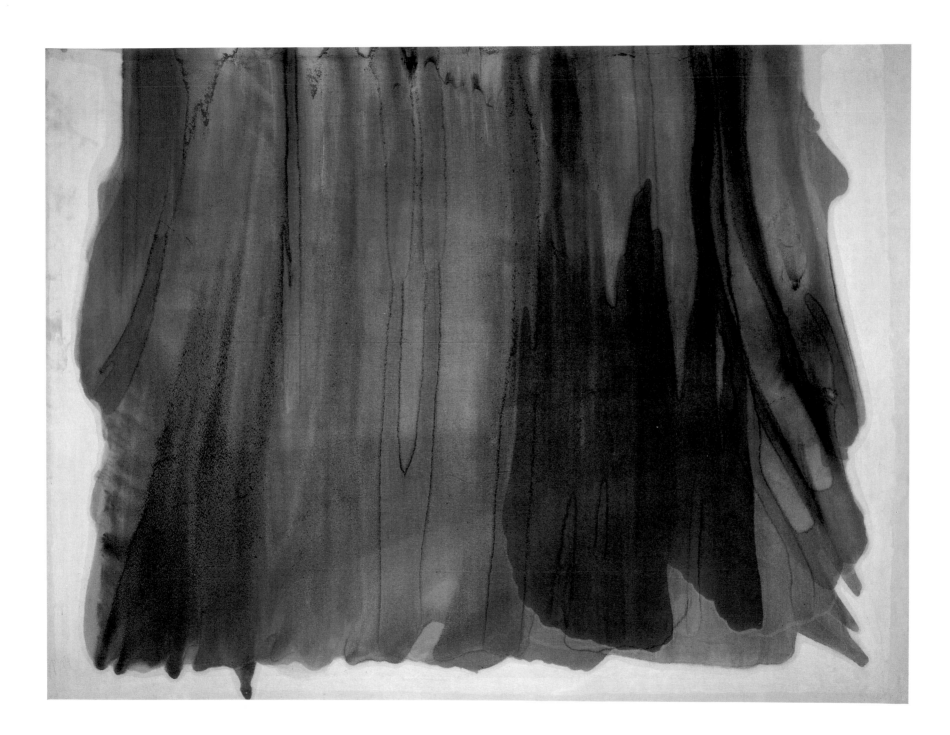

SALIENT
1954
6′ 2½″ × 8′ 3¼″
189.2 × 252.1 cm
Collection Donald and Barbara Zucker
*

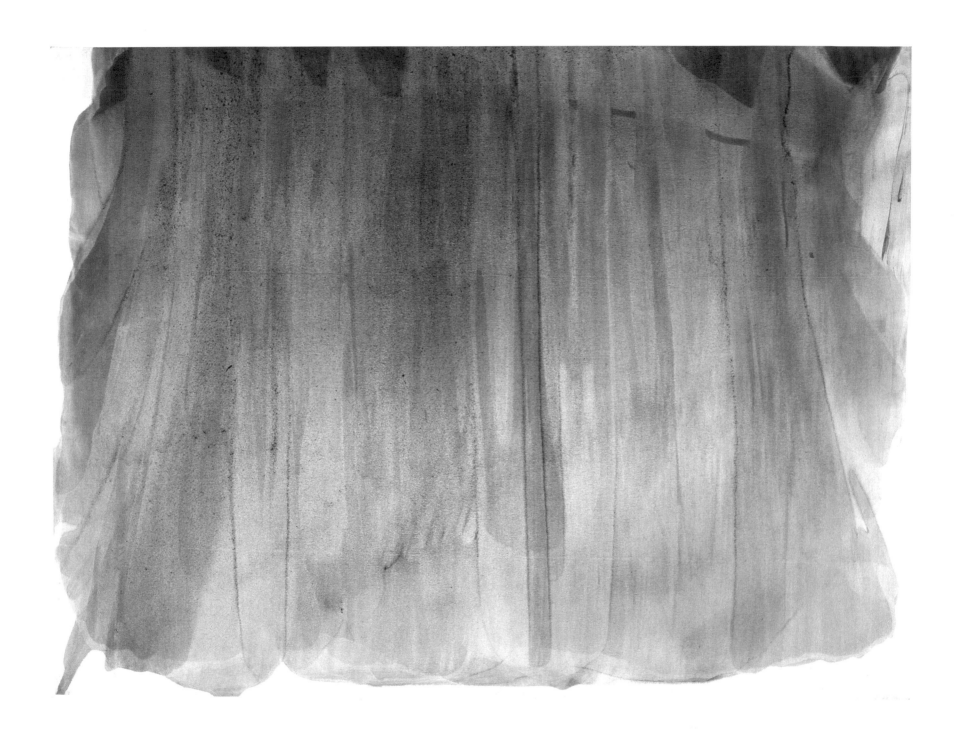

PENDULUM
1954
6′ 7″ × 8′ 9″
200.7 × 266.7 cm
Collection Mr. and Mrs. Harry W. Anderson

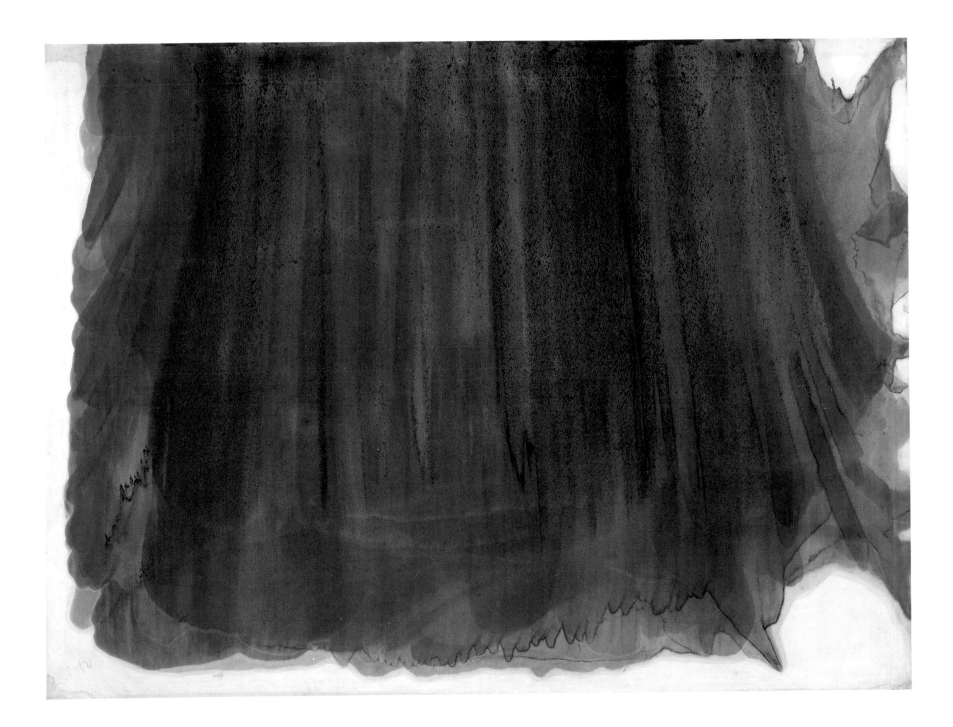

LONGITUDE
1954
8′ ½″ × 5′ 6″
245.1 × 167.6 cm
Collection Marcella Louis Brenner
**

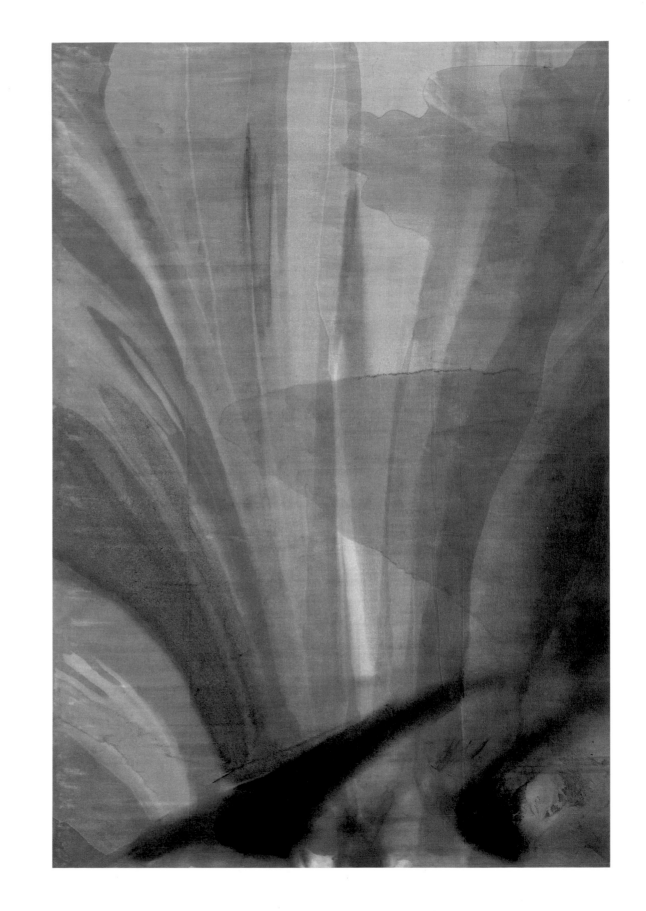

ATOMIC CREST
1954
9′ 9⅞″ × 6′ 5¾″
299.4 × 197.5 cm
The Lannan Foundation

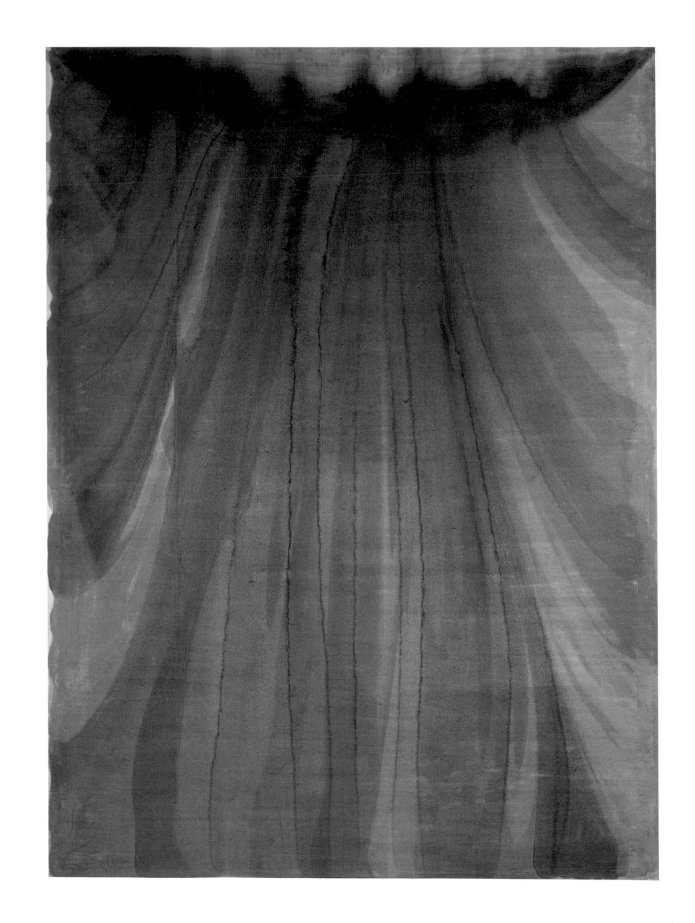

INTRIGUE
1954
6′ 8½″ × 8′ 9½″
204.5 × 268 cm
Collection Sylvia and Joe Slifka, New York
*

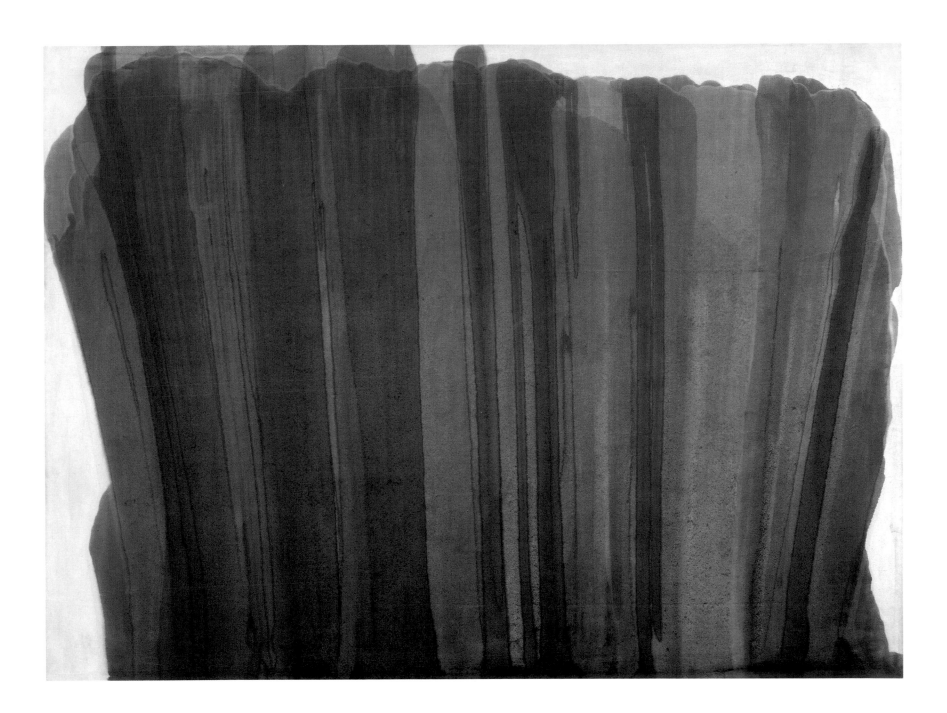

[BETH HEH]
1958
7′ 6″ × 11′ 8″
228.6 × 355.6 cm
Collection Mr. and Mrs. Graham Gund

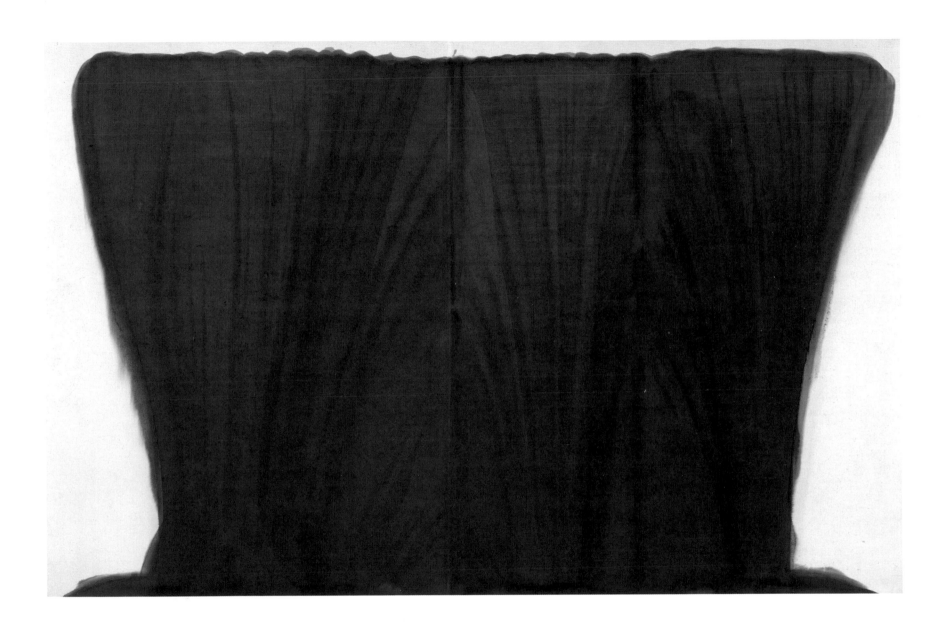

GOLDEN AGE
1958
7′ 7″ × 12′ 5″
231.1 × 378.5 cm
Ulster Museum, Belfast

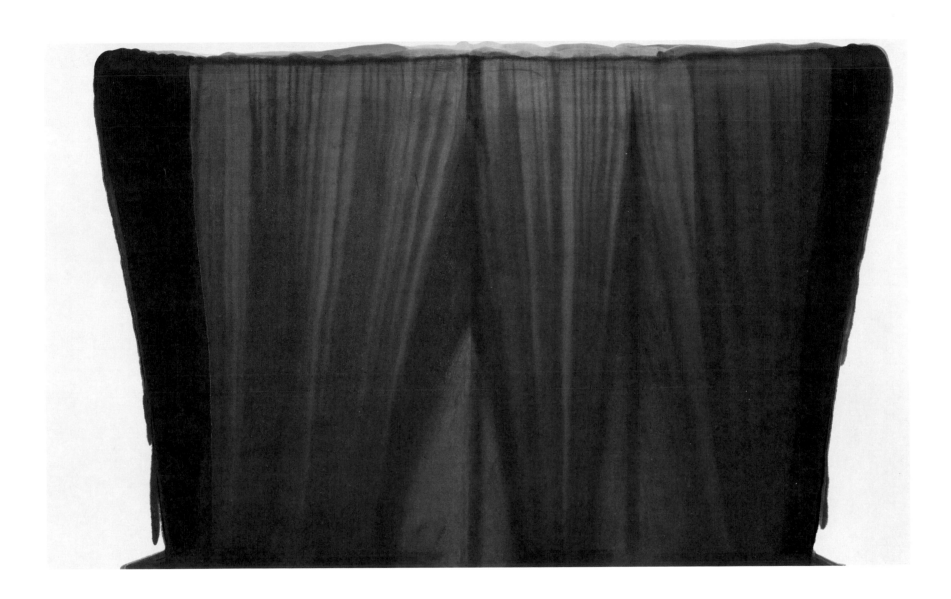

LOAM
1958
7′ 6¾″ × 12′ 4″
230.5 × 375.9 cm
The Museum of Fine Arts, Houston.
Museum purchase with funds
provided by The Brown Foundation

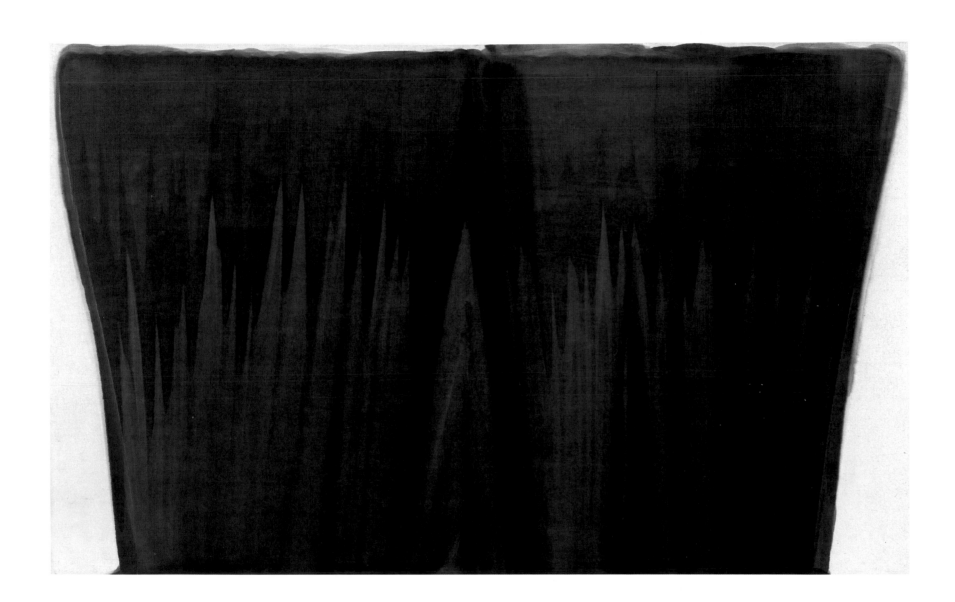

[BETH GIMEL]
1958
11′ 1″ × 7′ 9″
337.8 × 236.2 cm
Collection Robert A. Rowan

BOWER
1958
7' 11½" × 11' 5¼"
243 × 349 cm
Staatliche Museen Preussischer Kulturbesitz,
Nationalgalerie, Berlin

[BETH RASH]
1958–59
8′ 2″ × 11′ 9″
248.9 × 358.1 cm
Collection Mr. and Mrs. James J. Lebron

[BLUE VEIL]
1958–59
8′ 4½″ × 12′ 5″
255.3 × 378.5 cm
The Fogg Art Museum, Harvard University,
Cambridge, Mass.
Gift of Mrs. Culver Orswell
and Gifts for Special Uses Fund, 1965
*

SARABAND
1959
8′ 5⅛″ × 12′ 5″
256.9 × 378.5 cm
The Solomon R. Guggenheim Museum, New York

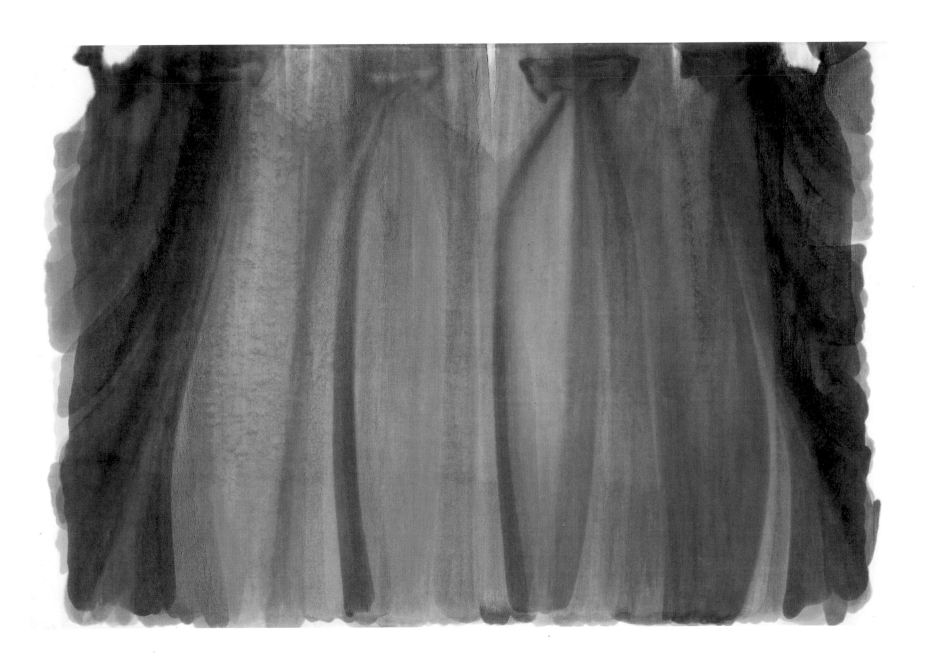

[BETH CHAF]
1959
11′ 7″ × 8′ 6½″
353.1 × 260.4 cm
Collection Marcella Louis Brenner

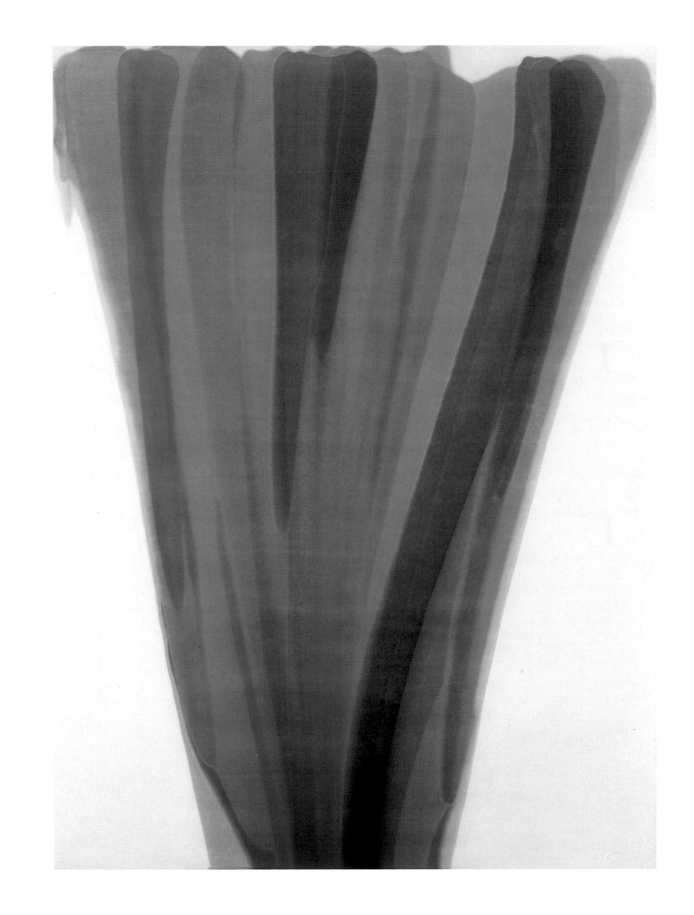

[NUMBER 1–89]
1959
8′ 2″ × 11′
248.9 × 335.5 cm
Des Moines Art Center, Des Moines.
Gift of Gardner Cowles, by exchange, 1972

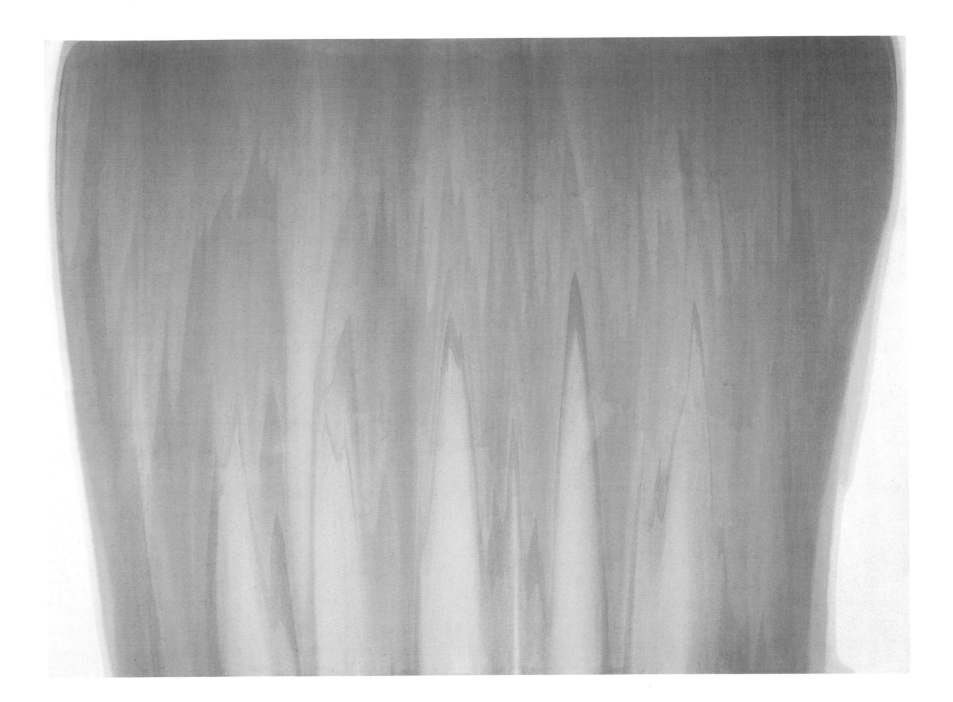

[MEM]
1959
8′ 1″ × 11′ 8″
246.4 × 355.6 cm
Collection Mr. and Mrs. Bagley Wright

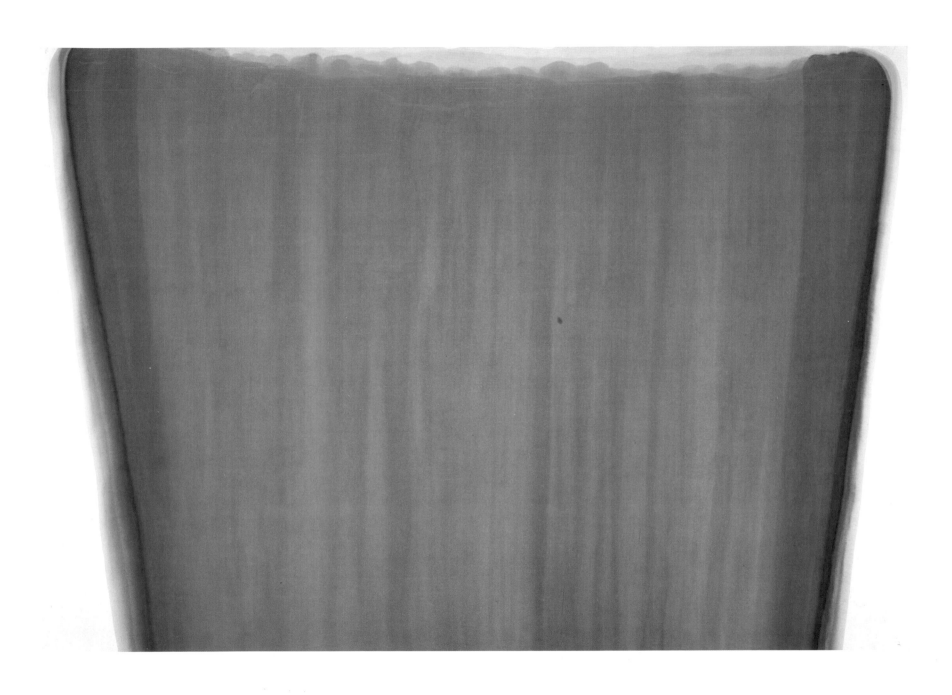

VERDICCHIO
1959
6′ × 8′ 7″
182.9 × 261.6 cm
Collection Mrs. John D. Murchison

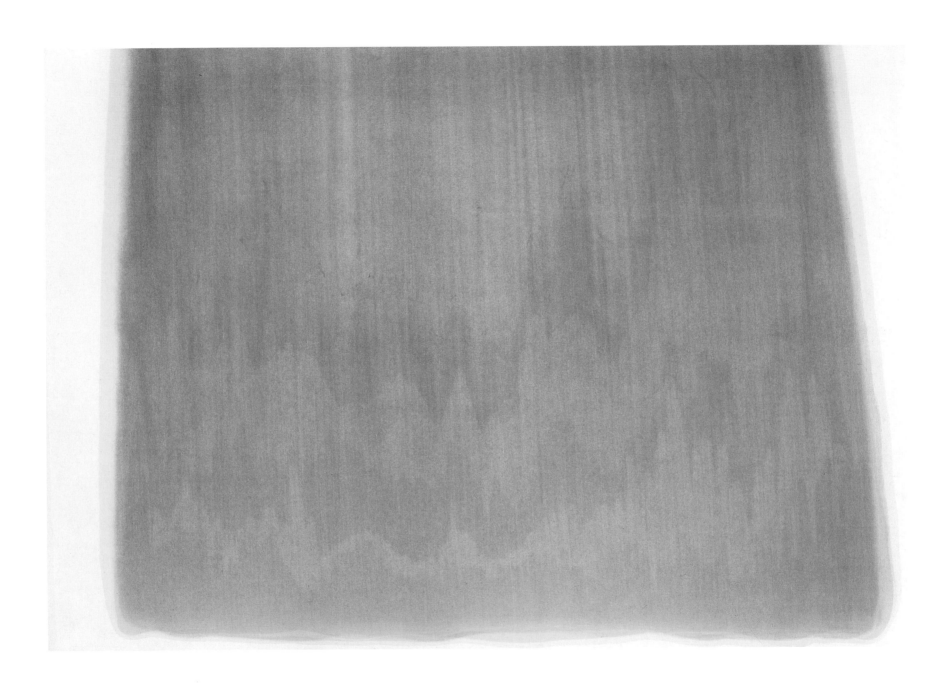

ITALIAN BRONZE
1959
6′ 3″ × 8′ 4″
190.5 × 254 cm
Collection Stephen Hahn, New York

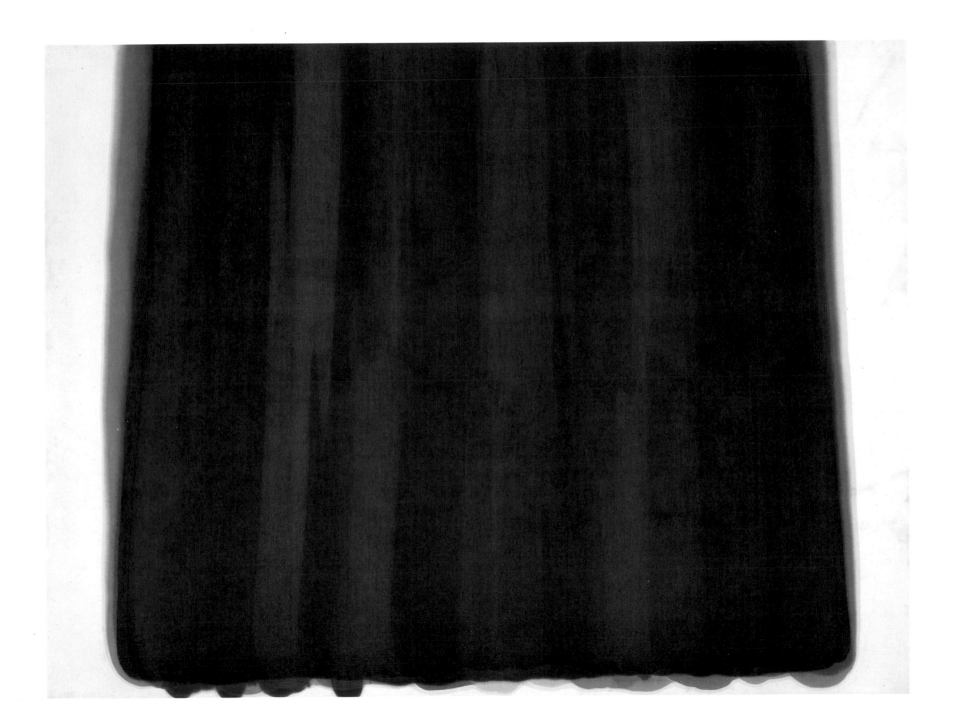

AIR DESIRED
1959
8′ 9″ × 6′ 3″
266.7 × 190.5 cm
Private collection

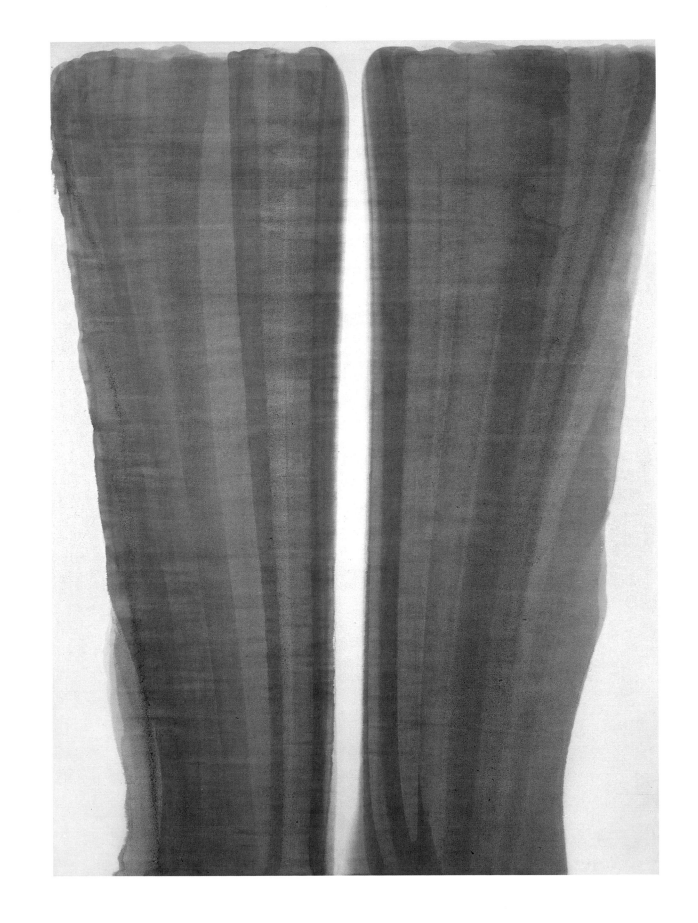

[WHILE SERIES II]
1959–60
8′ × 11′ 11″
243.8 × 363.2 cm
Collection Sally Lilienthal

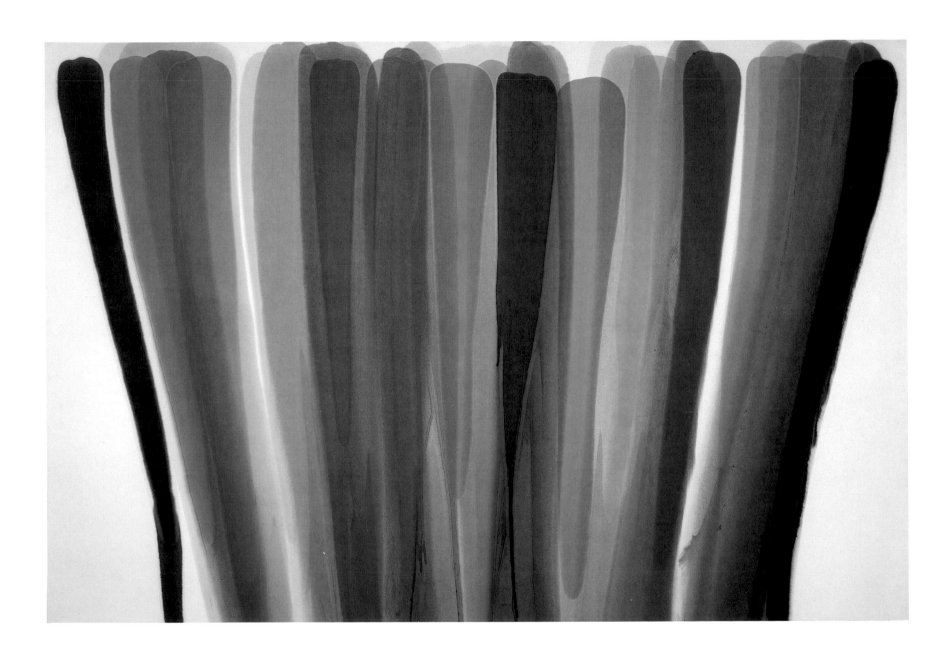

WHERE
1959–60
8′ 3¾″ × 11′ 10½″
252.4 × 362.1 cm
Hirshhorn Museum and Sculpture Garden,
Smithsonian Institution,
Washington, D.C.
Gift of Joseph H. Hirshhorn

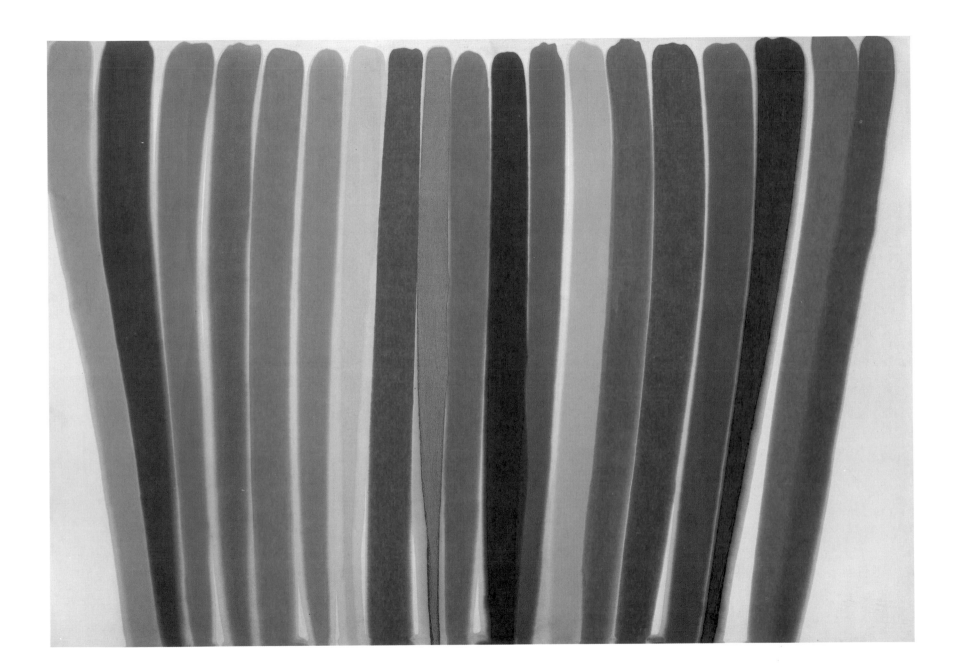

[BETH]
1959–60
8′ 9″ × 8′ 10¼″
266.7 × 269.9 cm
Philadelphia Museum of Art, Philadelphia.
Adele Haas Turner and Beatrice Pastorius Turner Fund

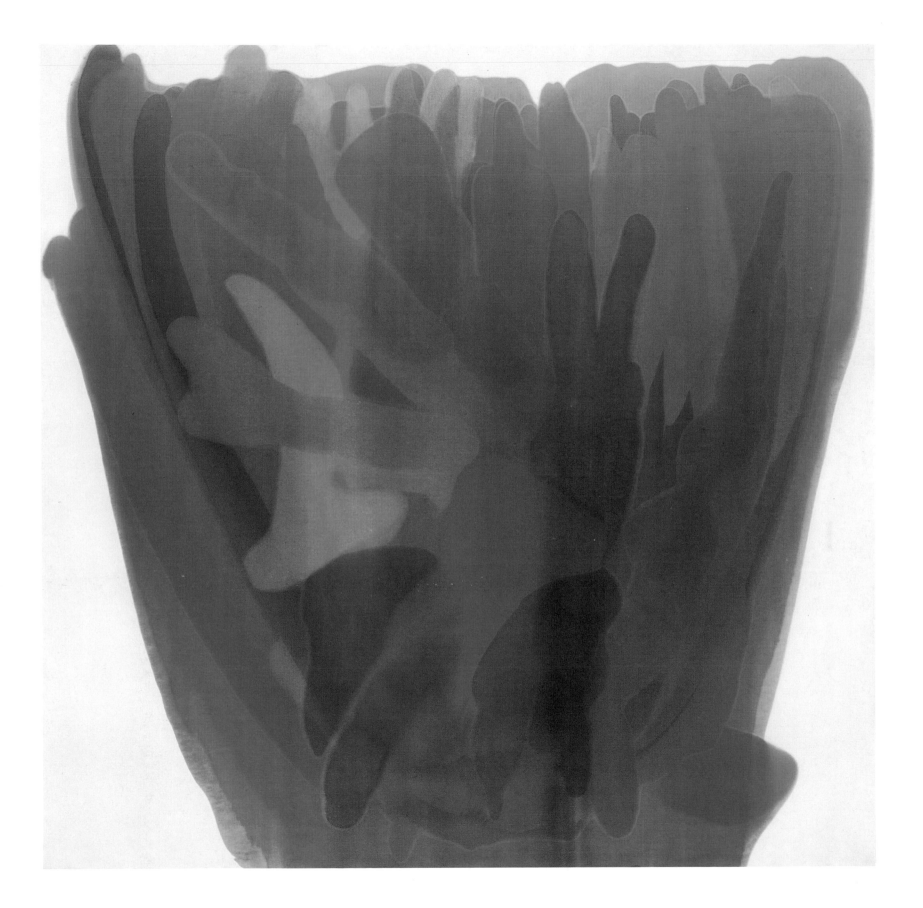

POINT OF TRANQUILITY
1959–60
8′ 5⅜″ × 11′ 2¾″
257.5 × 342.9 cm
Hirshhorn Museum and Sculpture Garden,
Smithsonian Institution,
Washington, D.C.
Gift of Joseph H. Hirshhorn

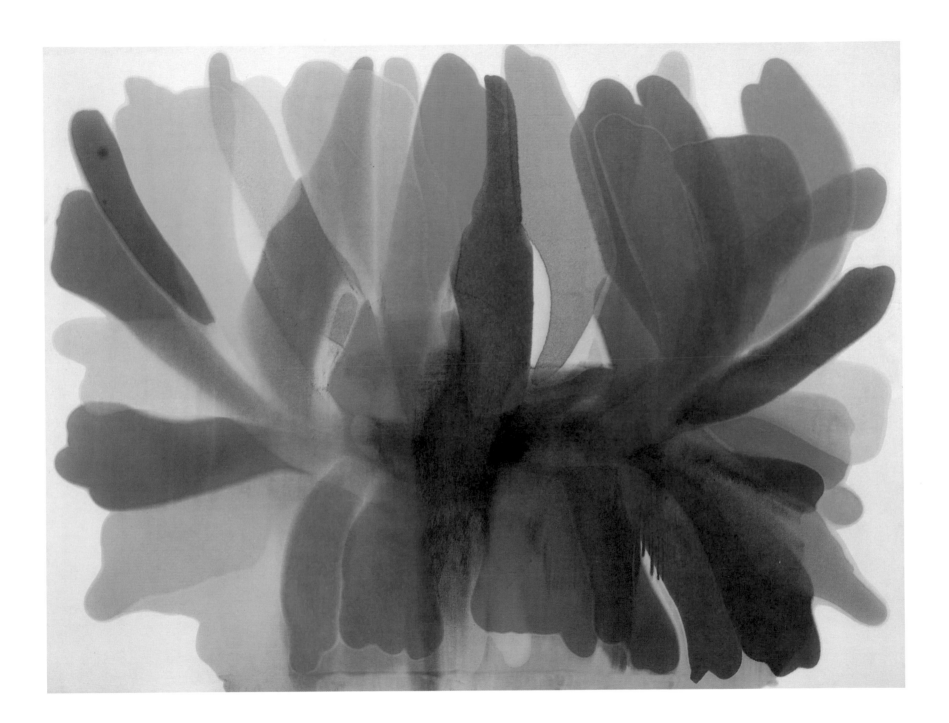

[ALEPH SERIES V]
1960
8′ 8¾″ × 6′ 10″
266.1 × 208.3 cm
Collection Helen Frankenthaler

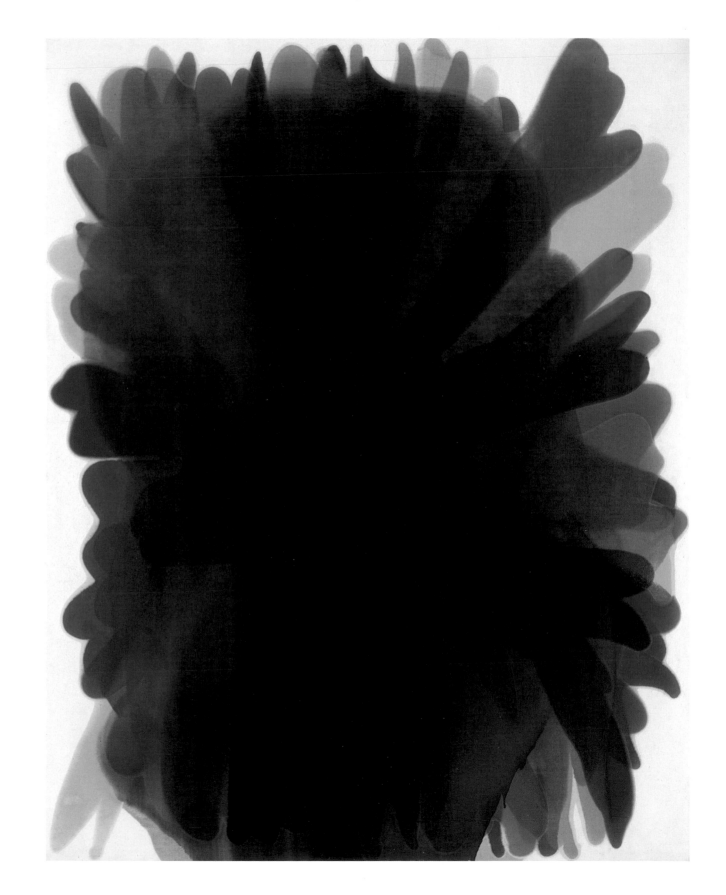

[GAMMA PI]
1960
8′ 8″ × 11′ 11″
264.2 × 363.2 cm
Private collection

[ALPHA ALPHA]
1960
8′ 9″ × 12′ 7″
266.7 × 383.5 cm
Collection William S. Ehrlich

[ALPHA BETA]
1960
8′ 6½″ × 13′ 3″
260.4 × 403.9 cm
Collection Mr. and Mrs. I. M. Pei
*

[ALPHA LAMBDA]
1961
8′ 6½″ × 15′
260.4 × 457.2 cm
Collection Dr. and Mrs. Charles Hendrickson

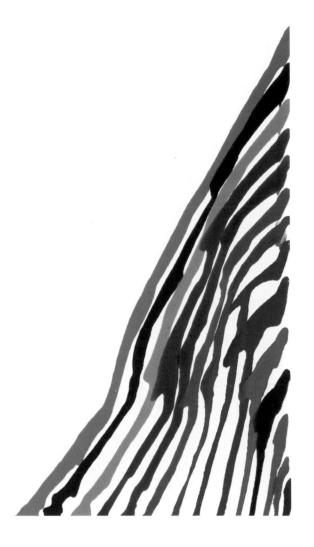

[BETA KAPPA]
1961
8′ 7¼″ × 14′ 5″
262.3 × 439.4 cm
National Gallery of Art, Washington, D.C.
Gift of Marcella Louis Brenner

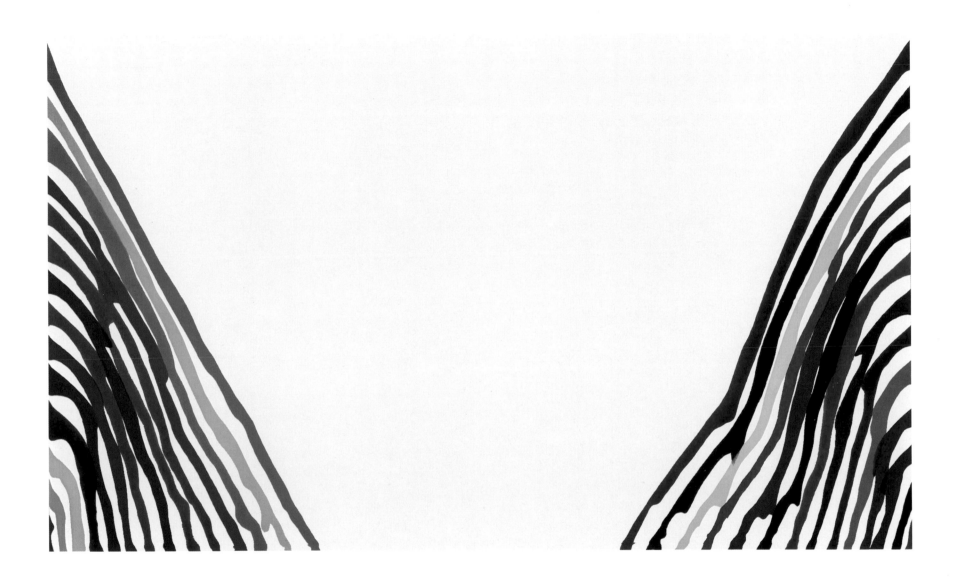

[SIGMA]
1961
8′ 7″ × 14′ 2½″
261.6 × 433.1 cm
Private collection

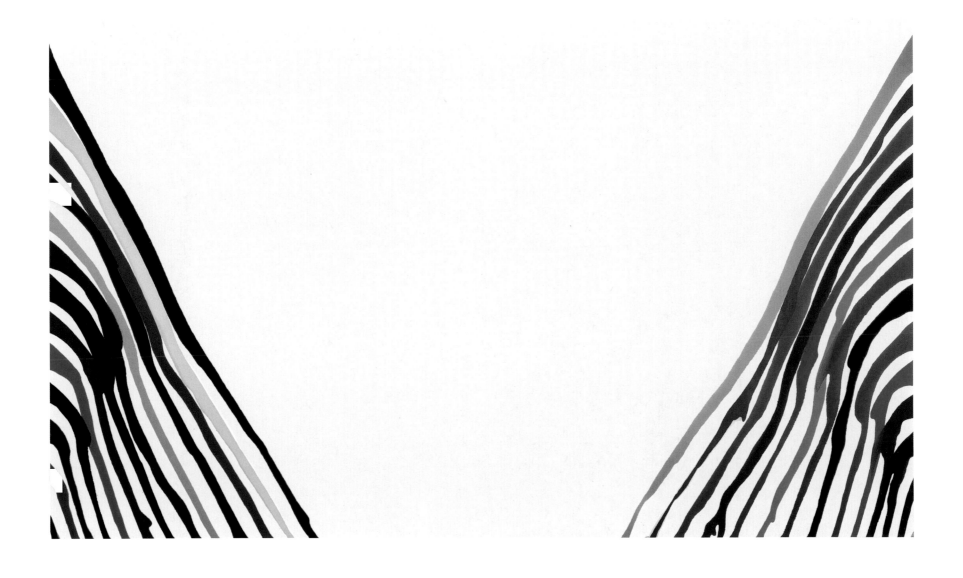

[NUMBER 11]
1961
6 × 6′
182.9 × 182.9 cm
Private collection

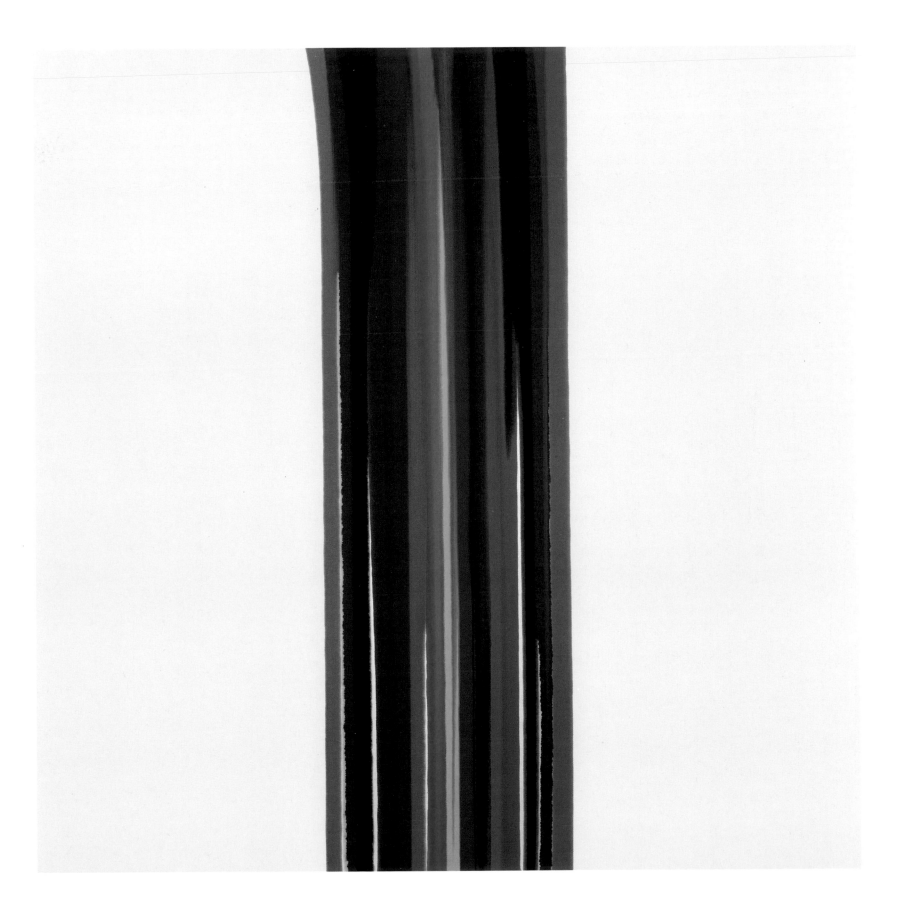

BURNING STAIN
1961
7′ 3½″ × 6′
222.3 × 182.9 cm
Sheldon Memorial Art Gallery,
University of Nebraska, Lincoln.
Nebraska Art Association,
Thomas C. Woods Collection

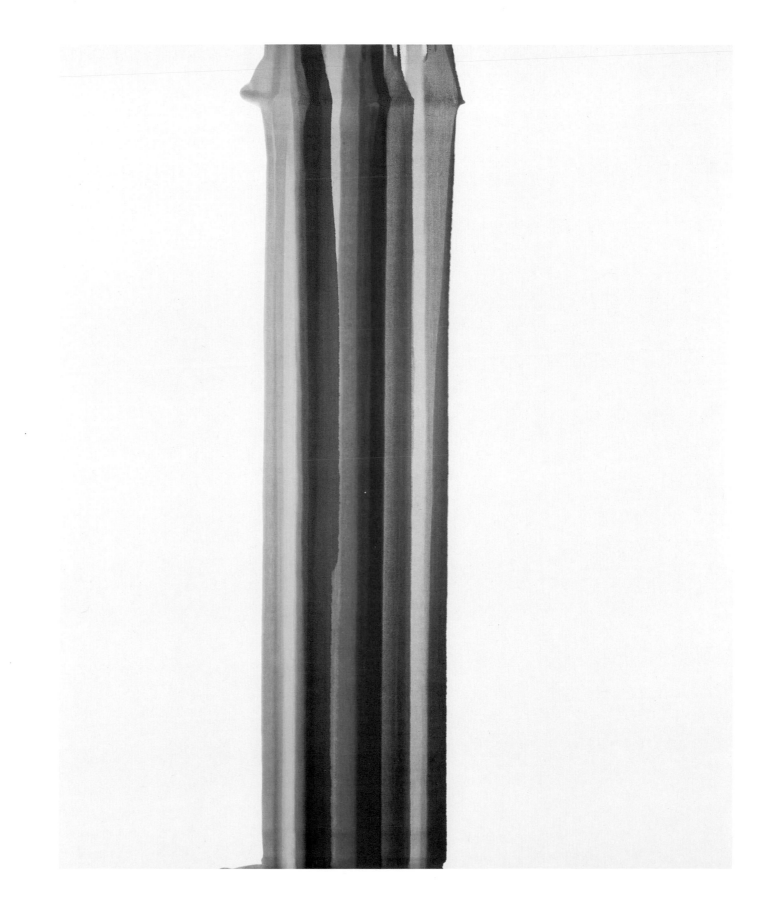

[NUMBER 9]
1961
7′ 3″ × 6′
221 × 182.9 cm
Collection Lois and Georges de Menil

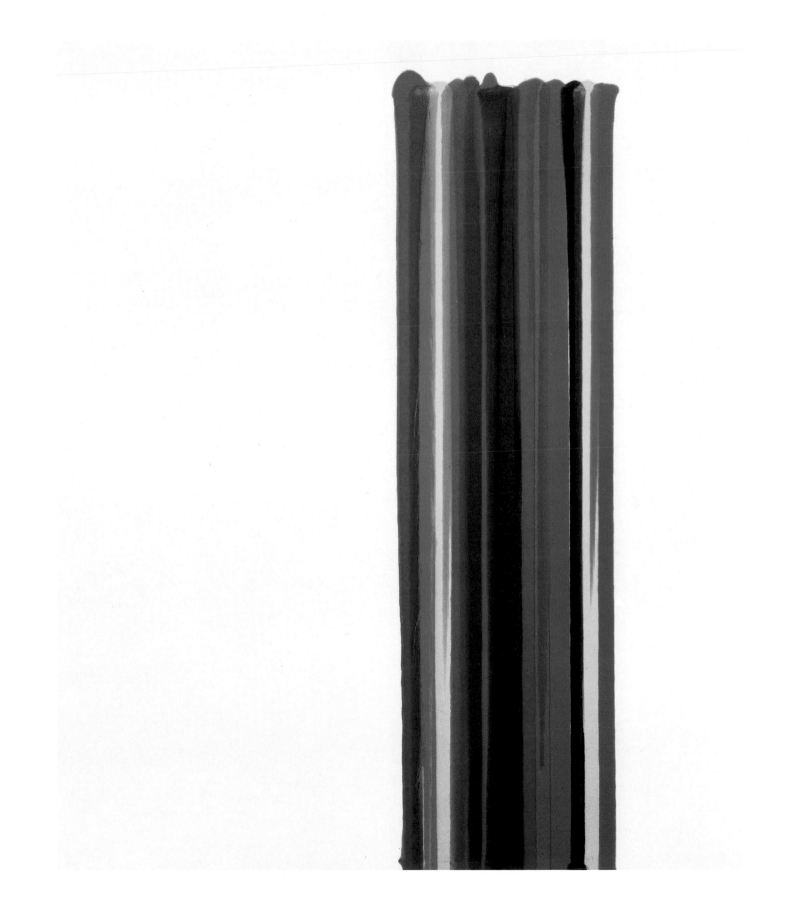

THIRD ELEMENT
1961
7′ 1½″ × 4′ 3″
217.2 × 129.5 cm
The Museum of Modern Art, New York.
Blanchette Rockefeller Fund

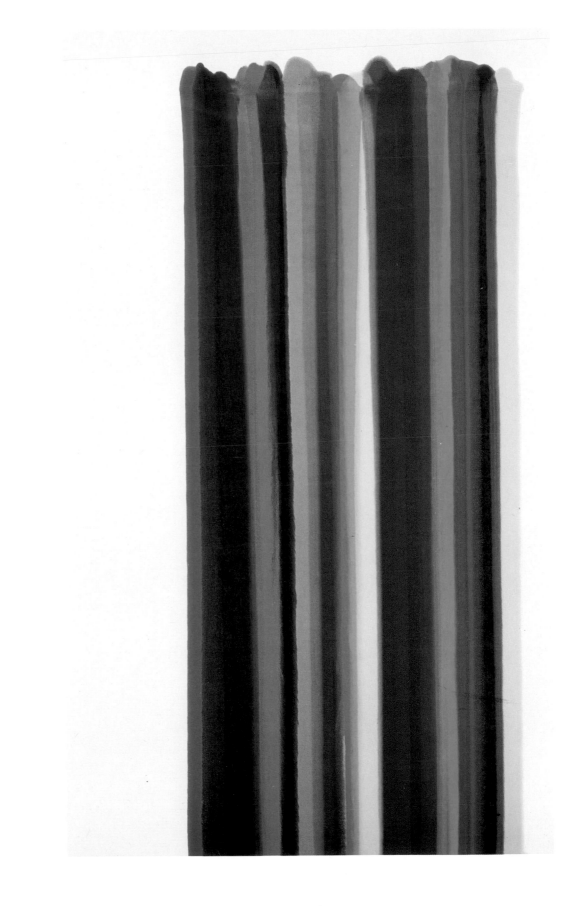

[NUMBER 33]
1962
7′ 3¼″ × 2′ 10⅝″
221.6 × 88 cm
Private collection

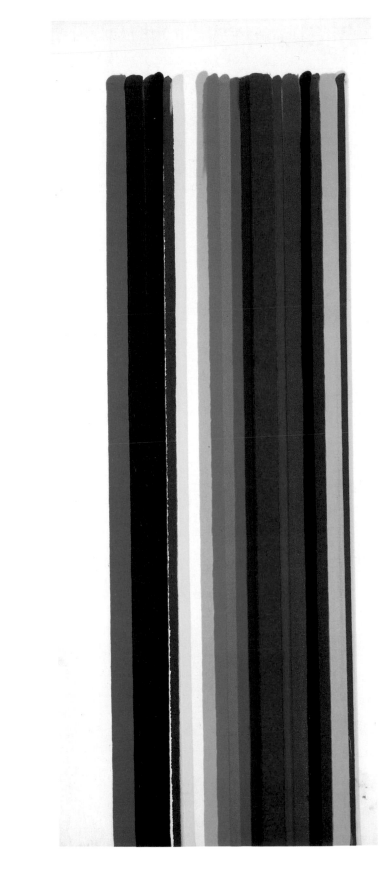

[NUMBER 2–64]
1962
6′ 9½″ × 1′ 9½″
207 × 54.6 cm
Collection Mr. and Mrs. Arthur Rock

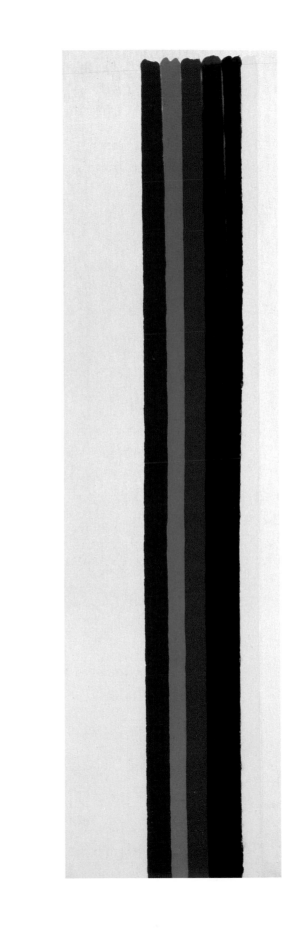

[CASTOR AND POLLUX]
1962
7′ 5½″ × 3′ 11⅛″
227.3 × 119.7 cm
The Eli and Edythe L. Broad Collection

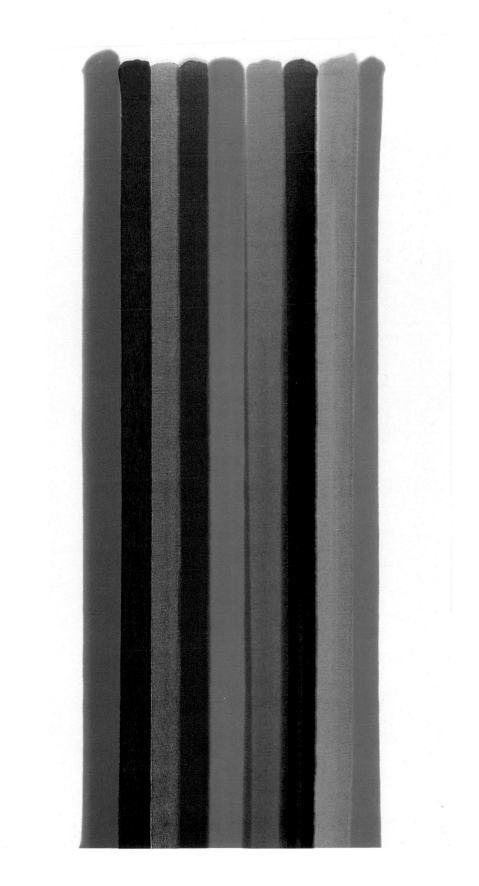

[ALBIREO]
1962
6′ 10″ × 4′ 4¾″
208.3 × 134 cm
Collection Mr. and Mrs. Marshall Cogan

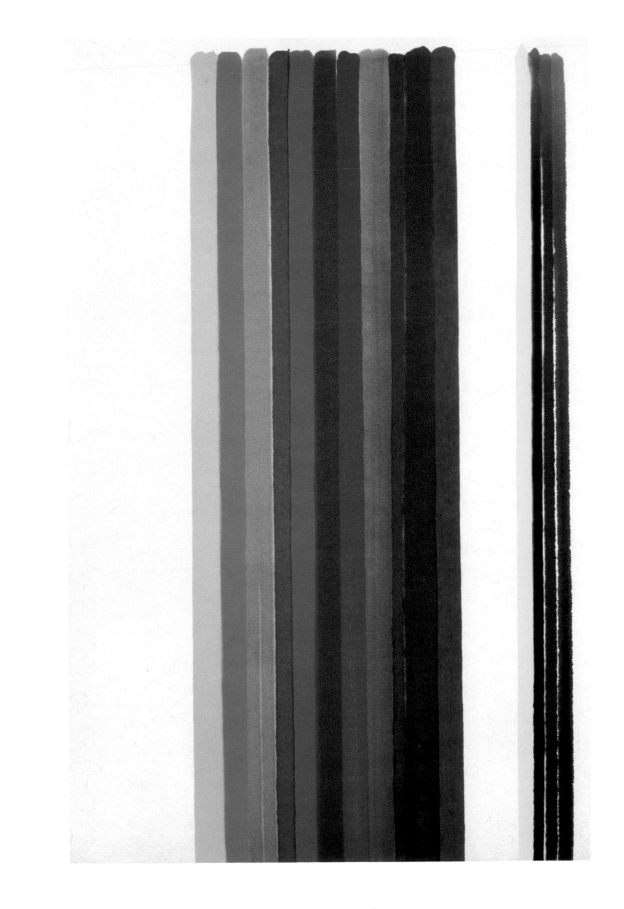

[NUMBER 19]
1962
6′ 8½″ × 1′ 1½″
203.5 × 34.3 cm
Collection Mr. and Mrs. David Mirvish

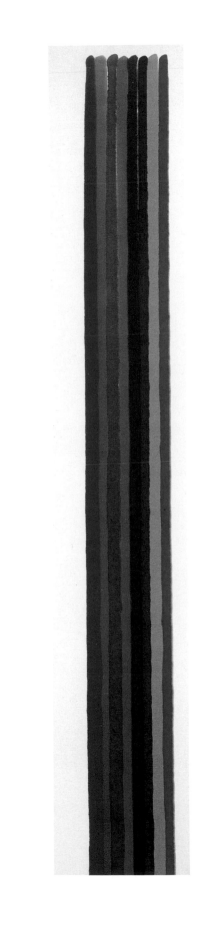

[BIPLANE]
1962
7′ × 1′ 7⅞″
213.4 × 50.5 cm
Collection Mr. and Mrs. Thomas Weisel

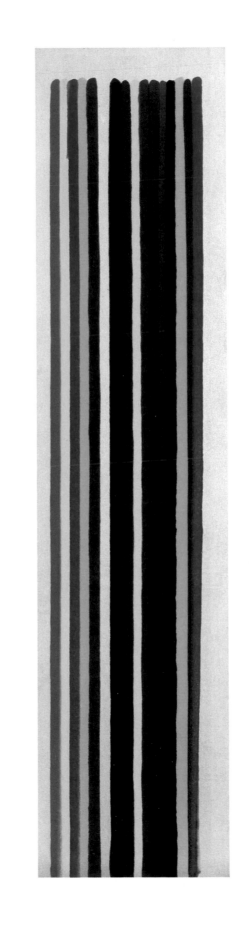

[NUMBER 1–99]
1962
6′ 6¾″ × 6′ 3″
200 × 190.5 cm
Collection Marcella Louis Brenner

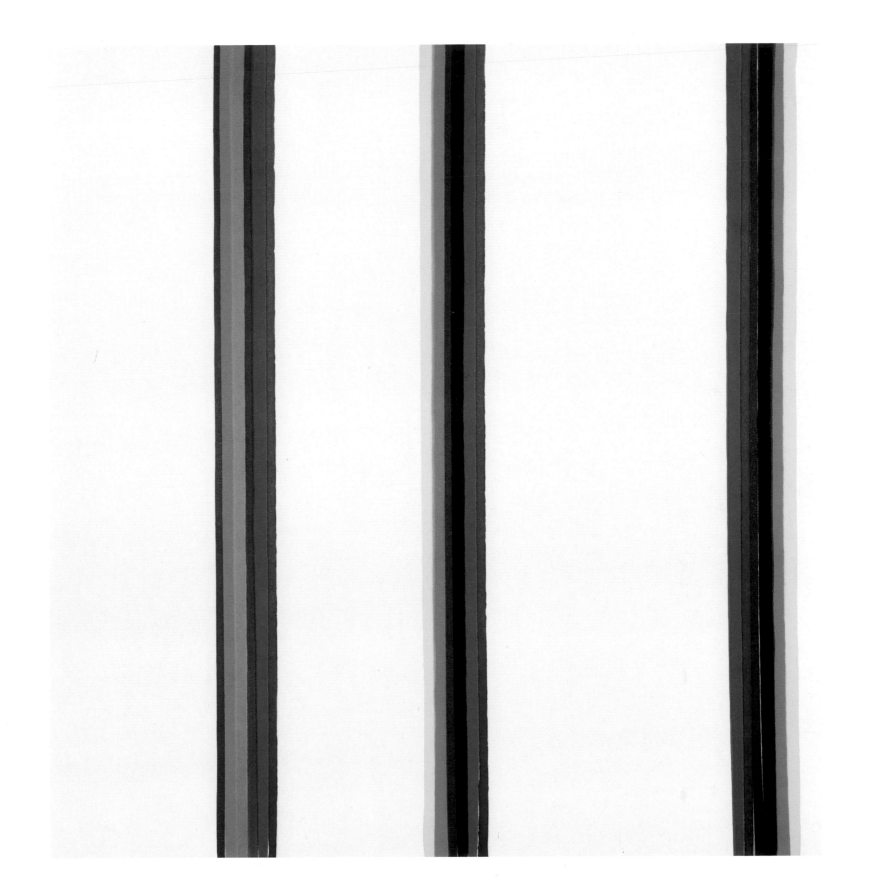

[HORIZONTAL VIII]
1962
2′ 1¾″ × 7′ 11½″
65.4 × 242.6 cm
Private collection

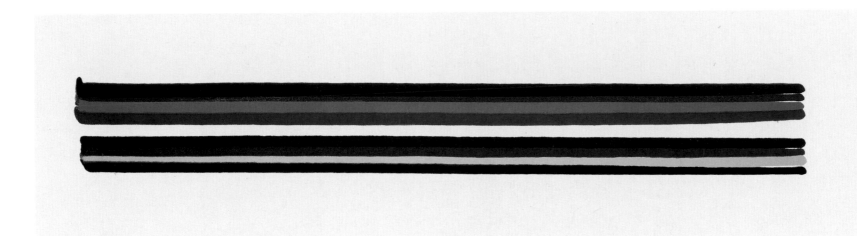

[HORIZONTAL I]
1962
2′ 8″ × 9′ 7″
81.3 × 292.1 cm
Collection Mr. and Mrs. Marshall Cogan

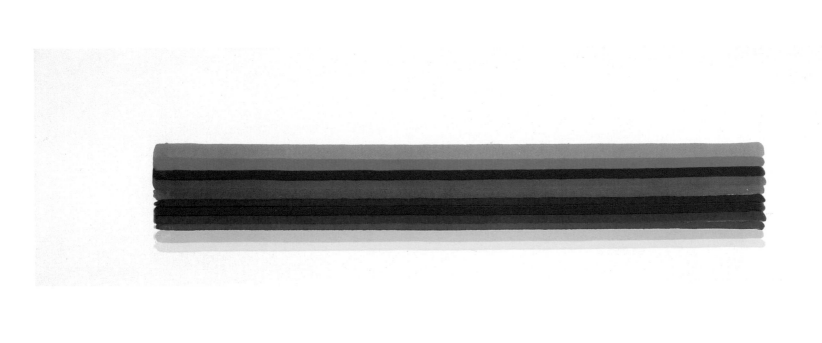

HOT HALF
1962
5′ 3⅛″ × 5′ 3⅛″
160.3 × 160.3 cm
Private collection

EQUATOR
1962
5′ 3″ × 5′ 3¼″
160 × 160.7 cm
Private collection

CHRONOLOGY

1912

November 28: Morris Louis Bernstein born in Baltimore, Maryland.

1918–27

Attended Baltimore public schools.

1927–32

Attended Maryland Institute of Fine and Applied Arts.

1933

Began sharing studio in Baltimore office building and supporting himself through various odd jobs.

1934

Assisted in Works Progress Administration (WPA) mural for a public school in Baltimore.

1935

Elected president of Baltimore Artists' Union.

1936

Moved to New York. Participated in the Siqueiros workshop. Became friendly with paint manufacturer Leonard Bocour.

1937

March: Exhibited two paintings at ACA Gallery, New York.

1938

Changed name legally to Morris Louis.

1939–40

Exhibited one painting at WPA Pavilion of New York World's Fair: *Broken Bridge*.

February 27, 1939–August 27, 1940: Employed by Easel Division of WPA Federal Art Project.

1943

Returned to Baltimore. Relied on his family for financial support.

1947

July 4: Married Marcella Siegel. Moved to two-room apartment in Silver Spring, Maryland; converted bedroom into a studio.

1948

Included in *Maryland Artists 16th Annual Exhibition*, at The Baltimore Museum of Art.

Began using only Magna, an acrylic resin paint made by Bocour.

1950

Served on Artists' Committee of The Baltimore Museum of Art.

1951

Commuted to Baltimore to teach small private painting class.

1952

Artists' Equity representative during second term on The Baltimore Museum of Art Artists' Committee.

Moved to house in Washington, D.C.; converted dining room into a studio.

Taught two painting classes per week at Washington Workshop Center of the Arts; became friends with fellow instructor Noland.

1953

Taught painting at Howard University as well as at Washington Workshop Center, and continued teaching private students in Baltimore and Washington.

April 3–5: Louis and Noland spent weekend in New York. Noland introduced him to Greenberg. Visited Frankenthaler and saw her painting *Mountains and Sea*, after which he destroyed most of his paintings of this year.

April 12–30: First one-man exhibition at Workshop Art Center Gallery, Washington, D.C. Exhibited: *Firewritten I, Firewritten II, Firewritten III, Firewritten IV, Firewritten V, Snow Flowering Image, Falling Upward, Set-Free, The Distance of Time, Vertical–Vertigo, Within–Without, Man Reaching for a Star, I'm in Love, The Tranquilities I, The Tranquilities II, The Tranquilities III*, selected drawings.

1954

January 11–30: Included in *Emerging Talent*,

at Samuel M. Kootz Gallery, New York. Exhibited: *Silver Discs, Trellis, Foggy Bottom*.

June 1: By this date had painted sixteen Veil pictures (first series).

June 6: Sent nine paintings, including seven Veils, to dealer Pierre Matisse for his consideration.

Returned to making more conventional Abstract Expressionist paintings.

1955

April 2–3: Greenberg visited Louis in Washington; encouraged him to come to New York more often.

October 5–24: One-man exhibition at Workshop Art Center Gallery, Washington, D.C. Exhibited: *Figures, Yellow, Close Black, Tea Rose Garden, Hot Eyes, Magnolia, Brittle Air, Slick, The Round Black*.

1957

May 6–25: Included in *New Work* at Leo Castelli Gallery, New York. Exhibited: *Untitled* (5–76), *Untitled* (5–75), *Untitled 1956*.

November 5–23: One-man exhibition, *Morris Louis*, at Martha Jackson Gallery, New York. Exhibited: *1954 (Salient), February 1956, March 1956, 1956 (Untitled 1956), January 1957, January 1957, February 1957, March 1957, April 1957, July 1957, August 1957 (No. 1), September 1957*.

Destroyed three hundred or more of his 1955–57 paintings.

1957/58

Winter: Began second Veil series.

1959

April 10–May 2: One-man exhibition, *Morris Louis*, at French & Company, New York. Exhibited: *Iris, Intrigue, Spreading, Terrain of Joy, Longitudes (Longitude), Breaking Hue, Pendulum, Libation, Atomic Crest, Colonnade, Surge, Turning, Broad Turning, Green Thought, Aurora, Plenitude, Moss, Lower Spectrum, Green by Gold, Russet, Crown, Bower, "Stand So We Must."*

Summer: Concluded second Veil series.

Included in *Summer Gallery Exhibition* at French & Company. Exhibited: *Intrigue, Bower, Turning*.

1960

Began to use more porous canvas, allowing greater color penetration.

March 23–April 16: One-man exhibition, *Morris Louis*, at French & Company, New York. Exhibited: *Loom, Addition, Seal, Bisection, Matrix, Winged Hue, Point of Tranquility, Where, Monsoon, Flood, Taper and Spread, Air Desired, While, Doubt, Drop, Joust, Saraband, Impending, Floral, Air Born, Quo Numine Laeso*.

Spring: One-man exhibition, *Morris Louis*, at Institute of Contemporary Art, London. Exhibited: *Intrigue, Libation, Air Desired, Quo Numine Laeso, Winged Hire (Winged Hue), Drop*.

April: Began using new formula of Magna paint of a more fluid consistency.

May: Greenberg's article "Louis and Noland," appeared in *Art International*.

May 3–13: Included in *New American Painting* at Galerie Neufville, Paris. Exhibited: *Iris, Air Desired*.

Early summer: Began to paint Unfurleds.

Exhibited two paintings at André Emmerich Gallery, New York: *Picture with Red Stripe, Picture with Blue Stripe*.

October 19–November 15: One-man exhibition, *Morris Louis*, at Bennington College, Vermont. Exhibited: *Drop, Alpha, Delta, Gamma, Capricorn, Green Painting (Salient)*.

November 23–December 2: One-man exhibition, *Morris Louis*, at Galleria dell'Ariete, Milan. Exhibited: *Autumnal, Vernal, Buskin, Zenith, Hesperides, Ganymede, Masque, Spawn*.

November 1960–February 1961: Included in *From Space to Perception* at Rome–New York Art Foundation, Rome. Exhibited: *Winged Hue, Iris*.

1961

January–February: Concluded Unfurled series and began to paint Stripe pictures.

March 17–April 22: One-man exhibition, *Morris Louis*, at Galerie Neufville, Paris. Exhibited: *Quo Numine Laeso, Vernal*.

October 3–21: One-man exhibition, *Morris Louis*, at André Emmerich Gallery, New York. Exhibited: *Water Shot, Earth Gamut, Pillar of Risk, Pungent Distances, Color Barrier, Pillar of Fire, Vaporous Pillar, Sky Gamut, Split Symmetry, Notes of Recession*.

October–November: Included in *New New York Scene*, at Marlborough Fine Art Ltd., London. Exhibited: *Libation, Moss, Colonnade, Spawn*.

October 13, 1961–January 1, 1962: Included in *American Abstract Expressionists and Imagists* at The Solomon R. Guggenheim Museum, New York. Exhibited: *Burning Stain*.

Included in *Society for Contemporary Art Exhibition* at The Art Institute of Chicago. Exhibited: *Pungent Distances*.

1962

April 21–October 21: Included in *Art Since 1950: U.S.A.* at Seattle World's Fair. Exhibited: *Pillar of Fire*.

April 27–May 24: One-man exhibition, *Morris Louis*, at Galerie Schmela, Düsseldorf, West Germany. Exhibited: *Quo Numine Laeso, Sidle*.

July 1: Cancer of the lung diagnosed.

Summer: Corresponded with André Emmerich about his forthcoming exhibition and gave James Lebron dimensions for stretching works to be included.

September 7: Died in Washington, D.C.

October 10–November 10: One-man exhibition, *Morris Louis*, at André Emmerich Gallery, New York. Exhibited: *No End, Equator, Hot Half, Prime, Infield, Purple Fill, Moving In, Apex*.

APPENDIX

Exhibition history; posthumous reputation; cropping and orientation; methods and materials; conservation

WHEN LOUIS died in 1962, he left behind approximately 650 paintings, of which all but 100 or so remained in his estate. Some 600 of the surviving paintings date from the nine-year period that constitutes his mature career.

Fewer than one hundred of the six hundred were seen publicly in Louis's lifetime. What is more, the degree of exposure of different types of pictures varied enormously. Hence, of the 16 1954 Veils, 9 were exhibited (at French & Company in 1959); of the 1955–57 pictures, probably 15 were exhibited (most at the Martha Jackson Gallery in 1957); of the 125 1958–59 Veils, 27 were exhibited (about half at French & Company in 1959 and 8 in Milan in 1960); of the 118 transitional pictures of 1959–60, 19 were exhibited (at French & Company in 1960); of the 98 Unfurleds, only 2 were exhibited (at Bennington College in 1960); and of the 230 Stripes, only 25 were exhibited (most at André Emmerich Gallery in 1961–62, including the exhibition that Louis prepared just before he died). It was therefore very difficult, during Louis's lifetime, to get an accurate idea of what constituted his *oeuvre*, even if one saw all the exhibitions up to 1962, whose contents are itemized in the Chronology. To put it another way, not only is Louis's reputation largely a posthumous one, so is our understanding of his artistic identity.

As the foregoing statistics show, a larger proportion of Veil pictures were shown in Louis's lifetime than any other kind of picture. This has remained generally true in exhibitions after Louis's death. By 1985, 11 of the 16 1954 Veils and 108 of the 125 1958–59 Veils had been exhibited. However, certain kinds of Veils remain less known. The six 1954 Veils in the exhibition which this publication accompanies represent the largest group of these pictures assembled since nine were shown at French & Company in 1959. Moreover, five of the six 1954 Veils bought by J. Patrick Lannan had never been seen publicly until their removal this year to The Lannan Foundation's museum in Lake Worth, Florida. Moreover, public ex-

posure of the bronze Veils, the first group in the 1958–59 series, was surprisingly slow to develop. Only eight of these approximately fifty pictures had been shown in Louis's lifetime. There were none in the 1963 memorial exhibition at The Solomon R. Guggenheim Museum, New York,[1] or in any subsequent retrospective until one was shown in the 1967 retrospective of fifty-four pictures organized by the Museum of Fine Arts, Boston.[2] Not until after the André Emmerich Gallery's 1969 exhibition, *Morris Louis: Bronze Veils*, did these important pictures become better known. Even then, the 1977 exhibition of twenty pictures, *Morris Louis: The Veil Cycle*, organized by the Walker Art Center, Minneapolis, included only five bronze Veils.[3]

Louis's wishes with regard to the 1955–57 pictures that he repudiated have been generally respected, and very few of them have been shown since his death. It has been claimed that the transitional pictures of 1959–60 have not received the attention they require, and that some remain largely unknown.[4] While it is true that many of the experimental pictures of this period have not been exposed, other pictures have been exhibited regularly; some two-thirds of them (74 out of 118) had been shown by 1985. This contrasts sharply with only nineteen seen in Louis's lifetime. Largely the result of the periodic release by Louis's dealers of hitherto unseen types of pictures (for example, a 1967 exhibition at the André Emmerich Gallery was devoted to Alephs), this has been corroborated by several museum retrospectives, a number of which have included a proportionally high number of such works (most notably the 1974 London exhibition, whose thirty-nine pictures included fifteen transitional works).[5] In 1970 the Whitney Museum of American Art, New York, first exhibited the Omega series. It is, of course, impossible to know what Louis himself would have thought of this, and the situation is complicated by the existence of seventeen of sixty-three canvases that Louis had directed to be destroyed in 1962

but that were not destroyed.[6] These are all from this transitional period, and a few are stylistically close to transitional 1959–60 works that he did exhibit in 1960. It is possible to deduce from these repudiated works that Louis may well have wanted to repudiate additional pictures, now in his *oeuvre*, had he lived longer. Greenberg has stated that Louis intended to destroy those transitional pictures now known as the Saf and Ambi series.[7] However, Louis's decision to destroy the sixty-three canvases was made the summer before his death, after his operation for cancer, and when he was too weak to paint. According to Marcella Louis Brenner, Louis constantly threw away pictures that did not satisfy him, and also periodically pruned his *oeuvre*. This, she observed, constituted a more extensive pruning than usual.

The Unfurleds, which now seem so quintessential to Louis's achievement, offer the most telling lesson in terms of the posthumous understanding of what constitutes his *oeuvre*. Since relatively few members of the art community can have seen the 1960 Bennington College exhibition at which two were shown, these paintings remained virtually unknown until after Louis's death, when one was included in the 1963 Guggenheim exhibition. (Mrs. Brenner has said that she was simply unaware of their existence.) In 1964 seven Unfurleds were first shown together at the André Emmerich Gallery. By 1985, some three-quarters of the extant works (seventy-three out of ninety-eight) had been exhibited.

Since the Stripes had been extensively shown prior to and just after Louis's death, the 1963 Guggenheim exhibition did not include any. This turned out to be a forecast of how the Stripes would be treated in most Louis retrospectives (the 25 exhibited in Louis's lifetime jumped, by 1985, to 168 or around three-quarters of the 230 made). The fifteen Stripes in the current exhibition probably comprise the largest number of these pictures ever shown together.

It should, finally, be observed in this context that Louis's pre-1954 pictures have only been shown once in some depth since his death: in the 1967 Boston retrospective.

A study of the exhibition history of Louis's pictures reveals that complete understanding of all the series that constitute his *oeuvre* gradually emerged only after his death. Such evidence as there is suggests that Louis's main series of pictures were worked on quite separately. (The evidence is less conclusive about the transitional pictures of 1959–60; there some series may well have been worked on concurrently.) However, the separate terms we use to describe them are not Louis's. For example, the designation "Veils" was suggested by William Rubin.[8] And it has been quite common for what are more properly considered Florals to be described as Veils, even in the catalogues of major exhibitions. However, it is unlikely that Louis himself would have been bothered by this. All the various designations for transitional 1959–60 pictures (Aleph, Ambi, Omega, etc.) are posthumous. Louis did obliquely suggest the name "Unfurleds," when he wrote of *Alpha* and *Delta* as "unfurling" pictures.[9] However, he referred to the Stripes as "pillars."[10] That designation gradually became more closely attached to those pictures now usually referred to as Columns; the designation Stripes is now so firmly established that it would be fruitless to try to return to Louis's term. As mentioned in Chapter Three, Louis was not interested in giving titles to individual works. However, with a few exceptions (for example, *Castor and Pollux*), all pictures other than Stripes with unique (not generic) titles were given in Louis's lifetime, though not usually by Louis himself, and may usually be taken as an indication that Louis himself released the work from his studio. After Louis's death, it was decided to title the hitherto untitled Veils that remained in the estate after the transliterations of names of the letters of the Hebrew alphabet (*Beth Heh*) and the Unfurleds after the Greek alphabet (*Alpha Beta*).

With the exception of the contemporaneous titles *Alpha* and *Delta*, which suggested this approach, all such titles are posthumous. The generic titles containing the word "Pillar" were given in Louis's lifetime and, like two-word titles such as *Burning Stain*, identify 1961 Stripe paintings; most 1962 Stripe paintings titled in Louis's lifetime have single-word titles. However, paintings named after stars (for example, *Albireo*) were titled posthumously. There is only one title in Louis's *oeuvre* that suggests the specific period of the work's creation: *Atomic Crest* of 1954. However, a letter from J. Patrick Lannan to Louis, dated July 15, 1958, describes his purchase of a work "in very bright colors that cross the painting horizontally . . . like a new modern flag or banner of an atomic regiment." The reference may be to another picture Lannan also bought;[11] that other picture may well be *Atomic Crest*. In any event, Lannan, not Louis, seems to have suggested this title.

Many paintings, especially Stripes, bear numbers not titles. These are estate numbers and were given as the canvases in Louis's house were unrolled after his death. It is sometimes assumed that paintings with numbers close to each other were painted around the same time. However, according to Mrs. Brenner, except for some of the smaller Stripes, Louis rolled his pictures separately,[12] and must have periodically reviewed groups of pictures, altering the order in which they were stored (or rolled). Louis usually gave titles or dates to his works when preparing for exhibitions. Similar contemporaneous titles (like *Verdicchio*, *Vernal*; *Pillar of Celebration*, *Pillar of Delay*) may usually be taken to indicate that the works in question were painted around the same time, but it cannot be assumed that they were painted consecutively.

More problematical are the dates that Louis inscribed on his canvases before sending them out for exhibition since these sometimes do not represent the dates the paintings were made. As explained in the text, the exact chro-

nology of Louis's paintings is likely to remain obscure. The chronology offered in the text is hypothetical and differs in some respects from that in the catalogue raisonné. Among specific problems of chronology not covered in the text are the following.

Regarding 1953–54: Greenberg has said that he was shown approximately thirty pictures in January 1954 when he visited Washington and that most contained floral motifs and were too dependent on Pollock.[13] The catalogue raisonné lists only nine pictures from this crucial period when Louis responded to the impact of *Mountains and Sea*; the other pictures were presumably destroyed. Also problematical is the identity of the nine works that Louis sent to New York in June 1954.[14]

Regarding 1958–59: It has been suggested that those Veils with what looks like the mark of a horizontal stretcher bar on their surfaces possibly precede the triadic Veils, and that Louis learned from the "mistake" that caused the horizontal mark when he constructed the stretcher for the triadic Veils so as to produce two clearer vertical marks.[15] This, however, cannot be true. The horizontal mark appears on Veils on the larger width canvas that Louis only began using after most of the triadic Veils had been completed. Furthermore, it is by no means certain that the horizontal mark was produced by a stretcher bar. Especially problematical is the dating of the Italian Veils, some of which are inscribed with the date 1960 while the catalogue of their first exhibition, in 1960, dates them 1959–60. I follow Diane Upright in believing that they were painted in 1959 and that Louis dated them before releasing them for exhibition.[16]

Regarding 1959–60: The only guide for establishing a reasonable chronology here is the exhibition record for 1960. It is in this period that my account differs most from that in the catalogue raisonné, especially in placing the "While" and "Where" pictures closer to the Veils, in associating the "Winged Hue" pictures with the Florals, and in placing the Alephs

after the Florals not before them. (It should also be noted that *When*, 1960, unlocated in the catalogue raisonné, is in a New York private collection and is a picture similar to *Spawn*.)

Although Louis's method of making his pictures is discussed at several points in the text, these additional observations, and guesses, are worth noting. According to Mrs. Brenner, Louis placed his stretcher against the only window-free wall in the studio at the house at 3833 Legation St. N.W. Its maximum dimension was about twelve feet, if not less, and some pictures, therefore, must have been painted in sections. The vertical divisions within the triadic Veils have been explained as the result of Louis folding his canvases to allow this. However, Diane Upright has convincingly demonstrated that these vertical marks are the impressions of wooden braces against which the canvas rested, and argues that Louis must have constructed a special stretcher with internal vertical braces to produce these pictures.[17] She also suggests that Louis must have had different stretchers for different series. If so, the height of the stretcher was determined by the width of canvas Louis used at a particular time and its length by the desired dimensions of the works in a particular series (except for the Unfurleds, whose lengths usually exceed that of any stretcher Louis could have fit against his studio wall). This would mean that the 1954 Veils, the 1959 Italian Veils, the 1961 Stripes, among others, were made on an approximately seven-by-nine-foot stretcher, the 1958 bronze Veils on an approximately eight-by-twelve-foot stretcher, and the larger 1959 Veils, and other paintings, on an approximately nine-by-twelve-foot stretcher.

Mrs. Brenner is certain that there was only one stretcher at any time in Louis's studio. If it was the same stretcher from 1954 through 1962 (which has to be unlikely), the theory of different stretchers for different series is clearly wrong. In any event, it probably requires revision of that theory. There may well

have been only two stretchers: one eight feet high and one nine feet high, according to the size of canvas Louis used, and both around twelve feet long, for Mrs. Brenner is sure that the stretcher filled all the available space on the window-free studio wall and that smaller pictures used only part of its length.

The theory that Louis constructed a special stretcher with vertical braces is challenged by Mrs. Brenner's memory of there being no stretcher with any internal divisions at all, only the four elements that formed its rectangular shape. Diane Upright's photograph of the back of one Veil (*Dalet Mem*) indisputably shows the imprint of a vertical strut.[18] This would seem to contradict Mrs. Brenner's memory. And yet, that imprint could conceivably have been produced by the lateral upright of the stretcher if Louis had made such pictures in sections, moving the canvas horizontally across the stretcher as he painted it. This would have required very careful measurement on Louis's part, since the spacing of the internal verticals in the approximately fifty triadic Veils is virtually identical. But Louis was an extremely dexterous person (his widow remembers), and it is known that he used lengths of string to check compositional elements in his students' work.[19] It is reasonable to assume he used them in his own.

However, there is an alternative explanation for the vertical divisions within the triadic Veils. It is interesting to note that Upright's photographs show only the imprint of a vertical strut. If Louis had constructed a stretcher with vertical struts dividing, and therefore attached to, the external rectangle, one would expect to see the impression not only of the vertical but of the horizontal it abuts. The fact that one does not see this suggests that the verticals were separate from the stretcher and carefully positioned in front of it, that the canvas was loosely tacked over them onto the stretcher, and that Louis used these vertical elements as levers to control the flow of paint down and across the surface. This is, naturally,

supposition. But it serves to explain two hitherto mysterious features of some triadic Veils: those with large areas of bare canvas at the base of the dark vertical elements within the painted image and those where the dark vertical element on the right stops below the top edge of the painted image. The former is difficult to explain if one assumes that the vertical struts were part of the stretcher. If their tops were rested against the top horizontal edge of the stretcher and their bottoms were pulled forward from the stretcher, with the canvas draping around them, that would be the result. The latter is impossible to explain if the vertical struts were part of the stretcher. But if Louis pulled down the one on the right so that its top lay against the wall below the top horizontal of the stretcher (leaving the left vertical to rest on the horizontal), that would be the result.

As noted above, some Veils have a horizontal mark running across their surfaces. This is almost certainly not the mark of a stretcher bar since it is too irregular and too thin for that. Some Veils (for example, *Air Desired*) show a sequence of horizontal striations. These may have been caused by Louis applying the dark scrim with a cheesecloth-covered swab, which abraded the surface in this way, or they may have been caused by Louis rolling his pictures immediately after completing them, then piling other pictures on top of them, thereby flattening somewhat the unprotected rolls. However, the cause of the single, bolder horizontal marks remains unknown.

Since all of the 1954 Veils were released in Louis's lifetime, they pose no problems with regard to their cropping. In the case of later Veils, however, there are some anomalies that deserve mention. Cropping at top and bottom is rarely a problem. Louis's rule, with a few exceptions, seems to have been, at the top, to use whatever amount of canvas (usually very little) was available above the painted image and, at the bottom, to cut through the middle of the puddled paint at the base of the image. There is only one work, *Plenitude*, where the base of the painted image is floated entirely free of the bottom edge of the picture. This, however, was cut down after its first exhibition, and it is conceivable that the base line was changed. Cropping at the sides is where anomalies exist. Of the ten 1958 Veils in the 1959 French & Company exhibition, eight were subsequently recropped, bringing in their margins—mostly at the sides but also, at times, at the top. *Bower* is one of the recropped pictures (it originally measured 8′ 10″ × 14′ 10″ and now measures 7′ 11½″ × 11′ 5¼″). The two pictures not recropped (presumably because already sold) were *Russet* and *Turning*. A narrow Veil, *Gamma*, shown at Bennington in 1960, was also subsequently recropped. It has been the practice of the Louis estate to follow the approach of narrow cropping.

Only two Unfurleds (*Alpha* and *Delta*) were stretched in Louis's lifetime. For the others the practice of the Louis estate has been to establish the top edge by using the maximum amount of canvas available there even if that has meant that the uppermost rivulets descend from beneath the corners rather than from on them, as in *Delta*. This conservative approach is unquestionably the correct one, but it cannot, of course, be known what Louis's would have been. The first Unfurled to be stretched after the artist's death was done in such a way as to leave a maximum horizontal dimension too.[20] However, this allowed scuff marks, where the canvas had been folded around the stretcher at the sides, to show on the front of the picture. Subsequently released works were stretched slightly narrower so as to remove these marks. One picture at least (*Alpha Lambda*) is stretched so as to leave visible the slight pooling of the paint in each rivulet before it began its descent of the canvas. It is uncertain whether there are more like this. In any event, the vast majority of pictures are stretched so as to remove these elements. *Alpha* and *Delta* are stretched with these elements removed. However, whether Louis would have treated narrow-band Unfurleds in the same way—or all pictures of each type similarly—cannot, of course, be known.

Many of the Stripes were left in the estate without indication of how they should be cropped at the top. According to Greenberg, Louis regularly left this decision to last since he felt it was the most crucial.[21] As with the Unfurleds, the estate has followed the conservative practice of using the maximum amount of canvas available although in the case of some narrow-stripe pictures the maximum can seem to be too much. In the vast majority of cases, the sides were indicated by Louis's green crayon crop marks.

Other questions concerning the cropping of the Stripes are discussed in the text. To the remarks there concerning the orientation of these pictures two points should be added. First, there is still some confusion regarding Louis's preferred hanging of the horizontal Stripe pictures. According to André Emmerich, Louis intended these pictures to be seen either vertically or horizontally but preferred them horizontal. According to Greenberg, Louis was undecided about their orientation.[22] Second, there have been questions raised as to the orientation of the diagonal Stripe pictures, E. A. Carmean, Jr., having suggested that Louis may have considered hanging them with the canvases as diamonds and the stripes horizontal.[23] Since the evidence for this is not conclusive, it would be difficult to justify their being hung other than as squares.

The basic properties of Louis's paint, Magna, are discussed in Chapter Two. More detailed information about Magna itself, and acrylic paints in general, is readily available.[24] However, information about the special conservation problems associated with Louis's paintings is extremely sparse, and some that is readily accessible is misleading. The following notes offer some guidance on this subject.

The advantage of Magna over oil paint for

staining is that it does not contain an acidic component to the degree that oil does, which will eventually deteriorate the fibers of un-primed canvas. Because it is oil-compatible, it can be thinned with turpentine as oil paint can. It can also be extended with additional amounts of the acrylic resin vehicle used in its manufacture (Acryloid F-10), but it dries much more quickly than oil paint. Louis, we know, did thin his Magna, often very heavily indeed. Diane Upright has estimated that in 1958 he used about twenty-nine times as much thinner (both turpentine and resin) as paint, and that a typical 1958 Veil was produced from about nine two-ounce tubes of paint and four and a half gallons of thinner.[25]

The use of so much thinner has two potentially injurious results. First, it is a health hazard to use such large quantities of toxic substances in a confined space. Second, if the thinner is turpentine rather than resin, it risks so diluting the resin in the paint itself that its ability to bond the pigment particles and create a firm and stable paint film is reduced. Therefore, the higher the proportion of turpentine over resin that Louis used, the more fragile are the painted surfaces of his pictures. The matte surfaces caused by the use of turpentine abrade more easily than the relatively glossy surfaces caused by the use of resin. They also tend to trap airborne particles of dirt, and are less easily cleaned, for whereas the glossy resin surface has a similar kind of resistance to that of a varnish, the matte surface is unprotected in this way. Of course, the glossy surface produced by extending with resin cannot be removed and replaced as a varnish can—and it is not known whether the resin might eventually discolor somewhat, thereby altering the value of the colors—but it does produce a sturdier surface. The painted parts of all Louis's pictures are necessarily stiffer than the unpainted parts. (This can create problems in stretching, for some of them have to be pulled very tightly to flatten the painted parts.)[26] Louis used turpentine ex-

tensively in the 1954 and 1958 Veils. The 1959 Veils with brighter colors were painted with somewhat less of it. By 1960, when Louis began using a more liquid form of Magna and turned from area to linear pouring, thinning was necessarily required less often, and when Louis did thin the paint he tended to use more resin than turpentine. The actual paint areas of the 1960–62 pictures are therefore sturdier than those of the preceding ones. (Greenberg observed that Louis was forced to destroy forty Unfurleds because their blues were not fast.[27] It is not known what Louis had done to cause this to happen, but excessive thinning was again probably the culprit.) However, these later pictures are the ones that often contain larger areas of unpainted canvas, which is more fragile and less easily cleaned than any painted area.

Louis apparently did not stop sizing his canvases with rabbit-skin glue until sometime either in 1958 or 1959. Hence, the 1954 Veils and some of the 1958–59 Veils contain sizing of this kind in addition to the canvas manufacturer's size (cornstarch). Traditionally, the point of sizing was to prepare for the application of a primed ground that would isolate the paint surface from the canvas and inhibit the "sinking" of paint. Louis's first pictures in which he experimented with staining, like *Trellis* of 1953, are primed; of course, none of his stained pictures from 1954 onward are primed. But the sizing itself inhibits, to varying degrees, the penetration of stained color into the surface. According to Greenberg, Louis used sizing to control the degree of absorbency of his surfaces.[28] According to Louis's widow, he did not use it for every picture, but just as he needed it, and to the degree he needed it. In the 1954 Veils, its use—along with excessive turpentine—prevents the even absorption of the medium by the fabric, thereby leaving sedimented paint particles on the picture surface. If sizing is unevenly applied in stained paintings, the degree of penetration, and therefore the intensity, of the subsequently ap-

plied color is necessarily affected. If it is applied on top of a manufacturer's sizing (as it was in Louis's case), it can be applied very evenly indeed but still affect the degree of penetration of the subsequently applied color. For unless the manufacturer's sizing is removed by washing the canvas, the new size makes the original one resoluble, creating irregular patterns. Their effect on color penetration is visible in the 1954 Veils particularly.

These patterns, and the patterns of the brushstrokes that applied the size, can also become visible in the unpainted parts of the canvas as it ages. It has been suggested that the brown streaks that have appeared in the bare canvas areas of some Veils and Florals are the result of Louis having coated these areas with acrylic resin in the mistaken assumption that he was thereby protecting them, and that this can be identified by the unusual stiffness of the unpainted canvas. This, however, is by no means certain. It is possible that the size that Louis applied—or the white paint he sometimes used in these areas—produces these marks (and the stiffness of the canvas).

Louis's use of sizing may have provided him with one more method of articulating the painted areas of the Veils, but in the unpainted areas it was certainly problematical. It also causes greater than usual fluctuations in the degree of tautness between painted and unpainted areas when fluctuations of temperature and humidity occur. Louis, however, was unlikely to have realized this since he did not stretch his paintings until they were sent for exhibition, often did not stretch them himself, and did not keep stretched paintings in his house. When he abandoned sizing, it was certainly to achieve greater and more even color saturation, as can be seen by the pictures of 1960, by which time he had certainly stopped sizing any work.[29] The same reasons lie behind his turn from a heavier (No. 10) weight canvas to the lighter and more porous (No. 12) weight canvas that same year.[30] But he did not wash out the manufacturer's sizing: he

did not want the very extreme level of saturation that would have created.

A number of the 1954 Veils show whitened areas around the veil image itself that terminate in loose brushstrokes just short of the tacking edges. These areas are almost certainly created with white paint and not with gesso, as is often assumed. In Chapter Two I referred to how the whiteness of the paint accentuates the vividness of the shape of the veil and how its granularity associates itself with the gritty sediment within the veil. To this should be added, first, that its method of application—fading out toward the margins—is yet another example of Louis making reference to Pollock's compositional methods; and second, that when Louis began consciously shaping the veil image in his 1958 pictures, and moved to darker tonalities too (partly to emphasize their shape), the whiteness of the paint was no longer needed. (Louis continued at times, however, to use a duller white paint in these areas.) Nor was its granularity needed, since Louis additionally eliminated granular detailing, relying instead on drawn detailing to hold the eye to the surface of these pictures. (When granular detailing does appear in Veils of 1958 and 1959, it is almost certainly accidental.) In 1960 Louis briefly returned to the use of white paint around the margins of some pictures. Greenberg has explained that the preparators at French & Company suggested using it to cover up the finger-marks on the margins of some of the pictures he exhibited there that year, and that Louis liked the effect and used it for a while for aesthetic reasons. (It does not, in fact, successfully cover finger-marks unless used so thickly as to be bothersome in effect.)

Although Magna is an oil-compatible paint, it cannot be cleaned with the common solvents used for cleaning oil paintings since they tend to soften or even dissolve the resin that holds the paint together. Being oil-compatible, it is, in theory, able to be cleaned by water. In practice, however, this can be ex-

tremely risky, especially if the paint is under-bound by resin. A number of Louis's paintings have been washed. Among the risks, however, are that the painted and unpainted areas react very differently to moisture. If the whole surface is wet, there is a very great danger that it will warp and change in shape. In those paintings that have been washed the painted and unpainted areas have been treated separately. Some works, of course, do not allow for easy separation of these two areas, and the paint areas of others are so clearly under-bound by resin as to render them water-soluble. The paint areas of certain Stripe pictures where the resin content of the paint is very high have been successfully cleaned in this way, but not without the risk of problems in other parts of these pictures. The general danger in this approach is that the picture must be removed from its stretcher and kept under tension while it is being cleaned. On numerous occasions, increase in dimensions of the picture has been the result of these washing procedures. Additionally, washing is likely to produce one or more of the following deleterious results. In the painted area, it can cause actual pigment loss, especially in turpentine-thinned pictures. This may show in the form of a lightening of the painted area, causing a picture to seem paler than it was previously, or in the form of increased tonal variation within the area. In pictures with sedimented pigment on the surface, it could well remove the sediment, thereby drastically defacing them. In the unpainted area, it has been shown to produce a loosening and napping of the canvas fibers (and therefore a fuzzy, out-of-focus look) because it removes the cornstarch size. Such size cannot be reintroduced evenly without difficulty. Washed pictures have been resized with a synthetic size (Klucel) after their surfaces have been sponged in such a way as to make their fibers lie in the same direction and therefore look uniform in color. It has been claimed that Klucel also has the effect of returning depth of color to faded or abraded areas. How-

ever, the matted appearance of the surface of some washed pictures (which even at times seems like that of fiberglass) may possibly be attributed to its use. Washing may also draw through to the surface of a picture, by capillary action, an inscription on its verso.

Even more dangerous than washing with water is the use of bleach. It can exacerbate all the problems associated with washing, has been known to remove surface inscriptions, and, since it is difficult to remove bleach entirely, it can darken later, leaving the canvas in a worse condition than before. All this suggests, therefore, that only surface cleaning without solvents performed by a qualified conservator is safe for paintings like Louis's. However, it is wrong to assume that any painting can ever be returned to the state it was in when it left the artist's studio—even if one knew what that state was. In the case of Louis's paintings, attempts at cleaning can at times make matters worse, causing even greater abrasions (showing as lighter marks) in the painted areas and smudges in the unpainted ones.

Clearly, the unpainted areas are the most vulnerable to damage and the most difficult to clean. Airborne pollutants that are allowed to rest within the fabric can in time, under high-humidity conditions, promote deterioration, thus weakening and discoloring the fabric. It has been suggested that the soiling of the un-coated canvas would be greatly reduced or prevented if the entire picture was coated with a transparent lacquer, the solvent of which did not soften or dissolve the acrylic resin. Leaving aside the aesthetic problem, the technical problem is that no solvents are totally safe.

All of this suggests that Louis's paintings are prone to soiling. However, certain basic methods of care and attention, easily adopted, will keep them in good repair. They should be shown with a maximum illumination of thirty foot-candles, in stable conditions of relative humidity between forty-five and fifty-five percent and of temperature between sixty-five

and seventy degrees, and in unpolluted conditions. Intense light will both degrade the fabric and cause colors to fade. Unstable conditions of humidity and temperature will cause constant alterations in the tension of the canvas. High humidity will encourage mold growth, and pictures should not be hung on damp or outside walls. As hot air rises, it will carry with it airborne dirt and pollutants; pictures, and especially those with bare canvas, should never be hung close to the ceiling as they will begin to discolor along the top edge. In addition, like all paintings, they should be stretched on a broad, firm stretcher with sufficient cross members to keep them in plane and eliminate racking. (A constant tension stretcher is not recommended unless very limited fluctuations of temperature and humidity can be absolutely guaranteed. Otherwise, too much stress is placed on the fabric.) Their edges should be protected by a frame of some kind. And backing-board should be used to prevent damage from careless handling of the back of the canvas and to form an air pocket, which minimizes oscillation when the picture is moved.

Since the acidity in the wood of the stretcher can cause discoloration of the adjacent canvas area in certain conditions (especially if the picture is kept in an area that is too hot, too damp, or has poor ventilation), it is recommended that the wood of the stretcher be isolated from the canvas. This can be done by painting the stretcher or by coating it with a stable resin. Physically isolating the picture itself by loose-lining is suggested as an additional preservation procedure. (A polyester fabric is strongly recommended.) This serves the additional purpose of supporting the canvas; it is noticeable that the bare canvas at the tacking edges of especially large pictures tends to weaken and even tear, as the fabric weave is pulled open there by the tension of stretching. Loose-lining supports the canvas without altering its surface.

These paintings should be periodically inspected for damage. Particular attention should be paid to weakening of the fabric along the tacking edge, to signs of rust around Louis's tack and staple marks, especially if they appear on the surface of the picture, as they do in some Veils and many Stripes, and to signs of dust accumulation. Periodic vacuuming of both front and back surfaces should be performed by a qualified conservator in order to keep them dust free.

Great care should be taken before keying a picture and increasing its surface tension to compensate for changes in humidity. There is a real danger of the canvas tearing if it is over-keyed. Far better to wait for a few days to see if the tension adjusts by itself.

Many Color Field pictures have been glazed to protect them from accidental damage. Although aesthetically not pleasing, this does of course afford very good protection. Works to be stored for extended periods can be removed from their stretchers and rolled on a drum (the larger the better) if their surfaces are not too fragile. Many larger paintings are now stretched on folding stretchers to facilitate moving them. If the folding operation is undertaken by qualified handlers it is an acceptable solution to this problem. However, pictures should never be stored thus folded for lengthy periods.

NOTES TO THE TEXT

ALL REFERENCES are given in abbreviated form; full citations may be found in the Selected Bibliography.

CHAPTER ONE

1. Upright 1979, pp. 16–18.
2. Quoted in Upright 1985, p. 10.
3. Upright 1979, cats. 215ff.
4. Alloway 1963, n.p.
5. Quoted in Benson 1969, p. 37.
6. Quoted in Truitt 1961, p. A10.
7. See Moffett 1977, pp. 20–22, and Waldman 1977, pp. 9–17.
8. Quoted in Benson 1969, p. 37.
9. Cf. Rose 1971—2, pp. 21–34.
10. Greenberg 1964—2, p. 91.
11. Greenberg 1952, p. 153.
12. Greenberg 1948, p. 144.
13. See Sandler 1978, pp. 2–11, 15–16.
14. Dzubas 1965, p. 51.
15. Sandler 1978, p. 15.
16. Greenberg 1952, p. 146.
17. Quoted in Carmean 1976—3, Part 1, p. 71.
18. Greenberg 1960, p. 28.
19. Fried 1970, pp. 12–13.
20. Quoted in Swanson 1977, p. 10.
21. Quoted in Truitt 1961, p. A20.
22. Truitt 1961, p. A20.
23. Noland 1963, p. 10.
24. Quoted in Moffett 1977, p. 22.
25. Waldman 1977, p. 16.
26. Noland, quoted in Moffett 1977, p. 22.
27. Noland, quoted in Moffett 1977, p. 40.
28. Moffett 1977, p. 40.
29. E.g., Upright 1985, cats. 67, 76.
30. Fried 1970, p. 28.
31. Upright 1985, cats. 43–51.
32. Moffett 1977, p. 25.
33. Quoted in Upright 1985, p. 15.
34. Quoted in Upright 1985, pp. 60–61.
35. Jacobson 1970, p. 9.
36. Rosenblum 1963, p. 24.
37. Upright 1985, cat. 53.
38. Greenberg 1952, p. 146.
39. Quoted in Upright 1985, pp. 60–61.
40. Greenberg 1978, p. 5.
41. Fried 1970, p. 10.
42. See Greenberg 1978, p. 5.
43. E.g., Upright 1985, cats. X1–X17.
44. Quoted in Truitt 1961, p. A20.
45. Jacobson 1970, pp. 9–10.
46. Greenberg 1978, p. 5; cf. Upright 1978, pp. 86–87.
47. Greenberg 1965, p. 66.
48. Rosenzweig 1980, pp. 17–19.
49. See Sandler 1978, pp. 52–57.
50. Moffett 1977, p. 96, n. 54.
51. Greenberg 1955, pp. 208–229.
52. See Sandler 1978, p. 13.
53. See Sandler 1978, pp. 279–280, 254–287.
54. New York 1957; Moffett 1979, pp. 30–31, n. 24.
55. See Robbins 1965, pp. 42–48.

CHAPTER TWO

1. Eliot 1920, p. 49.
2. Forge 1978, n.p.
3. Smith 1954, p. 250.
4. Eliot 1920, p. 48.
5. Cf. Fried 1970, p. 13.
6. Steinberg 1972, p. 72.
7. Gouk 1970, p. 145.
8. Greenberg 1955, p. 218.
9. Cf. Elderfield 1983, p. 66.
10. Fried 1970, pp. 16–18.
11. Gouk 1970, p. 147.
12. Quoted in Moffett 1977, p. 39.
13. Greenberg 1963, p. 174.
14. Greenberg 1960, p. 28.
15. Carmean 1976—3, Part 1, p. 71.
16. Flam 1982, n.p.
17. Fried 1970, p. 23.
18. Greenberg 1966, p. 83.
19. Harrison 1969, p. 190.
20. Greenberg 1965, p. 66.
21. Cf. Upright 1985, p. 43.
22. Lynn 1971, p. 30.
23. Cavell 1971, pp. 105ff. and 115ff.
24. Greenberg 1963, p. 175.

25. Quoted in Rubin 1975, p. 72.
26. Greenberg 1965, p. 66.
27. Cf. Cavell 1971, p. 170.
28. Greenberg 1963, p. 173.

CHAPTER THREE

1. See New York 1959.
2. Quoted in Sandler 1978, p. 299.
3. Cf. Greenberg 1962; Greenberg 1964—1.
4. Fried 1970, p. 38.
5. Rosenblum 1963, p. 24.
6. Elderfield 1977, pp. 29–32.
7. Gombrich 1971, p. 114.
8. Tillim 1967, p. 18.
9. Carmean 1976—3, Part 2, pp. 114–115.
10. Cf. Krauss 1971, n.p.
11. See Upright 1985, p. 11.
12. Tillim 1967, p. 18.
13. Tillim 1967, p. 19.
14. See Upright 1977, p. 20; Upright 1985, p. 16.
15. Fried 1970, p. 24.
16. Quoted in Carmean 1976— 3, Part 1, p. 73.
17. Cf. Rose 1971—1, p. 63.
18. Fried 1970, p. 26.
19. Cf. Frye 1971, pp. 206ff.
20. Quoted in Lipsey 1982, p. 143.
21. Rosenblum 1976, p. 22.
22. Novak 1969, p. 122.
23. Wilmerding 1976, p. 40.
24. Cf. Cavell 1971, pp. 113–115.
25. Greenberg 1960, p. 28.
26. Moffett 1979, pp. 8–9.
27. Fried 1970, pp. 25–26.
28. Fried 1970, p. 27.
29. Lipsey 1982, p. 142.
30. Lynn 1971, p. 33.
31. Moffett 1979, p. 9.
32. Greenberg 1966, p. 84.
33. Lipsey 1982, p. 142.
34. Rosenblum 1963, p. 24.
35. Rosenblum 1963, p. 24.
36. Fried 1970, p. 28.
37. Milan 1960.
38. Greenberg 1960, p. 28.

39. Upright 1978, pp. 91–92.
40. New York 1960.
41. Moffett 1979, p. 28.
42. Greenberg 1978, p. 5.
43. Cf. Moffett 1970, p. 45.

CHAPTER FOUR

1. Cavell 1971, p. 22.
2. Noland, quoted in Moffett 1977, p. 50.
3. Fried 1970, p. 38.
4. Bannard 1974, p. 20.
5. Greenberg 1954, pp. 137–138.
6. Greenberg 1954, p. 134.
7. Upright 1985, p. 56.
8. Bennington 1960.
9. Fried 1970, p. 35.
10. Fried 1965, p. 30 (on Noland).
11. Greenberg 1962, p. 370.
12. Cf. Baker 1970, p. 39.
13. Tillim 1967, p. 19.
14. Quoted in Duthuit 1950, p. 43.
15. Quoted in Fourcade 1972, pp. 93, 132.
16. Bannard 1974, p. 20.
17. Lynn 1971, p. 30.
18. Lynn 1971, p. 33.
19. Cook 1956, p. 105.
20. Fried 1970, pp. 40–41.
21. Kermode 1961, pp. 107ff.
22. Goldwater 1979, pp. 1, 18.
23. Arendt 1958, p. 170.
24. Goldwater 1979, pp. 18–26.
25. Ashton 1963, p. 7.
26. Quoted in Fourcade 1972, p. 201.
27. Fourcade 1977, pp. 54–55.
28. Millard 1977, p. 257.
29. Fried 1970, p. 214, n. 18.
30. Fried 1970, p. 36.
31. Upright 1985, pp. 27, 39–42.
32. See Fried 1970, p. 36; Upright 1985, p. 42.
33. Upright 1985, pp. 44, 47.
34. E.g., Upright 1985, cats. 458, 474.
35. Fried 1970, pp. 35–36.
36. Fried 1970, p. 37.
37. Cf. Fried 1970, p. 37.
38. See Upright 1976, and Carmean 1976—1.

39. See Upright 1985, p. 47.
40. Millard 1977, p. 257.
41. Fried 1970, pp. 37, 48.

APPENDIX

1. Alloway 1963.
2. Fried 1967.
3. Swanson 1977.
4. Upright 1978, p. 84.
5. Elderfield 1974.
6. Upright 1985, cats. X1–X17.
7. Greenberg 1978, p. 5.
8. Upright 1985, p. 37.
9. Upright 1985, p. 37.
10. Upright 1985, p. 38.
11. Upright 1985, cat. 53.
12. Cf. Upright 1985, p. 25.
13. Fried 1970, p. 11.
14. Upright 1985, cats. 53–57, 61, 63, 68.
15. Upright 1977, p. 33, n. 27.
16. See Upright 1985, cat. 189.
17. Upright 1977, pp. 24–25; Upright 1985, pp. 28, 54–55.
18. Upright 1985, p. 52, figs. 9, 54.
19. Jacobson 1970, p. 8.
20. Upright 1986, cat. 401, p. 42.
21. Greenberg 1965, p. 66.
22. Upright 1985, pp. 43, 47.
23. Carmean 1976—1; Upright 1976.
24. Rudenstine 1967—2; Upright 1985, p. 259, bibl. 407–436.
25. Upright 1985, p. 58, n. 8.
26. Sitwell 1982, p. 102.
27. Moffett 1970, p. 46.
28. Greenberg 1963, p. 174.
29. Greenberg 1960, p. 28.
30. Upright 1985, p. 56.

SELECTED BIBLIOGRAPHY

BIBLIOGRAPHIC ENTRIES are limited to works referred to in the text, and are divided into two groups: "Works on Louis" and "Other Works." They are listed alphabetically by author or, in the case of some exhibition catalogues, by city. The abbreviated reference preceding each entry provides a key for the Notes to the Text. "Works on Louis" contains the most useful of the many publications on the artist; for a more comprehensive list of references on Louis see Upright 1985.

WORKS ON LOUIS

Alloway 1963
Lawrence Alloway. "Introduction." In *Morris Louis: 1912–1962*. New York: The Solomon R. Guggenheim Museum, 1963.

Ashton 1963
Dore Ashton. "Art." *Art & Architecture* 80 (November 1963).

Baker 1970
Elizabeth C. Baker. "Morris Louis: Veiled Illusions." *Art News* 69 (April 1970).

Bannard 1974
Walter Darby Bannard. "Morris Louis and the Restructured Picture." *Studio International* 187 (July–August 1974).

Bennington 1960
Bennington, Vermont. Bennington College. *Morris Louis*. 1960. Exhibition checklist.

Benson 1969
LeGrace G. Benson. "The Washington Scene." *Art International* 13 (December 1969).

Carmean 1976—1
E. A. Carmean, Jr. "A Possible Reversion in Morris Louis' Work." *Arts Magazine* 50 (April 1976).

Carmean 1976—2
E. A. Carmean, Jr. "Introduction." In *Morris Louis: Major Themes and Variations*. Washington, D.C.: National Gallery of Art, 1976.

Carmean 1976—3
E. A. Carmean, Jr. "Morris Louis and the Modern Tradition." Part 1. *Arts Magazine* 51 (September 1976); Parts 2, 3. *Arts Magazine* 51 (October 1976); Parts 4, 5. *Arts Magazine* 51 (November 1976); Part 6. *Arts Magazine* 51 (December 1976).

Elderfield 1974
John Elderfield. "Introduction." In *Morris Louis*. London: Arts Council of Great Britain, 1974. Reprinted (in German) in *Morris Louis: Gemalde 1958 bis 1962*. Düsseldorf: Städtische Kunsthalle, 1974.

Elderfield 1977
John Elderfield. "Morris Louis and Twentieth-Century Painting." *Art International* 21 (May–June 1977).

See also *Other Works*.

Fried 1967
Michael Fried. "Introduction." In *Morris Louis: 1912–1962*. Boston: Museum of Fine Arts, 1967. Reprinted in *Artforum* 6 (February 1967).

Fried 1970
Michael Fried. *Morris Louis*. New York: Harry N. Abrams, Inc., 1970.

See also *Other Works*.

Greenberg 1960
Clement Greenberg. "Louis and Noland." *Art International* 4 (May 1960). Reprinted in Milan 1960.

Greenberg 1963
Clement Greenberg. "Introduction." In *Three New American Painters: Louis, Noland, Olitski*. Regina, Saskatchewan: Norman Mackenzie Art Gallery, 1963. Reprinted in *Canadian Art* 20 (May 1963) and Fried 1967.

Greenberg 1965
Clement Greenberg. "Letter to the Editor." *Art International* 9 (May 1965). Also in Fried 1967.

Greenberg 1966
Clement Greenberg. "Postscriptum, November 1966." In Fried 1967.

Greenberg 1978
Clement Greenberg. "Letter to the Editor." *Art*

in America 66 (March–April 1978).

See also *Other Works*.

Harrison 1969
Charles Harrison. "London Commentary." *Studio International* 177 (April 1969).

Jacobson 1970
Helen Jacobson. "As I Remember Morris Louis." In *Ten Washington Artists: 1950–1970*. Edmonton, Alberta: Edmonton Art Gallery, 1970.

Krauss 1971
Rosalind Krauss. "Introduction." In *Morris Louis*. Auckland, New Zealand: Auckland City Art Gallery, 1971.

Lipsey 1982
Roger Lipsey. "Diptych: (1) Veiled Meaning in Morris Louis; (2) Form and Meaning in Criticism Today." *Arts Magazine* 57 (November 1982).

Lynn 1971
Elwin Lynn. "Louis in Australia." *Art International* 15 (November 1971).

Milan 1960
Milan. Galleria dell'Ariete. *Morris Louis*. 1960. Exhibition catalogue.

Millard 1977
Charles Millard. "Morris Louis." *The Hudson Review* (Summer 1977).

Moffett 1970
Kenworth Moffett. "Morris Louis: Omegas and Unfurleds." *Artforum* 8 (May 1970).

Moffett 1979
Kenworth Moffett. *Morris Louis in the Museum of Fine Arts, Boston*. Boston: Museum of Fine Arts, 1979.

See also *Other Works*.

New York 1957
New York. Martha Jackson Gallery. *Morris Louis*. 1957. Exhibition catalogue.

New York 1959
New York. French & Company. *Morris Louis*.

1959. Exhibition catalogue.

New York 1960
New York. French & Company. *Morris Louis*. 1960. Exhibition checklist.

Robbins 1965
Daniel Robbins. "Morris Louis at the Juncture of Two Traditions." *Quadrum* 18 (1965).

Rose 1971—1
Barbara Rose. "Quality in Louis." *Artforum* 10 (October 1971). Correction in *Artforum* 10 (November 1971).

Rose 1971—2
Barbara Rose. "Retrospective Notes on the Washington School." In *The Vincent Melzac Collection*. Washington, D.C.: Corcoran Gallery of Art, 1971.

Rosenblum 1963
Robert Rosenblum. "Morris Louis at the Guggenheim Museum." *Art International* 7 (December 1963).

See also *Other Works*.

Rudenstine 1967—1
Angelica Rudenstine. "Chronology." In Fried 1967.

Rudenstine 1967—2
Angelica Rudenstine. "Morris Louis' Medium." In Fried 1967.

Sitwell 1982
Christine Leback Sitwell. "Morris Louis 1912–1962: *Vav*, 1960." In *Completing the Picture: Materials and Techniques of Twenty-Six Paintings in The Tate Gallery*. London: The Tate Gallery, 1982.

Swanson 1977
Dean Swanson. *Morris Louis: The Veil Cycle*. Minneapolis: Walker Art Center, 1977.

Truitt 1961
James M. Truitt. "Art—Arid D.C. Harbors Touted 'New' Painters." *Washington Post* (December 21, 1961).

Upright 1976
Diane Headley [Upright]. "Morris Louis: Dis-

posing the Diagonal." *Arts Magazine* 50 (April 1976).

Upright 1977
Diane Headley [Upright]. "Documentation: The Veil Paintings." In Swanson 1977.

Upright 1978
Diane Headley [Upright]. "In Addition to the Veils." *Art in America* 66 (January–February 1978).

Upright 1979
Diane Headley [Upright]. *The Drawings of Morris Louis*. Washington, D.C.: Smithsonian Institution, 1979.

Upright 1985
Diane Upright. *Morris Louis: The Complete Paintings*. New York: Harry N. Abrams, Inc., 1985. Catalogue raisonné.

OTHER WORKS

Arendt 1958
Hannah Arendt. *The Human Condition*. Chicago and London: University of Chicago Press, 1958.

Cavell 1971
Stanley Cavell. *The World Viewed: Reflections on the Ontology of Film*. New York: Viking Press, 1971.

Cook 1956
Bradford Cook, trans. *Mallarmé: Selected Prose, Poems, Essays, and Letters*. Baltimore: The Johns Hopkins Press, 1956.

Duthuit 1950
Georges Duthuit. *The Fauvist Painters*. New York: Wittenborn, Schulz, 1950.

Dzubas 1965
Max Kozloff. "An Interview with Friedel Dzubas." *Artforum* 4 (September 1965).

Elderfield 1983
John Elderfield. *The Modern Drawing*. New York: The Museum of Modern Art, 1983.

See also *Works on Louis*.

Eliot 1920
T. S. Eliot. "Tradition and the Individual Talent." In *The Sacred Wood*. New York and London: Methuen, 1920. Reprinted 1980.

Flam 1982
Jack D. Flam. *John Walker*. Washington, D.C.: The Phillips Collection, 1982.

Fried 1965
Michael Fried. *Three American Painters*. Cambridge, Mass.: Fogg Art Museum, Harvard University, 1965.

See also *Works on Louis*.

Forge 1978
Andrew Forge. "Frankenthaler." In *Helen Frankenthaler: A Selection of Small-Scale Paintings 1949–1977*. Washington, D.C.: International Communication Agency, 1978.

Fourcade 1972
Dominique Fourcade, ed. *Henri Matisse: Ecrits et propos sur l'art*. Paris: Hermann, 1972.

Fourcade 1977
Dominique Fourcade. "Something Else." In *Henri Matisse: Paper Cut-Outs*. St. Louis and Detroit: The St. Louis Art Museum and The Detroit Institute of Arts, 1977.

Frye 1971
Northrop Frye. *Anatomy of Criticism*. Princeton: Princeton University Press, 1971.

Goldwater 1979
Robert Goldwater. *Symbolism*. New York: Harper & Row, 1979.

Gombrich 1971
E. H. Gombrich. *Norm and Form: Studies in the Art of the Renaissance*. London and New York: Phaidon, 1971.

Gouk 1970
Alan Gouk. "An Essay on Painting." *Studio International* 180 (October 1970).

Greenberg 1948
Clement Greenberg. "The New Sculpture." In *Art and Culture*. Boston: Beacon Press, 1961.

Greenberg 1952
Clement Greenberg. *"Partisan Review 'Art Chronicle,' 1952."* In *Art and Culture*. Boston: Beacon Press, 1961.

Greenberg 1954
Clement Greenberg. "Abstract, Representational, and so forth." In *Art and Culture*. Boston: Beacon Press, 1961.

Greenberg 1955
Clement Greenberg. "'American-Type' Painting." In *Art and Culture*. Boston: Beacon Press, 1961.

Greenberg 1962
Clement Greenberg. "After Abstract Expressionism." In Henry Geldzahler. *New York Painting and Sculpture: 1940–1970*. New York: Dutton, 1969. Reprinted with revisions from *Art International* 6 (October 1962).

Greenberg 1964—1
Clement Greenberg. "Post-Painterly Abstraction," *Art International* 8 (Summer 1964). Reprinted from Los Angeles, Los Angeles County Museum of Art. *Post-Painterly Abstraction*. 1964.

Greenberg 1964—2
Clement Greenberg. "The Crisis of Abstract Art." In *Arts Yearbook 7: New York: The Art World* (1964).

See also *Works on Louis*.

Kermode 1961
Frank Kermode. *Romantic Image*. London: Rutledge and Kegan Paul, 1961.

Moffett 1977
Kenworth Moffett. *Kenneth Noland*. New York: Harry N. Abrams, Inc., 1977.

See also *Works on Louis*.

Noland 1963
Kenneth Noland. "Kenneth Noland at Emma Lake, 1963." In *Ten Washington Artists: 1950–1970*. Edmonton, Alberta: Edmonton Art Gallery, 1963.

Novak 1969
Barbara Novak. *American Painting of the 19th Century*. New York: Praeger, 1969.

Rosenblum 1976
Robert Rosenblum. "The Primal American Scene." In Kynaston McShine, ed. *The Natural Paradise: Painting in America 1800–1950*. New York: The Museum of Modern Art, 1976.

See also *Works on Louis*.

Rosenzweig 1980
Phyllis Rosenzweig. *The Fifties: Aspects of Painting in New York*. Washington, D.C.: Smithsonian Institution Press, 1980.

Rubin 1975
William Rubin. *Anthony Caro*. New York: The Museum of Modern Art, 1975.

Sandler 1978
Irving Sandler. *The New York School*. New York and London: Harper & Row, 1978.

Smith 1954
David Smith. "Second Quotes on Sculpture." In Barbara Rose, ed. *Readings in American Art Since 1900: A Documentary Survey*. New York and Washington: Praeger, 1968.

Steinberg 1972
Leo Steinberg. "Other Criteria." In *Other Criteria: Confrontations with Twentieth-Century Art*. New York: Oxford University Press, 1972.

Tillim 1967
Sidney Tillim. "Gothic Parallels: Watercolor and Luminism in American Art." *Artforum* 5 (January 1967).

Waldman 1977
Diane Waldman. *Kenneth Noland: A Retrospective*. New York: The Solomon R. Guggenheim Museum, 1977.

Wilmerding 1976
John Wilmerding. "Fire and Ice in American Art: Polarities from Luminism to Abstract Expressionism." In Kynaston McShine, ed. *The Natural Paradise: Painting in America 1800–1950*. New York: The Museum of Modern Art, 1976.

PHOTOGRAPH CREDITS

Courtesy Albright-Knox Art Gallery, 23, 65; Jörg P. Anders, 105; Artech, Inc., 117; Lee Brian, 20 top; Geoffrey Clements, 66; Colten, 29; George Cserna, 95, 107, 123, 137, 139, 145, 169; Ali Elai, 121; courtesy André Emmerich Gallery, 66; M. Lee Fatheree, 89, 125, 157, 165; courtesy Fort Worth Art Museum, 11 bottom, 59 top; courtesy Mr. and Mrs. Graham Gund, 97; Greenberg, Wrazen, & May, 48; David Heald and Myles Aronowitz, 111; Greg Heins, 17; Kate Keller, 27 top, 64, 91, 103, 133, 135, 147, 153, 155, 173, 175; Barry Kinsler, 93; courtesy M. Knoedler & Co., 87; A. Mewborn, 101; Eric Mitchell, 129; Thomas Moore, 163; courtesy National Gallery of Art, 13, 49 bottom, 143; Steven Oliver, 159; David Penney, 115; Rolf Peterson, 31; Earl Ripling, 85; Runco Photo Studios, 65; Lee Stalsworth, 127, 131, Strüwing reklamefoto, 113; Soichi Sunami, 10 top, 14 top, 22, 26, 28, 32; John Tennant, 167; courtesy Ulster Museum, 99; courtesy University of Nebraska, 149; Thomas P. Vinetz, 141; Malcolm Varon, 151, 161, 171.